JEAN DUBUFFET

LAURENT DANCHIN

The publisher wishes to thank the Fondation Dubuffet for its invaluable help and cooperation.
We also wish to record our thanks to Mr Gérard Caumont, the Musée Historique du Havre, as well as the Musée de l'abbaye Sainte-Croix, Les Sables d'Olonne.

Editors
Anne Zweibaum and Annelise Signoret
Layout
Michel Gourtay
Translation
Portes Paroles – Edward Freeman
Copy editor
Soline Massot
Iconography
Nadine Gudimard
Proof reader
Christophe Gallier
Lithography
L'Exprimeur

© **FINEST S.A. / EDITIONS PIERRE TERRAIL, PARIS 2001**
Publication number: 287
ISBN 2-87939-240-3

Printed in Italy

Cover illustration
Casse Gamelle (detail)
7 June 1962
Gouache on paper
50x67 cm
Musée des Arts décoratifs, Paris

page 1
La Calipette (detail)
31 August 1961
Oil on canvas
89x116.5 cm
Galerie Daniel Malingue, Paris

Page 2
Etre et paraître
(To Be and to Seem)
(detail)
25 July 1963
Oil on canvas
150x195 cm
Private collection

Jean Dubuffet in 1979

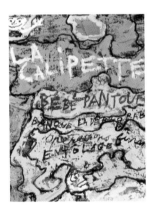

Jean
Dubuffet

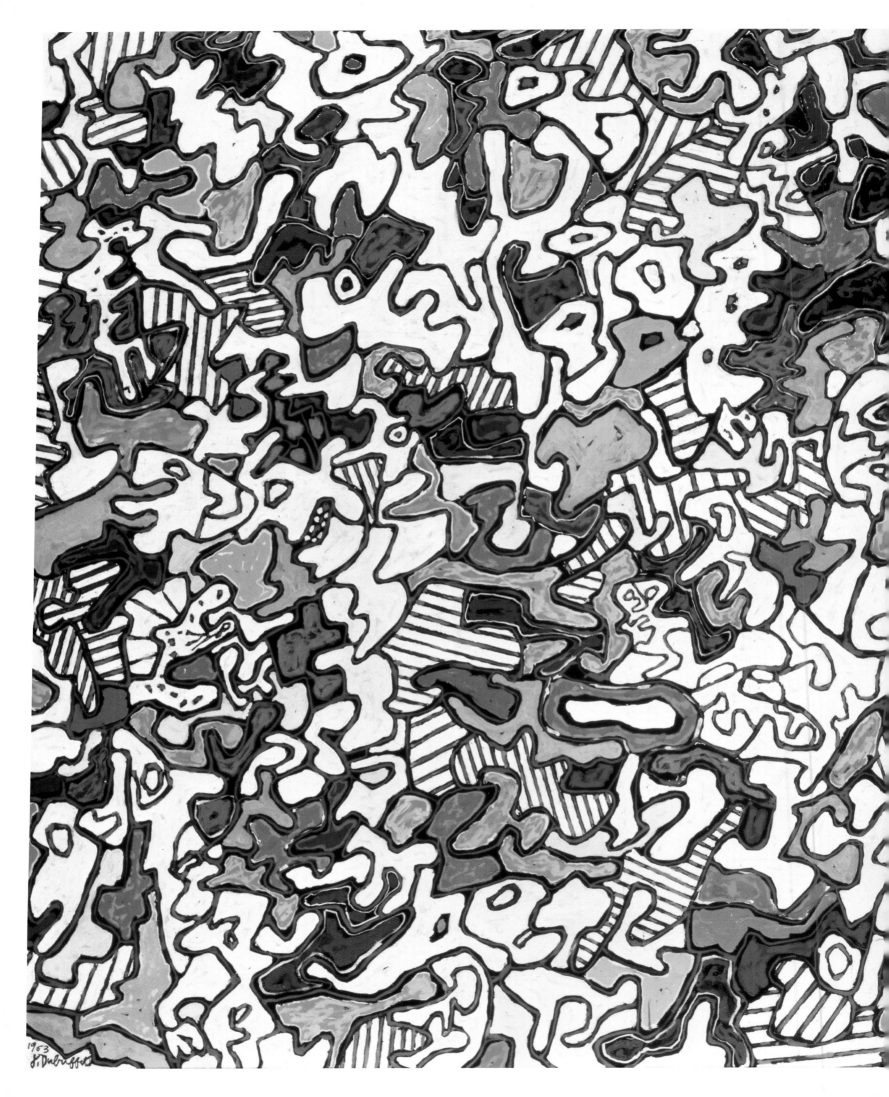

Contents

From the *Hourloupe* cycle to the *Non-lieux*: painting or metaphysics?

4

Appendices

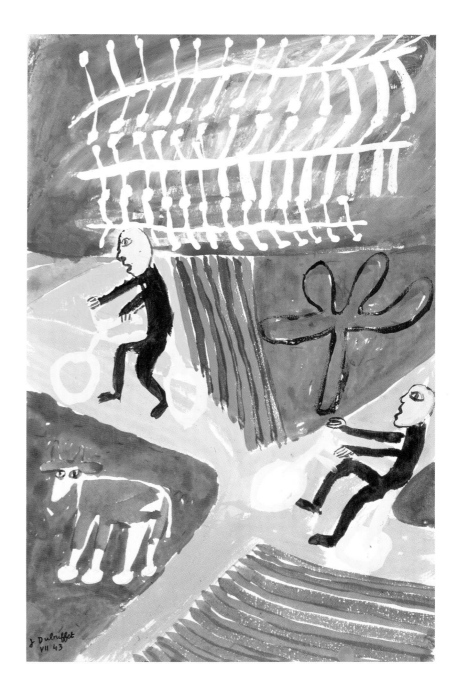

Campagne aux cyclistes
(Countryside with cyclists)
July 1943
Gouache on paper
25x15 cm
Musée des Arts décoratifs, Paris

Introduction

● **Tissu d'épisodes**
(Fabric of episodes)
16 April 1976
Acryl on paper mounted on canvas
(with 44 pasted pieces added)
248x319 cm
MNAM - G. Pompidou Center, Paris

For all sorts of reasons, mystery surrounds the name of Dubuffet in France. That it should still be possible to confuse the originator of the *Hourloupe* with Bernard Buffet, whose name sounds similar, says a lot in itself. He is much misunderstood by the majority of people or thought of merely in terms of a hoax which he would have been the only one to take seriously for any length of time; he is even sometimes accused of having betrayed himself by giving in under pressure to the museum system which he spent his life fighting. Dubuffet the inventor and collector of Outsider Art (*art brut*), Dubuffet the "Flower Beard", the Dubuffet of anti-culture and the scandalous law-suit with the Renault car company, Dubuffet the merchant of wines and then of pictures but also a writer and a thinker, philosopher and metaphysician, protector of Céline and Artaud, the friend of Paulhan, Ponge, Vialatte and Michaux, is still in his own land an author waiting to be discovered.

Where does one go, for example, to visit the *Tower of Figures*, the *Winter Garden*, or the *Closerie Falbala*? Which museums in France contain the best holdings of his work? And which museums abroad? Who understands the precise role played by the Fondation Dubuffet (Dubuffet Foundation), which is a private institution occupying a quite unique place in the fine art world in France? And do people even know that a vast *Catalogue of Jean Dubuffet's works* exists in French? Dubuffet is the only painter besides Picasso to have undertaken systematically to document and publish the whole of his work: more than forty illustrated volumes with a vast number of extremely detailed technical notes.

And above all how many people know the "writings" of Jean Dubuffet? Have they "read" the innumerable prospectuses, manifestoes, statements, announcements and pamphlets of this extraordinary writer? Dubuffet's correspondence in particular, replete with anecdotes, character sketches and verbal inventions in the most audacious literary style, would be the envy of many a professional writer. For you need to read and re-read Dubuffet, slowly absorb the profound originality of his mind, become attuned to the mentality of this great scourge of culture; Dubuffet was a sort of dissident of the far-left before the letter, an untiring apostle of the self-taught and of spontaneous creation, a champion of that outsider art with which he was for so long totally associated and to which he was committed so passionately – and yet ambiguously. Dubuffet was a true enemy of the insider's position in the little world of contemporary art, an inveterate challenger and stirrer-up of controversy, and as such a remedy for painting in senile decline.

One could go on at great length about all the reasons for the relative failure of Dubuffet to be understood in France over the last thirty years. And this lack of understanding continues even now, sixteen years after his death, at a time when his work at last seems to be getting some kind of official consecration, witness the Dubuffet exhibition with which the new Jeu de Paume Gallery opened in 1991 and the Beaubourg Center retrospective ten years later on the centenary of his birth. These events seem only to have changed the image of Dubuffet in the public eye from one extreme to the other, from the hostile if not scandalized silence with which he was first received to elevation to the status of a contemporary classic, only to bury him in due course in the automatic indifference that comes with posthumous fame.

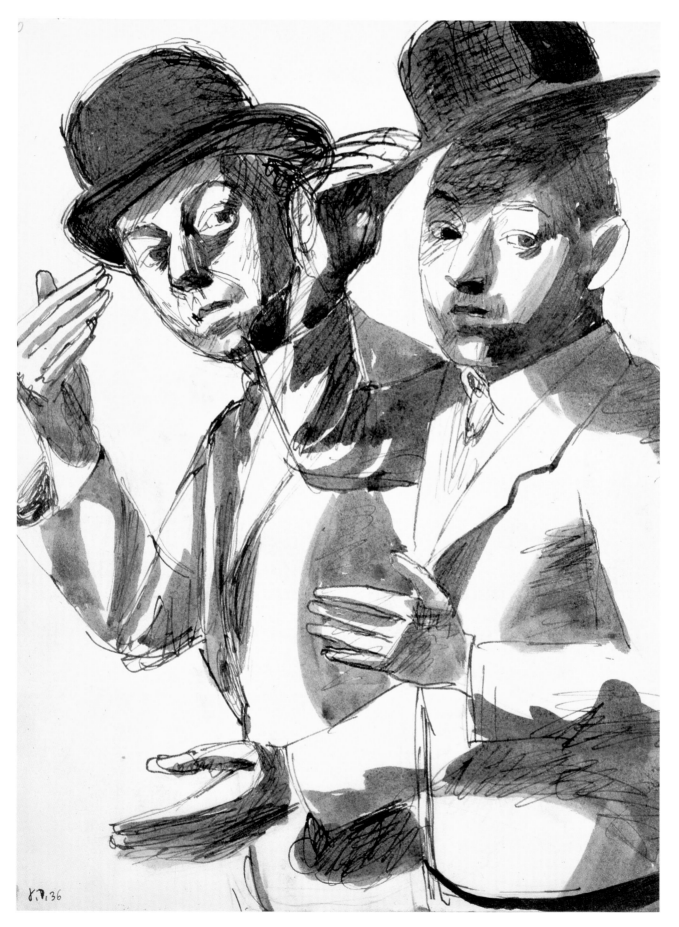

Double autoportrait au chapeau melon
(Double self-portrait in a bowler hat)
November 1936
Indian ink wash drawing on paper
31.5x23 cm
Fondation Dubuffet, Paris

First of all there is Dubuffet's particular sense of nihilism and derision and rather Zen sense of humor, which have always made it extremely difficult for the French to take his work seriously. Then there is his fundamentally anti-establishment disposition, which inevitably caused him to be surrounded by antagonisms and scandals, feuds and misunderstandings. It certainly has to be admitted that with his genius for stirring it up, challenging institutionalized culture and good taste, his friendships with writers and artists but never with journalists, Dubuffet used no half measures when it came to building up a wall of hostility and mistrust around himself.

It also has to be said that the creator of the *Hourloupe* sometimes gives the impression of having been totally off-hand in his relations with his own country, seeming to prefer foreign countries and audiences. He has never been particularly deferential towards France, and for a long time he refused all approaches from cultural institutions and state museums. It was a private museum that was the biggest beneficiary in Paris of a Dubuffet donation of work: the Museum of Decorative Arts, which had originally been created to strengthen the links between art and industry. It was a Swiss city, Lausanne, which received the gift of Dubuffet's magnificent collection of outsider art; clearly he preferred the tranquility and lack of pretentiousness of that provincial city to the very Parisian pomp and circumstance of Beaubourg. In fact, unlike Picasso, who was a fairly typical embodiment of that Communist commitment – often in the ranks of the social establishment – that triumphed in the avant-garde of the first half of the century, Dubuffet, whose entire output belongs to the postwar period, was always radical in a very different way. His was a peculiar, independent radicalism from which strictly political concerns were absent. And it is perhaps the apolitical nature of his struggle in the cultural world, his refusal to swear an allegiance to any cliques or political parties, that explain the relative loneliness of his destiny and the long period of isolation in which a country as politicized as France was happy to leave him.

Dubuffet's contradictions have been written about exhaustively: the enemy of official culture and museums who finished his career in the Gallery Maeght and at Beaubourg; the friend of self-taught artists, social outsiders and creative spirits living in destitution, who was himself extremely cultivated and wealthy; the denigrator of easel painting whose work was bought by rich collectors to be hung on walls in the most traditional manner. Criticism has also been directed at this 'ordinary man', obsessed with anonymity, who became a sort of star despite himself; a creator who was both paranoid in one sense and modest in another, endeavoring in vain to make painting accessible to the man in the street, yet failing to have any appeal to the mass of ordinary people; finally, the artist who scorned ideas, books and culture and never ceased to read, write and theorize.

Irascible, demanding, obsessive, tirelessly creative, often endearing, some-times unbearable, the character of Dubuffet, in the opinion of anyone who ever knew him, was fascinating and difficult. The catalog of his friendships, just like his obsessions, for example, is nothing but one long series of sud-den passionate commitments followed by equally dramatic breakups. He was in turn feared, admired, detested, loved, always extremely independent in spirit and needing to return periodically to breath the reinvigorating air on those solitary heights propitious like no other place to his creative activ-ity. On occasions he was as cut off from the world as a schizophrenic child, yet on the other hand careful always to retain links with a host of corre-spondents and contacts of various sorts. From the day when he finally devoted himself to painting, he was never to know failure, as if he was just destined to succeed along the very particular path he had chosen. It was a path that led him finally to a total intellectual asceticism bordering on the metaphysical. His work is difficult to classify, and if one were to make a comparison it would really have to be with the work of Picasso, where, although earlier in the century and in a quite different genre, we find the same exceptional creative energy and prodigious fertility.

Dubuffet versus mainstream art, Dubuffet the champion of Outsider art: today these controversies seem long out of date. And yet…much more than being just a painter, Jean Dubuffet always wanted to be the driving force behind a subversive current, or at least behind an attempt to redirect cul-ture towards something other than what had previously been its main cen-ter of gravity. Amid the arrogant clamor and sterile hysteria of the contem-porary art scene, he was probably one of the few to follow an authentic philosophical line, and he did so with constancy and tenaciousness, being truly clear about his aims and requirements, despite his success on the inter-national scene.

The last of the pure painters or the precursor of something new, like the art of the catacombs prefiguring a new Middle Ages; archaic and at the same time modern, backward-looking and also prophetic, Jean Dubuffet, working away in his laboratory of signs and symbols, offers all of these interpretations to the onlooker. In an age of transition in which all spatial and temporal dimensions have been explored, the last frontier is within the self. This study sets out to demonstrate the logic of a quite exception-al human destiny. As part of the process we shall examine the subject's often extraordinary life in some detail and trace the development of a cor-pus of art that is like no other. And in pinpointing finally the quasi-obses-sive leitmotivs that inform his writing and his thought, we shall be in a position to account for Jean Dubuffet's undiminished power of stimulat-ing and captivating the imagination.

"For a very long time I was too humble […] and lacking in confidence and composure; and I suffered cruelly because of this, appearing in my own eyes to be nothing more than the most abject dogturd. It was only at a late stage – when in the end I had resigned myself to living like a dogturd without shame or regret and making the best of the situation – that it dawned on me that everyone else was also a dogturd."

Jean Dubuffet, Letter to Jacques Berne, 11 June 1947, *Prospectus II*, p. 252.

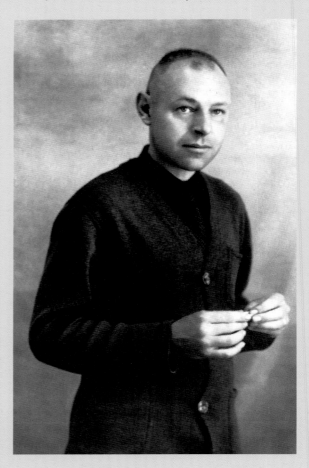

Jean Dubuffet in 1943
at the dawn of his career
as a painter

1

1901-1942
the years of
apprenticeship

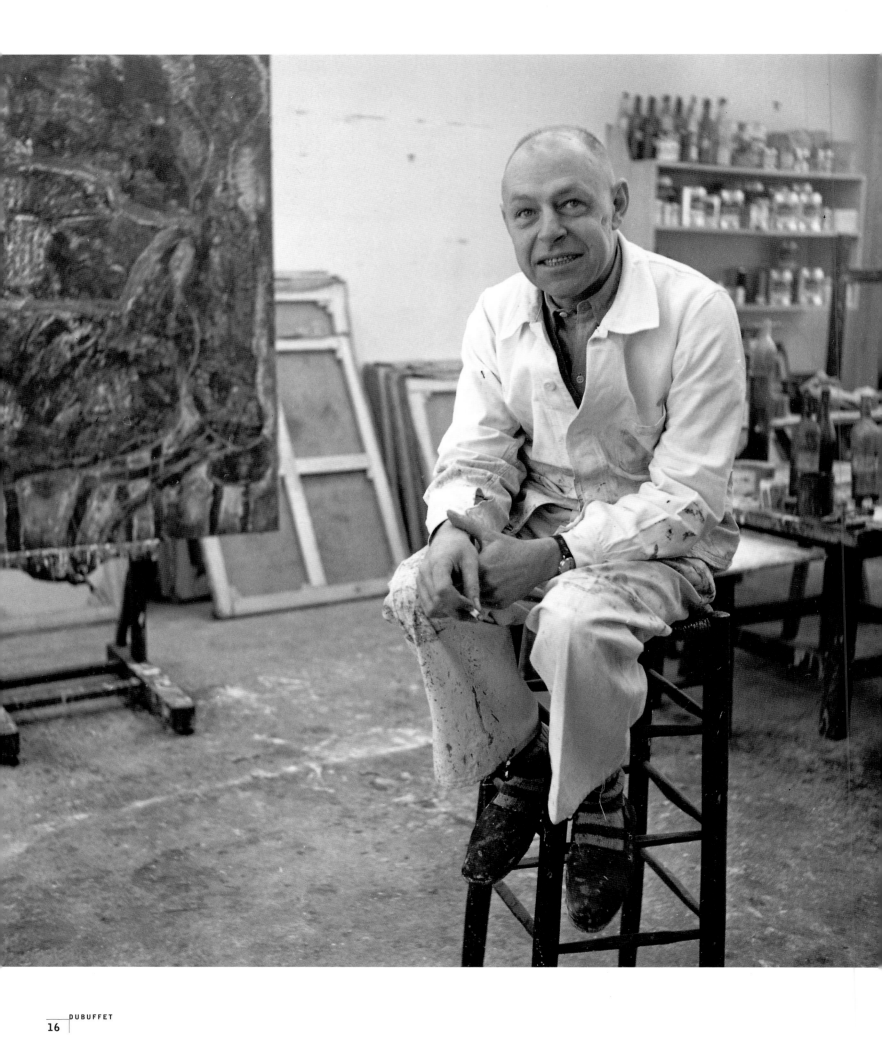

"It's usually by racing on stilts
that you learn to ride a bike, by sailing
on a stormy sea that you become a fine
dancer, and by playing the flute
that you learn to paint."

(Jean Dubuffet, Letter to Jacques Berne, 17 March 1947,
Prospectus II, p. 248 and *Prospectus IV*, p. 110)

Jean Dubuffet at the age of 8
1909

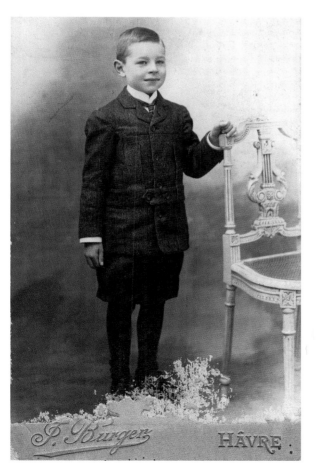

A BIOGRAPHY IN TWO STAGES

The beginning of what very rapidly became Jean Dubuffet's public existence, his career as a painter, occurred at the end of 1942, when he was forty-one. He was the son and grandson of wine merchants who himself adopted the same profession both out of choice and necessity. It took him more than twenty years to succeed finally in the vocation to which he had always felt called, twenty years during which doubts and identity crises and the enormously high demands he placed on himself caused him to abandon this vocation twice.

The first time was in 1924, when he was twenty-three, after his formal art training had proved abortive, just like the difficult period of solo study that followed. As a result of the acute crisis that ensued, he chose to become an ordinary man rather than an artist. So he had to learn a profession, go into the family business, marry, etc, with the result that he was totally absorbed by the wine trade for the next nine years. The second abandonment of his vocation occurred in 1937, after a fresh attempt to take up painting that had lasted only a few years and culminated in divorce and remarriage. He had to rush to the rescue of the wine business, which he had badly neglected, and save it from certain bankruptcy. Then came another five more years of the humdrum existence of a wine merchant.

It was only in the Autumn of 1942, at his third attempt, that everything started to go right for him, and so it was to remain for more than forty

uninterrupted years of prolific creative activity: it was as if he had at last discovered the formula that would unlock the endless source of his inspiration. Whenever he commented later on his sudden and miraculous late start as a painter, Dubuffet would often say that he had found it impossible to discover the "way in". The wine trade is an unusual background for a painter, and it was as if Dubuffet had first to exhaust the hard code of those origins before he could have the courage to be himself and above all love his works totally, for themselves and without any external consideration.

This is how his fellow Le Havre friend, Georges Limbour, describes Dubuffet when they were both eighteen and making the big move to Paris (Limbour, to become a writer): "He was full of confidence then, but very fickle in his convictions and very unreliable by nature. In everything he had the fluency and panache of a sophist" (*L'Art brut de Jean Dubuffet. Tableau bon levain à vous de cuire la pâte*, Pierre Matisse-New-York/ René Drouin-Paris). Dubuffet set himself extremely high standards and it is believed that he felt compelled to destroy the major part of everything he had created before 1942, including a collection of wood carvings, and "paintings in the everyday popular style, like signs for shop-fronts and fairground booths " (*Prospectus IV*, p. 477), a few portraits, masks and plaster casts of friends' faces, and carved wooden Punch and Judy puppets. He was later to admit in correspondence that he had kept only about thirty of his works of this period. He certainly had no affection for them. Consequently when Beaubourg was given a piece of his juvenilia, dating from 1924, he quite naturally kicked up a considerable fuss: a new-born animal does not need to collect the remains of its placenta; when a rocket takes off, nothing is achieved by documenting the parts of the launching process.

THE LONELY CHILDHOOD OF A BOURGEOIS BOY

The ups and downs of Jean Dubuffet's career as a painter are not without interest. He was born on 31 July 1901 into a Le Havre wine merchant's family. He was the only son of the family and destined to be brought up the hard way by an extremely irascible and authoritarian father and a mother who was cold, cautious and possessed of extraordinary energy. As a child Dubuffet received affection only from his grandmother on his father's side, who constantly encouraged his creative efforts, most notably after passing his baccalaureate when he decided to try his luck in Paris.

The family business in Le Havre was called the Entrepôts Dubuffet (an "entrepôt" is a warehouse), and had been founded by Jean's grandfather, Arthur. With eighty branches, small grocery stores which were also outlets for the wine, this was a business of considerable size. It was thus inevitable that the heir apparent should receive a traditional bourgeois education: Latin, Greek, German, a piano lesson every morning before school, confirmation of his religious faith at the age of eleven, school prize-giving, then the baccalaureate, etc. Dubuffet was as it so happens a determined pupil and achieved good results. Like all boys in his social milieu, he was sub-

● **Portrait of Georges Dubuffet**
circa 1918
Pastels on gray-green paper
55x45.5 cm
Fondation Dubuffet, Paris

Entrepôts DUBUFFET.

Chais du Havre

The "Entrepôts Dubuffet"
Le Havre
1909

**Mrs Georges Dubuffet
and her sisters**
in 1919
Pastel on paper
30x36 cm
Fondation Dubuffet, Paris

jected to the merciless pressures of a class that valued only one outcome for its children: success. "Of the whole of my childhood", he wrote in some lines about himself in December 1976, "I retain a memory of loneliness and boredom, as well as being continually bullied and persecuted. [...] As a punishment I was often locked in my room, and that's how I developed my taste for solitude and confinement." (*Prospectus IV*, p.648).

What we hear about his father, Georges Dubuffet, is grim. "Very sedentary", "obsessed with authority" and proclaiming his "contempt for what he called feeling, which has an adverse effect on sanity and reason", he was, according to his son, someone who glorified "intelligence and initiative", "praised ambition and leadership" and "could fly into terrifying rages at any time" ("Biography at running speed", *Prospectus IV*, p.460). He was an agnostic devoted to culture, an avid reader with wide-ranging tastes, just as his son was to be later but in a very different register ("he was very fond of satire and controversial topics" and, while admiring Louis XI and Montaigne, read Rivarol and Léon Bloy!). He habitually shut himself away in his semi-clandestine library, where thousands of books were kept under lock and key. It did not take long for his son to find his way into the sanctuary.

This is partly the source of Jean Dubuffet's love of secrecy and enclosed spaces, which was to express itself very much later in various aspects of his behavior: the privacy of his *art brut* collections, for example, during the time when they were displayed in Paris, or the administrative setup of the Dubuffet Foundation, where you really have to prove your credentials to gain access. Then there is the conception of most of the structures in the *Hourloupe* cycle, the *Tower of Figures*, for example, which is a space without windows, or the *Closerie Falbala* , which is probably the strangest building of all, a sort of resurfacing more than half a century later of an identical mental process: initiatory access to a sanctuary that is both empty and closed, a personal metaphysical cenotaph, a Holy of Holies for strictly private use.

But it is above all in the relationship with books and reading that the father's influence is most marked: as a reaction perhaps, Jean Dubuffet experienced a sort of ambivalent, iconoclastic passion throughout his life for any books that came his way. As all his friends were to discover, Dubuffet felt no desire to keep books, even if they were personally dedicated to him, and he would often give them away to other people; he professed no more than a strictly utilitarian reason for keeping those books that interested him. "I've got masses of books on my shelves," he wrote to Paulhan in 1944, "I've read them, so they're empty of their contents so to speak, like empty bottles." (Letter of 10 April 1944, *Prospectus IV*, p.89). It seems that when he had to cope with a particularly thick volume, Dubuffet would even arm himself with a pair of kitchen scissors to cut it up into two or three chunks for easier handling.

Of Dubuffet's mother, whose maiden name was Jeanne Paillette, the third child of a leading Le Havre family that owned breweries, not a lot is known other than that she is believed to have quarreled with her son when he divorced in 1934. Just a few months before her death, this extraordinarily robust woman was asked by a local journalist for the secret of her amazing

"You only live once. If you get three good years in a lifetime, that's something to be pleased about."

("More modest", *Prospectus I*, p. 92)

● **Jean Dubuffet's mother**
at the age of 103
16 August 1984

Mme G. Dubuffet was born on 16 December 1880, and died on 12 October 1984, two months before her hundred and fourth birthday and seven months to the day before her son died.

"Any way is good for the mind to build its castles, just as any grain of sand is good for the oyster to make its pearl."

(Letter to Pierre Bettencourt, 31 July 1955,
Prospectus II, p. 315)

longevity (she was 103), and this was the answer: "The main thing is to be good natured. I've tried not to have too many upsets in my life. That's how I've lasted so long." And she had this advice for women dreading old age: "Take it steady. Always keep something back in reserve and don't push your luck with nature!" Jean had just one sister, Suzanne, who was nine years his junior. He seems to have had a good relationship with her if we are to judge by the fact that, when their father died in 1927, Jean allowed his share of the inheritance to go to her.

Of the grandmother, the one who was affectionate with Jean, a portrait has survived, dating from 1921. It must be said that women and the whole phenomenon of love do not seem to occupy a vital place, putting it mildly, in the mental universe of the somewhat Spartan philosopher Jean Dubuffet, who was more accustomed to masculine friendship and the cut and thrust of debate among men. Or perhaps it is rather that women were used to being maternal and decorative, content to be physically present and yet keep a low profile, according to the norms of a traditional upbringing: men talk and act, women keep quiet.

Dubuffet's first marriage was a marriage of convenience, ending in failure despite the birth of a daughter, Isalmina, in whose upbringing – to the detriment of them both no doubt – Dubuffet was never involved. When he wrote about this marriage in his *Biography at running speed*, this was Dubuffet's unemotional comment: "Looking back on it, I don't think it was a good idea. She was certainly a beautiful and graceful girl, but I knew nothing about her apart from glimpses of her dark Southern skin." (*Prospectus IV*, pp. 472-473). She was indeed from Southern France and he

had been captivated by her accent, but this was hardly enough to cement a sound marriage. "My opinions about love," Dubuffet added at this point, "are the opposite of those of Doctor Freud and his followers, who believe that moods are the product of sexual drives. I believe on the contrary that love is largely dependent on ideology and mental attraction. At least as far as I am concerned. I must add that I tend to experience this phenomenon of attraction to things that are basically foreign to me." (*id*, p. 473).

That Dubuffet very early on developed a taste for painting while a lonely child and soon felt the call of an artist's vocation, despite the fact that it did not become fully apparent until much later after a long delay, is what emerges unambiguously from his own memories and the accounts of his friends. In the words of Michel Thévoz, "the young Dubuffet spent all his spare time inventing his own red-skin Indian language, creating a little museum of natural history containing rare substances, fossils and minerals, as well as making more or less formless miniature paintings which he would not show to anyone (inevitably we see him thus anticipating respectively his texts in nonsense language, collecting of outsider art, and his own painting)." (*Dubuffet*, Geneva, Skira, 1986, p.8).

As for the actual moment of discovery of painting, which was a veritable revelation for the child, it would appear to be recalled in a precise childhood memory, and this is how Dubuffet described it: "During a stay in the Mont-Dore region I came across a woman in the countryside who was sitting at an easel, painting the landscape in pastels which she was taking from an open box beside her. The colors in this box made a big impression on me, and so did her picture. You couldn't make out much more than patches of different shades of green, the kind of thing that people call a "plate of spinach" when they make fun of this type of painting. I felt immediately inspired to make similarly abstruse little pictures myself […] (I was about seven or eight years old)." ("Biography at running speed", *Prospectus IV*, p.459-460). Dubuffet's account in 1976 is more detailed and adds: "That little picture made a strong impression on me, and I have never forgotten it; I am sure that it was instrumental in attracting me to painting, especially as regards my fondness for jumbled indecipherable subjects." (*Prospectus IV*, p.648).

That Dubuffet has always had a certain taste for caricature rather than drawing in the strict sense, that is to say for detecting the essentials of universal ridicule in individual faces, is what we learn from one of Georges Limbour's reminiscences (like the future writers Raymond Queneau and Armand Salacrou, Limbour was a fellow lycée pupil with Dubuffet in Le Havre): "The art of drawing was one of those varied gifts among which it would later be necessary to do some thinning out. We should not misinterpret the use he made of this gift (and let's not forget the *More Beautiful Than Nature* portraits of 1947), but his caricatural drawings were usually done in the classroom and at the expense of his teachers. The fact is he had a sense of humor, and among the gifts that I have not yet mentioned there is one of the subtlest and most patient, which will prove to have the most

fruitful consequences for his work, the gift of observation." (*Quelques intro-ductions au Cosmorama de Jean Dubuffet Satrape, Travaux du Collège de Pataphysique,* Charleville, 1960, p.15).

The fact remains that the future painter, like most gifted children of the French bourgeoisie, was also profoundly sensitive at an early age to the lure of writing. At ten or eleven, in collaboration with a classmate who eventu-ally became a Benedictine monk, Dubuffet wrote a five-act classical tragedy in alexandrine verse. But what is most interesting, and unusual for a school-boy before 1914, he went to all the trouble of producing the whole of the text on a typewriter. This is the beginning of nothing less than a passion for typewriters which will prove providential for Dubuffet during the Occupation and stay with him all his life; it is just one instance of a gener-al fascination with all machines likely to help him in his creative endeavors. When he wrote a preface in 1945 for René de Solier's abortive *Short Treatise on Graffiti,* this was how Dubuffet, clearly wishing to demystify the issue, referred back to his beginnings as a painter: "In parallel to my commercial chores – I had the part time profession of wine merchant – I devoted myself to the labor of painting. This obsession developed in me gradually as a result of a course I followed at an Academy of Fine Art as soon as my sec-ondary schooling was over. I went partly out of curiosity about the tech-niques, partly because the artist's profession – or so it seemed at the time – offered many attractions, and very much because it was a chance to get away from my family and my hometown, where I was bored stiff: to live on your own and with no-one checking on you in Paris is a very tempting prospect for an adolescent." (*Prospectus II*, p.9).

In fact it seems to have happened not quite like this. In 1916, when he was fifteen, Jean Dubuffet had already enrolled in the evening classes at the Beaux-Arts of Le Havre. So at a time when he was wildly enthusiastic about the poetry of Charles Baudelaire, the archetypal suffering scion of the respectable bourgeoisie, Jean Dubuffet was getting the most traditional beginner's training in drawing and painting: plaster models, the academy tradition, and the prevailing "Impressionist" vision. It was after this, having passed his baccalaureate, and probably with the discreet support of his grandmother, that he decided to make the "big move" up to Paris together with his friend Georges Limbour. He began by enrolling at the Académie Julian, an independent art school associated with the Beaux-Arts. However he was only able to bear the atmosphere in the institution for a very short time and he left after just under six months. He tried somewhere else briefly, and then decided that from that point onwards his training and development as an artist would be in his own hands. For a boy of eighteen this was proof of an independent character.

To mark the change, our renegade artist made a big decision, consummating his defiance of the smug world of artists by completely changing his *image:* "It didn't take me long to realize that no tuition was given in that Academy […]. We chased girls, let our hair grow long and wore black hats – this was the uniform of The Artist. After a few months I began to see things differ-ently. I saw some exhibitions of avant-garde painting and was influenced by

August Natterer (Neter)
Witch heads
Between 1911 and 1922
Pencil, watercolor and pen
25.9x34.2 cm
Collection de l'Art Brut, Lausanne
and 25.9x34.2 cm
Prinzhorn Sammlung, Heidelberg

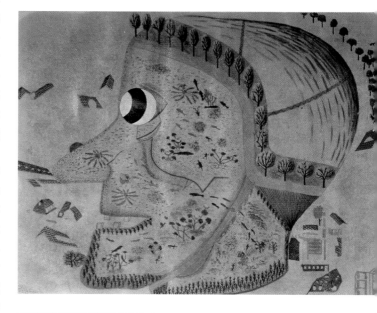

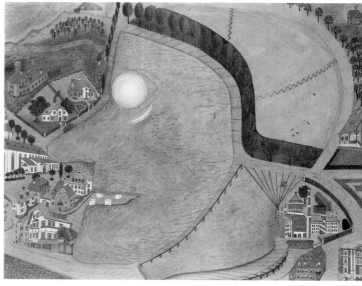

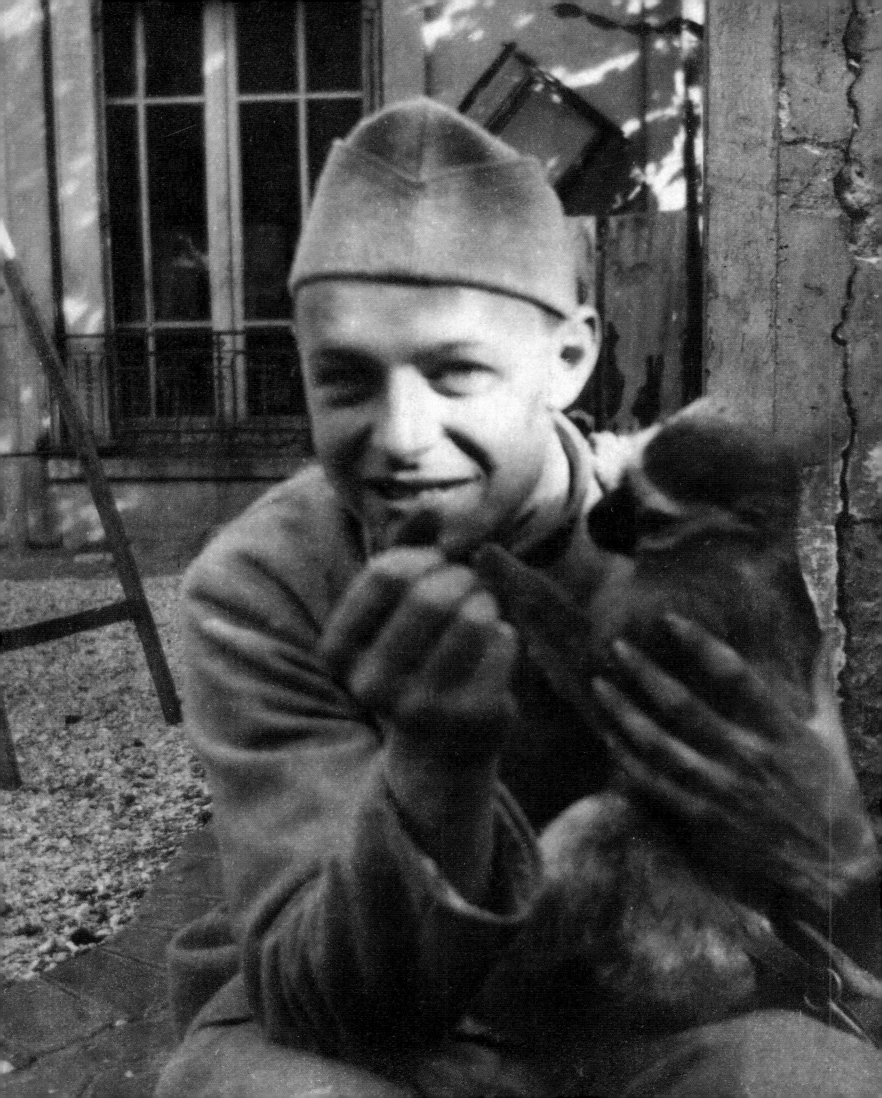

the writings of the modernists. The conviction grew in me that artistic creation should be firmly anchored in the common reality of everyday life: my black hat was replaced by a working man's cap. I took an intense dislike to the Latin Quarter and to students' talking shops. I went off to live in cheap rooms in the suburbs, feeling extremely happy in the most miserable premises." ("Biography at running speed", *Prospectus IV*, p.465-466).

Very much later Dubuffet admitted having been influenced by his discovery of Picasso's first pictures, as well as satirical leaflets and other handouts by the Dadaists which appealed to him. It is significant too that the budding young artist, who was an inveterate individualist throughout his life and totally hostile to any sort of militancy, should have been more receptive to the destructive and nihilistic anarchism that was part of Dadaism than he was a few years later in 1924 to the moralizing politico-philosophical pretentiousness of Surrealism. Quite simply it appears not to have made the slightest impression on him, whereas Georges Limbour on the contrary was to join the movement for a time with his friends Aragon, Bataille and Leiris, before being kicked out dramatically in 1930 for having contributed to a violent pamphlet targeted at André Breton (*A Corpse*).

Nevertheless, twenty-five years later, when Breton's star was in decline, betrayed as he was a thousand times over and abandoned by his supporters, the founder of Surrealism received an admiring tribute from the creator of the Art Brut Company, although it is true to say that it was purely a personal gesture and quite unrelated to his ideas. It was a symbolic incident reflecting the short surge of friendship and mutual esteem that united the two men briefly in 1948, as is clearly documented in their correspondence.

Just as unappealing to Dubuffet in the 1920s, despite his being so radical in other ways, were the theories and myths of the far left and in particular that ideal of a communist society that was to turn the heads of so many artists and intellectuals – only for them to have to shake their heads in embarrassment some time later. When he was about thirteen or fourteen, shortly after his confirmation ceremony, which was doubtless insisted upon by his mother, who was more or less a practicing Catholic, he had experienced a profound religious crisis resulting in a rejection of the Church and a loss of faith. But as far as we know, he was never tempted to subscribe to revolutionary utopianism, which was at that time enjoying an understandable prestige that it has subsequently lost.

Dubuffet was neither a Surrealist nor a Communist and at the most could contribute ironically for a while to the games played by his "co-religionaries" in the College of Pataphysics. Throughout his career as a painter, he professed a loathing for politics, and whether it was a matter of defending the collaborator Robert Brasillach from the death penalty or of protesting at the war in Vietnam, he refused to take sides or sign any petitions. There were just two exceptions, and not by chance: he supported Antonin Artaud financially for a while, and was the treasurer of the association formed to help the poet when he was released from the clinic in Rodez in May 1946. Above all he was actively involved in the defence of Céline when he was put on trial in 1950 on his return from Denmark.

"In the evenings, as soon as I was free, I rushed to meet Fernand Léger's lovely wife, with whom I was having a passionate love affair. He was quite happy about it, and even sometimes came round to my place in the morning to bring us croissants in bed."

("Biography at running speed", *Prospectus IV*, p.469)

> **"Boredom is the fertile compost out of which art is created. It is very healthy to be deprived of all festivities, because then you have to make your own, with your very own hands".**
>
> ("Notes for a television interview", *Prospectus II*, p. 494)

Hans Prinzhorn (1886-1933) •

A psychotherapist with a deep feeling for art, Prinzhorn amassed at the psychiatric clinic of Heidelberg University a collection of more than 5000 works by 450 inmates in Germany, Switzerland and Austria. In 1922, in Berlin, he published *Bildnerei der Geisteskranken* (Artistry of the mentally ill), which became the bible of the Bauhaus, where Paul Klee was teaching, as well as of the French surrealists.

AN ARTIST'S LIFE: A FALSE START

Let us return to 1919 and the time when the young student Dubuffet pulled out of the Académie Julian and decided to go his own way, quite independently, and at the risk of having to cope with loneliness and self-doubt. Although in the end Dubuffet was to discover meaning and logic in his life's course, these early years, when he was groping to find himself as an artist with a vocation, despite the superficial confidence of this talented and rebellious young provincial, were riddled with inner doubt. As a result of a crisis in 1924 he gave it all up and stepped back into line. Dubuffet gave up his attempt to make it as an artist, and decided to take up a profession and live a normal life.

During these immediate years after the First World War, it was his family and especially his grandmother that gave him the necessary financial support. Dubuffet came to live in the Chaussée d'Antin on the Right Bank of Paris, in premises belonging to the family's Le Havre wine company. He spent five leisurely years here, developing his cultural life in all directions, meeting people, pursuing new interests, some of them more related to literature than to painting. As well as keeping up his piano playing, he did a lot of novel reading, including Dostoyevsky, and he even began to learn Russian in the wake of the Diaghilev company's sensational impact on Paris. He went to stay in the Yonne region with the family of a painter friend, and on coming back he got in with a group of Montmartre artists all older than himself. These included Utrillo's mother, Suzanne Valadon, a painter called Utter, Élie Lascaux, as well as two writers, Charles-Albert Cingria and Max Jacob, the latter of whom he would go to meet several times in the Abbey of Saint-Benoît-sur-Loire after his conversion. He also visited a fellow Le Havre exile Raoul Dufy, and then in 1922 met André Masson, who was five years older than him and had a certain influence on his artistic beginnings. During the winter of 1919-20 he spent a few weeks on vacation with his parents, visiting Algeria for the first time, discovering Arab customs and trying his hand at various types of painting. During the rest of his time he had a few desultory romances; our young man from Le Havre was in fact quite a ladies' man and even had a brief affair with one of Modigliani's ex-mistresses.

Not much remains of his work of this period: watercolor memories of the woods at Chaville in the Dufy manner, and, as a result of an amorous idyll, an experiment for a fresco in an inn. This was one of the first signs of Dubuffet's later fascination with practicalities and materials, as he concocted his own subtle mixture of pigment and glue. Otherwise, all we have is a few pencil portraits, including one of his grandmother, and a series of five woodcuts reminiscent of Derain in a magazine edited by René Crevel. In the drawings and paintings inspired by Algeria, Dubuffet acknowledged the influence of Paul Cézanne and Suzanne Valadon.

With the passing of the years came Dubuffet's compulsory military service in 1923. This came after a vacation in Lausanne, the future capital of the *Art brut* movement, and Venice, where the *Hourloupe* was to be exhibited forty years later, and during which Dubuffet made the acquaintance of the writer and art critic Paul Budry, who was a friend of Blaise

Cerises au fumeur

(Cherries with Smoker)

1924-1925

Oil on canvas

45x37 cm

Fondation Dubuffet, Paris

Cendrars, and of the painter from the Vaudois region, René Auberjonois. Dubuffet's posting to the meteorological service on the Eiffel tower was ideal for a poet, for it was here that for the first time chance put him in contact with what is often called mediumistic or visionary art, which was to be his passion for the rest of his life. Here he discovered a series of illustrated notebooks containing the observations and hallucinatory drawings of a certain Clémentine Ripoche, who, in response to an investigation by the National Meteorological Office, had carefully studied the state of the sky on certain fixed dates. It was also at about the same time that Jean Dubuffet received a present from Paul Budry in the shape of Hans Prinzhorn's famous work on the art of the mentally ill, which had been published in Berlin the previous year. He could not read German, but avidly studied all the illustrations, just as did all the Surrealists and Bauhaus artists at this time.

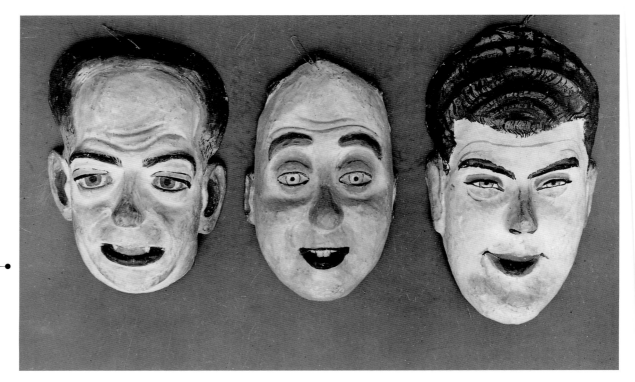

Masques de trois amis
(Masks of three friends)
1935
Painted papier mâché
Robert Polguère: 25x18 cm
André Claude: 24x15 cm
René Ponthier: 28x17 cm
The Hirshhorn Museum and Sculpture
Garden, Washington D.C., U.S.A.

Finally Dubuffet was demobilized in August 1924, and there was an immediate crisis. Unable to continue his dilettante artistic existence any longer, with his private experiments as an enlightened amateur, and perhaps wishing to earn his own living at last, he succumbed to the temptation of a big adventure. Influenced by Blaise Cendrars and above all Dos Passos, his near contemporary whose novels he was one of the first to read in France, he left Europe for the New World. So the Dubuffet who was thereafter to prove rather sedentary set off on the trail of a distant relative, Marcel Paillette, an uncle on his mother's side who had emigrated to Argentina and was to prove difficult to track down. This was in October 1924; Dubuffet was twenty-three.

When he got to Buenos Aires, Dubuffet worked for a while on a building site scraping rust off girders. Then, once he had made contact with his relative, he found work of a slightly less arduous nature with a central heating company, calculating the volume of the rooms to be heated. So it was in Buenos Aires, perhaps while spending evenings in tumultuous bars listening to tangos, popular music that was at a polar extreme from his own petit bourgeois music culture of classical piano, that Jean Dubuffet forgot his aspirations to be an artist. He was faced perhaps with a looming truth: something had gone wrong in Europe, and to escape from the general feeling he had of being a fake, a neurotic, bogged down in routine, it was going to be necessary to wipe the slate clean, forget the past and set off in a new direction.

When a letter brought him news of the death of his grandparents in Le Havre and the consequent reorganization of the firm that his grandfather had been running, our young exile decided to return home and join the firm, where a job inspecting the salesmen was awaiting him. On the face of it, this would appear to signal the failure of his attempt to break the stranglehold of his social milieu, and the abandonment of any vague desire he still might have to become an artist.

SUDDEN CHANGE OF TACK:
THE "COMMON MAN" AT WORK

For almost twenty years, except for a break between 1933 and 1937, Jean Dubuffet was to live as a businessman, enter into a marriage of convenience, father a child, get divorced and remarry. His professional life, essentially in the wine trade, would more or less obliterate any aspirations to creativity.

In 1944 Pierre Seghers, who had probably been tipped off by Jean Paulhan, dedicated a special number of the poetry magazine he edited in Villeneuve-lès-Avignon to Jean Dubuffet's first works. The title he gave it partitioned a hit: "Jean Dubuffet or the common man" (*Poésie 44*). The common man, that is to say the ordinary citizen, the man in the street, the typical commonplace representative of modern industrial society, clerk, workman, technician or shop assistant, in short the useful and normal individual playing his modest little rank and file instrument in the social orchestra that we are all part of. He is thus quite the opposite of the "artist", or at least the myth of the artist, with all that term's connotation of being pretentious and outmoded.

Whether the title was coined by Seghers or found by him in the painter's writings, it was going to play a major role in Jean Dubuffet's thought. "Three cheers for the common man", for example, proclaims the last of the *Notes for the Well-Read* in 1946: "There are no more great men, no more geniuses. Here we are at last liberated from those dummies with the evil eye: it was all an invention of the Greeks, like centaurs and hippogriffs. Geniuses have gone the same way as unicorns. And to think we've been scared of them for three thousand years! Men are not great. Man is great. It's not being an exceptional man that is marvelous. It's just being a man." (*Prospectus I*, p.88)

Throughout his career as a painter, Dubuffet was truly obsessed with not just destroying, obliterating and forgetting all trace of the bourgeois provincial education he had received, but more generally with cutting all threads linking him to European culture and the tradition of the Western world. This led him and many others to feel great enthusiasm for the ways of thought of other civilizations, North Africa and the East to begin with, of course, as well as Buddhism and primitive societies. It also explains his fascination with the repressed and forbidden world of art produced by mentally ill people, mediums and visionaries.

When he went off to Buenos Aires on a sudden impulse, it was an escape to the opposite ends of the earth, an attempt, if we may parody the poet Jules Laforgue, to go off and get his European scalp removed, brain included. When on his return in 1925 he took the decision to drop everything and give up hopes of achieving fame as an artist, and to just merge with the mass of normal people like his businessman father and grandfather, he was choosing the path of armchair revolution, a stubborn subterranean long march through the new industrial jungle in order to subvert the outmoded values of traditional culture from within.

In 1925 Dubuffet was only twenty-four years old. He might obviously appear to have settled down. In fact his situation was the result of a choice and a refusal. Out of disgust for the literary circles of the Parisian intelli-

Lili, marionnette à gaine
(Lili, glove puppet)
1936
Poplar wood and fabric
Height: 60 cm
Fondation Dubuffet, Paris

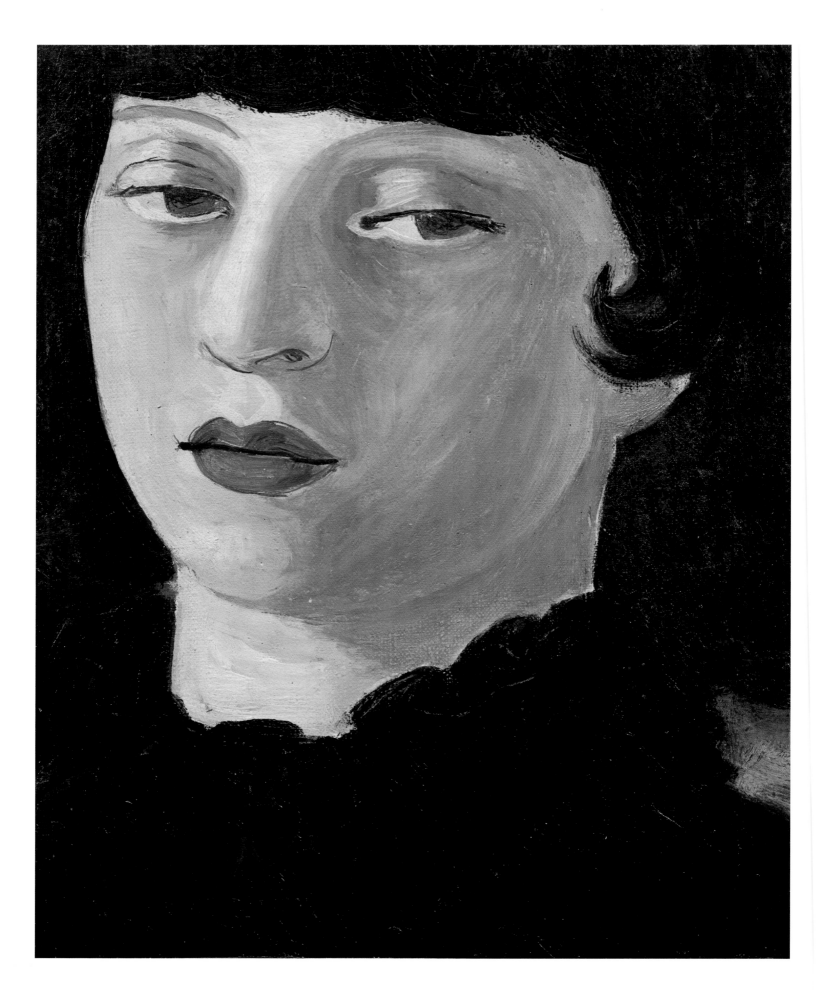

gentsia and the snobbery of its various cliques, and having no taste for smart social life, he finally preferred to return to his provincial existence and a complete change of milieu. Henceforth he was to reverse his priorities, opting to become a business man and not an artist, for he knew only too well in the latter field what he did not want to be and what one must not do. But as he had not yet found his true world, he preferred not to live it at all to living it badly and on dubious foundations.

It was also the case that he needed to earn his living and establish himself professionally, and as it was futile to keep on waiting to be blessed with grace, for an artistic miracle that was taking a long time to come, he was doubtless eager to get on with it. Provided he kept his mind on the job, he proved to be a good businessman, thanks to a flair for practicalities and decision-making. And yet he was not mercenary by nature, as we saw from the way he handled his inheritance, and as will be proven often enough by his generosity towards fellow artists such as Antonin Artaud and Gaston Chaissac and his many *protégés* in the Outsider Art world.

Since the publication of his *Biography* in 1995, we know how Dubuffet amassed the wealth in the wine trade that eventually gave him his personal freedom. In the early years of the Second World War, after his return to Paris on 3 August 1940, he took advantage of the division of France into a Northern "occupied" zone and a Southern "unoccupied" zone to purchase guaranteed superior quality wines in the South, where they were freely available, and sell them on to cafés and bars in Paris and the North. The wine was transported in specially made 220 liter barrels loaded in a fleet of refrigerated trucks. Via this combination of cunning and inventiveness did he succeed; it required him on certain evenings, aided and abetted by a local villager near the river Cher, to cross the famous demarcation line, disguised as a fisherman. This is not to say that his business activities always went smoothly, especially in the notorious year 1929, when Dubuffet had to pull out all the stops to avoid bankruptcy. But that a painter should be involved in the world of business has always been deemed unacceptable in France, a country where a merchant or wholesaler is synonymous with a bourgeois "capitalist", and as such the exact opposite of an intellectual or an artist. From this point of view, Dubuffet, who really did have entrepreneurial ability, could not be further from the Van Gogh type; he was a painter in an entirely new mould and a symbol of a new era.

THE DOUBLE LIFE OF A WINE MERCHANT

From 1925 onwards, then, Dubuffet lived a sedentary existence as a wine merchant; such adventure as he had in his life would henceforth be in his interior world. More or less as soon as he returned from Buenos Aires he set himself up in Le Havre and lived a banal existence there until 1929. His job as manager responsible for the company's representatives and travelers brought him into contact with a range of customers from all over France. It was not long before he decided to marry. It was a cool-headed decision, and his choice was the daughter of a shipping company administrator. It was a

"In the end all men are more or less to a standard model, just like light bulbs"

(Preface to A *Short Treatise on Graffiti* by René Solier, *Prospectus II*, pp.12-13)

Lili style Renaissance
(Lili in Renaissance style)
1936
Oil on canvas
26x21.5 cm
Fondation Dubuffet, Paris

"A song hollered by a girl while brushing the stairs moves me more than any exquisitely tasteful cantata. Each to his own taste. I like what is minimal, and also embryonic, poorly fashioned, imperfect, mixed. I prefer uncut diamonds, still in their matrix. And with their flaws."

("Notes for the Well-Read", *Prospectus I*, p.88)

big company, which bought its wines and spirits from the Dubuffet firm. Dubuffet was here demonstrating his rationality and orderliness, and he was in fact always to be methodical in everything he undertook. That same year his father died (this was while Dubuffet was on honeymoon in Algeria, his second trip to a country he was very fond of and to which he would return three times after the War). This was the occasion on which he voluntarily forfeited the major part of his inheritance to his mother and his sister. One of his cousins, more versed in business, took over the father's role as head of the firm. There then followed the birth of his daughter, the crisis of 1929, the first difficulties in the firm, as well as signs that all was not well between Dubuffet and his wife. It was clear that life was not always a bed of roses for this determined and yet depressive young man who, furthermore, did not appear to have much time to spare for the world of feelings and love.

A short while after, the firm's branch in Algeria was closed down, and Dubuffet, who was probably feeling too cramped in the all too familiar Le Havre milieu, formed the idea of moving back to Paris. He hoped to start up his own wine business in Bercy in a partnership with the ex-director of the Algerian branch. Although this idea of a partnership did not really come to anything, and Dubuffet had to build up his clientèle on his own, this is how, just five years after returning from Argentina, Dubuffet ended up first in Saint-Mandé and then in Paris in 1930.

As far as his business was concerned, Dubuffet succeeded quite well to begin with, but then gradually began to meet up with his old friends and return to his former activities. His wife, who thought she had married a wine merchant and not an artist, began to look askance at some of his tastes and inclinations. Finally after a few years the impulse to paint was irresistible and he claimed the right to do so with manic insistence. In 1933, after a break of nine years, the Bercy wine wholesaler Dubuffet opened a "painting workshop" in a studio that he rented in the rue du Val-de-Grâce. He shut himself away there for two or three hours every afternoon.

This was more than his wife could take. After several attempted separations, she filed for divorce, listing among her conjugal grievances an accusation of homosexuality against her husband. Dubuffet was much disturbed by this and left the business in the hands of a manager while he went to spend some weeks in the Swiss mountains, hoping things would sort themselves out. When he returned, he found his wife had moved out, taking refuge, curiously, with her in-laws in Le Havre, who welcomed her as the victim in the whole affair. Even if this severing of links with his wife was what he needed, Dubuffet was nevertheless shaken by the speed with which his domestic life was transformed. He moved to Montparnasse, sharing an apartment with his business partner for a few months, and in fact leaving his business entirely to be managed in his absence while devoting himself more and more to painting.

It was at this point that he became fascinated by all systems of writing, pictograms, calligraphy, etc. He studied the writing of the Mayas, Egyptian hieroglyphs (copying some from the obelisk in the Place de la Concorde), Chinese lettering and "romanesque calligraphy". What was at the heart of all this was a fascination with the graphic and visual aspect of language and the

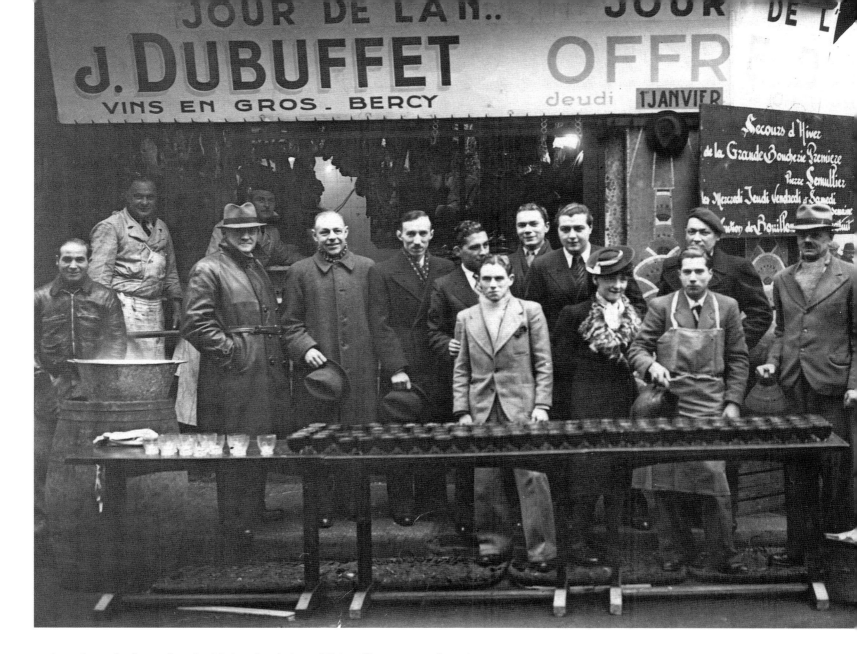

point where the latter fused with its visual signs. This will re-emerge later in his work, transposed to an imaginary plane, in the *Cabinet Logologique* and the whole of the *Hourloupe* cycle: the esoteric nature of sacred writing could not fail to appeal to someone who had a taste for secrecy since his childhood. It was at this point that Dubuffet met Lili, Emilie Carlu, a farmer's daughter full of imagination, whose private life was also difficult. She was the ex-girlfriend of a Dutch art dealer and married to a Hungarian painter from whom she would shortly be divorced. In her Dubuffet had met his kindred spirit, and once he too was divorced they were free to marry in 1937. The couple moved to the rue Lhomond and led a cosy dilettante life for two winters, those of 1935 and 1936. For Dubuffet it was like living his student years all over again, with many things to interest him. But this time he threw himself into painting purely in an amateur capacity, not feeling bound to try to prove anything, and driven solely by the wish to carry out experiments for his own satisfaction.

First he modeled or molded masks of all his friends in a realist, popular style. He made a series of portraits of Lili, then took it into his head to carve himself a set of Punch and Judy characters in wood with a view to going off

A free distribution of mulled wine in Les Halles
New Year's Day 1942.
This was to be
Jean Dubuffet's last year
in business at Bercy. Dubuffet
is the fourth from the left,
and fifth from the left is his
manager, M. Lutcher.

> **"It's not so much from indecisiveness that my efforts suffered for a long time, for the decision was taken very early [...], but committing yourself is a small matter, and what is difficult is not picking up current but finding the right wire along which to transmit it without breaks or loss of power."**
>
> *(Prospectus II, p. 220-221)*

Dactylographe •
(Typist)
Plate XVIII of *Matter and Memory or the Lithographers at School*,
text by Francis Ponge,
Fernand Mourlot Editions,
Paris, 1945
25 October 1944
Lithography
26.5x16 cm
Fondation Dubuffet, Paris

on a summer tour. Unfortunately a man called Jeanne, a puppeteer with few scruples, made off with the lot of them. All of these somewhat whimsical projects seem to be more the work of a craftsman than of an artist, and the plaster mixing-bowl appears to have played a bigger part in Dubuffet's work than a palette and brushes. What he was doing was ceaselessly innovating, experimenting, seeking to invent his own solutions.

With the arrival of 1937 this period of near vacation was brutally brought to a close, and the "little wine merchant's" second attempt to find himself as a painter was suspended yet again for some years. Dubuffet had been painting for four years, but debts had accumulated to such an extent while the wine business was going downhill that he was obliged to return to the latter to avoid bankruptcy. Business picked up a little, but the financial prospects were far from promising. The Second World War changed the situation dramatically. Dubuffet was drafted into the armed forces. He was posted first to the fort of Saint-Cyr, then to the Air Ministry (where his shorthand typing skills stood him in good stead), but was then transferred to Rochefort for "indiscipline". Finally when he was evacuated to the South amid conditions of total chaos, he took advantage of the situation to "demobilize" himself, as he was later to put it; in other words he deserted. We next see him near Céret, not far from Perpignan, where he was sheltered first by a couple of elderly peasants and then taken in by one Ludovic Massé. The latter was a schoolteacher and scholarly author, under whose roof Dubuffet was able to pursue his own scholarly research. These included a translation into everyday French of a comedy by Terence and a translation of some of the writings of Saint Gregory of Tours, an early Church father and historian, and courageous opponent of the lay authorities of his day.

Dubuffet returned to a deserted Paris on 3 August 1940, where his wife was waiting for him, having just come up from Rochefort. He went back into wine trading, taking advantage of the partitioning of the country with such skill that he was able not only to pay off his debts but to pay some interest too, he proudly pointed out later. Eventually after five years of effort, obligations and practical difficulties of all sorts, he had amassed so much money and become so weary of the wine trade and averse to it, that he was able to take his personal leave of it for good and put his business in the hands of a manager. With enough to live on for a few years, he rented a studio opposite where he was living in the rue Lhomond and finally devoted himself to painting once and for all. He had just had his forty-first birthday. His true life as an artist was beginning. Until his death forty-three years later, it was to be a near monastic existence in which his personal life and the development of his art were totally merged.

There is a Zen fable about a young man who came to ask a famous sage for the secret of life and wisdom. The old man appeared to be deaf to the request, and nodded towards an enormous pile of wood waiting to be cut up in the corner of the garden. Twenty years later, when the disciple was still cutting wood, the master called him over and said to him: "I have watched you working all these years. Now you have put in enough time. You are ready for what I am about to tell you." And at last he taught him the mystery of existence.

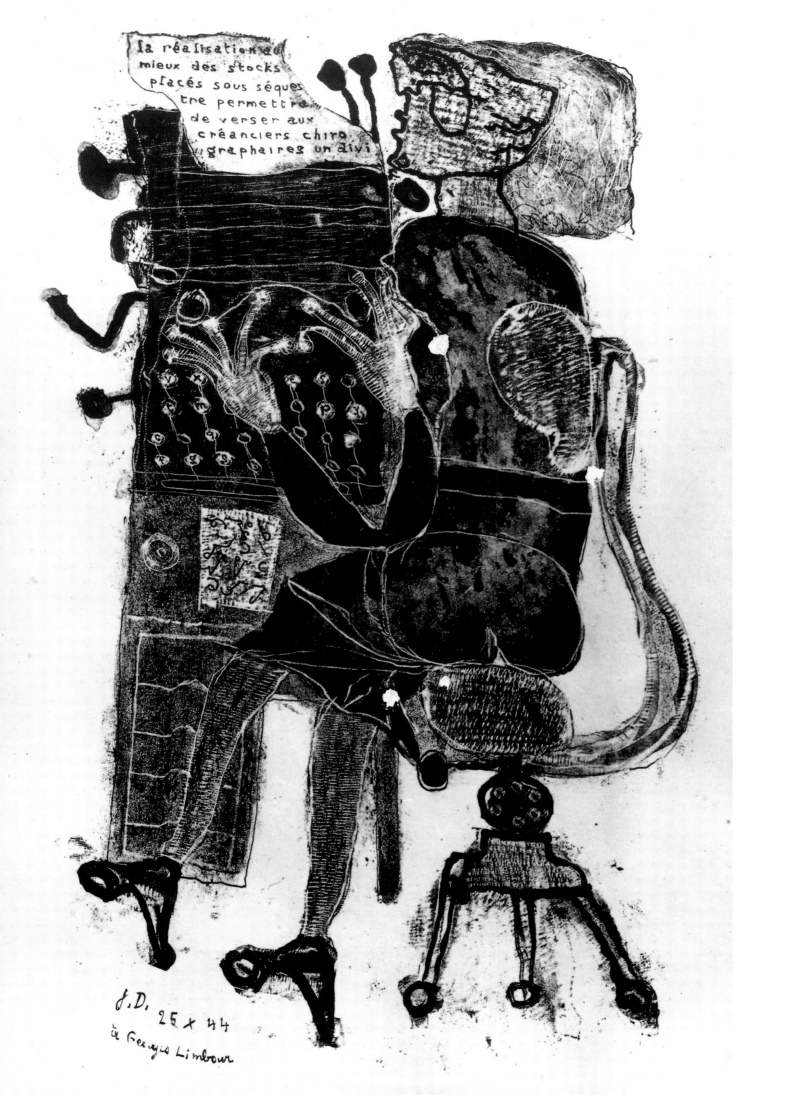

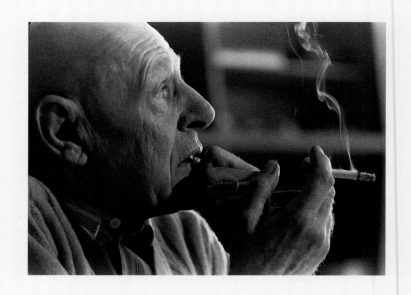

"Ambiguous facts always have a fascination for me in that they seem to occur precisely in gaps where life pulls aside the veil."

Jean Dubuffet, *Prospectus II*, p. 79.

Jean Dubuffet
in his studio in 1970

2
1942-1985
Forty-two years of unbroken creation

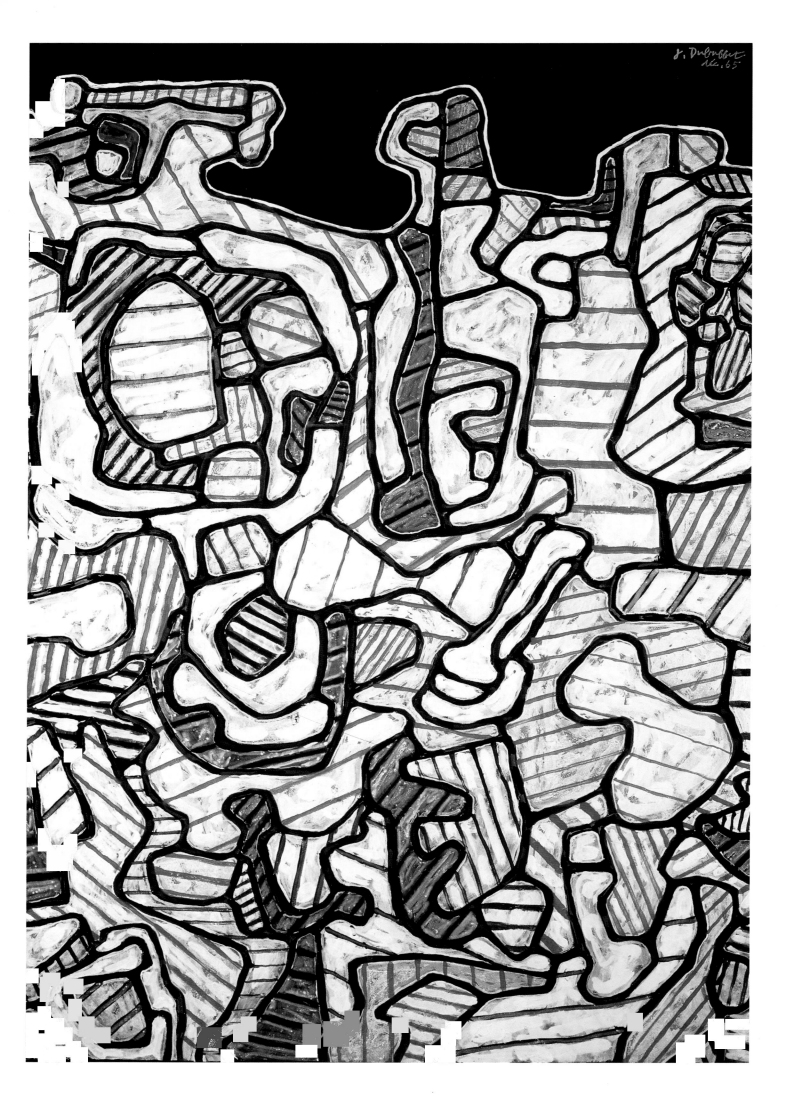

*du 20 octobre au 18 novembre
1944 à la galerie René Drouin
17 place Vendôme exposition de
tableaux et dessins de Jean Dubuffet*

Mourlot imp. Paris

"The mechanism of opening brackets, and then brackets within brackets, has always occupied a big place in the development of my work."

("Rambling conversations", *Prospectus III*, pp. 99 – 100)

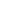

BEFORE AND AFTER THE *HOURLOUPE*

It would be tiresome to run through in chronological order the succession of cycles of work and periods in Jean Dubuffet's career, starting in 1942 and running on for forty-two prolific creative years. His flow of work was unbroken until suddenly in December 1984, just a few months before he died, the painter decided to call it a day. He had just enough time to write a rapid autobiography before making a dignified exit from the scene. To find our way through his copious and varied mass of work, we can simplify things somewhat by dividing it into three periods, with the middle one being that of the *Hourloupe*. This is the longest cycle (lasting twelve years from 1962 to1974), and the best known and the most distinctive. The *Hourloupe* was a sudden proliferation of "endless rambling writing", the childish appearance of which in fact masked highly cerebral aims. The creator of this writing became so fascinated by the principle of it that he had the greatest difficulty in breaking away from it, to the extent that he even gave up painting in the strict sense to devote himself to sculpture and then to the environment. It was as if the *Hourloupe* had been unleashed upon the world, scaling skyscrapers and gradually taking control of the planet.

Before the *Hourloupe* cycle, from the series called *Puppets of Town and Country* (1942-1945) to *Paris-Circus* (1961-1961) via the portraits *More Handsome Than They Think*, the *Ladies' Bodies* or the *Cows*, the *Landscaped Tables,* the *Landscapes of the Mind* or the *Stones of Philosophy,* the

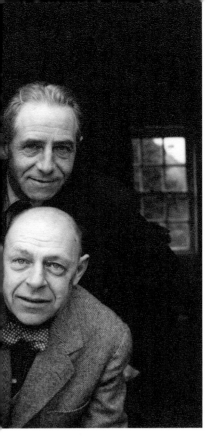

Jean Dubuffet and his friend George Limbour

staying with Roland Penrose and Lee Miller
at Farley Farm in England
26 March 1955
Lee Miller Archives, UK

Before the Hourloupe

Celebrations of the Ground and not forgetting *Texturologies, Materiologies, Print Assemblages* or A*ssemblage Pictures,* the *Beards* series and the lithographic experiments of the *Phenomena,* Dubuffet spent twenty extraordinarily varied and fertile years. He oscillated between a deliberately childish style reminiscent of grotesque graffiti and primitive drawing on the one hand and the technical perfecting, in almost scientifically controlled conditions, of textural effects arising from the materials he was using on the other. His work in this style was sometimes based on the almost hallucinatory perception of banal, everyday objects such as old walls, the ground and earth surfaces of gardens and worn roadways, etc, or derived from experiments with the physical characteristics of the materials themselves. More often than not, these were anything but the classic materials of the artist, but rather drawn from industrial or everyday life: different types of glue, tar, putty combined with twine and fiber, papier mâché, tinfoil, color additives of all sorts, enamel paint, etc. At the same time, after experiments carried out in 1953 with butterfly wings, and influenced by his friend, the painter and writer Pierre Bettencourt, he discovered the potential of collage, to which he preferred to give the name "assemblage". The possibilities were infinitely enhanced when he combined assemblage with printed materials, exploiting the effectiveness of lithography in the process. During this, his first and perhaps most interesting period, Dubuffet still worked in a relatively traditional manner despite appearances, being quite content to use gouache and watercolor, oil on canvas or hardboard, and pencil, crayon or ink. He would sometimes go off just like a landscape painter to make studies of a waterfall or of the surface of a road or the ground of a garden, and deliberately selected the most banal, everyday aspects of urban and rural life as his subjects. So we find the most familiar Parisian or provincial scenes: streets, automobiles, the metro, shopfronts and cafés, a typist sitting at her typewriter, a cyclist on a little country road, a man pissing against a wall, etc. On other occasions we see just tables, which can nevertheless stimulate meditation and clairvoyance, or a few cows, a grotesque reminder of life at its simplest, or portraits, nudes, female bodies. These have specially textured surfaces, which have been scraped, incised or over-painted, often producing the effect of fading graffiti on old walls.

Until the *Hourloupe* (except for the first series of brightly colored puppets which was interrupted at the end of 1944), Dubuffet's colors are both subtle and natural, like those of bark or pebbles; this muted palette is a deliberate choice. This is particularly the case with most of the *Texturologies,* and with the *Materiologies* series, shortly before which he had been using dried botanical specimens glued on canvas. With the *Hourloupe* everything changed. After the era of "shades reminding us of walls and murky mud", the "thick high reliefs" and "earthy colors", the "palette knife incisions into the thick coats of zinc oxide" (*Prospectus IV,* pp. 488 and 497), we come into the realm of the arbitrary and the unreal, the world of pure signs, of writing almost.

It is a simplified, imaginary type of writing winding round and round itself like a crazy puzzle, or like the alphabet of an unknown language in the flow

Danseuse de corde

(Girl with Skipping-Rope)
February 1943
Oil on canvas
100x73 cm
Private collection

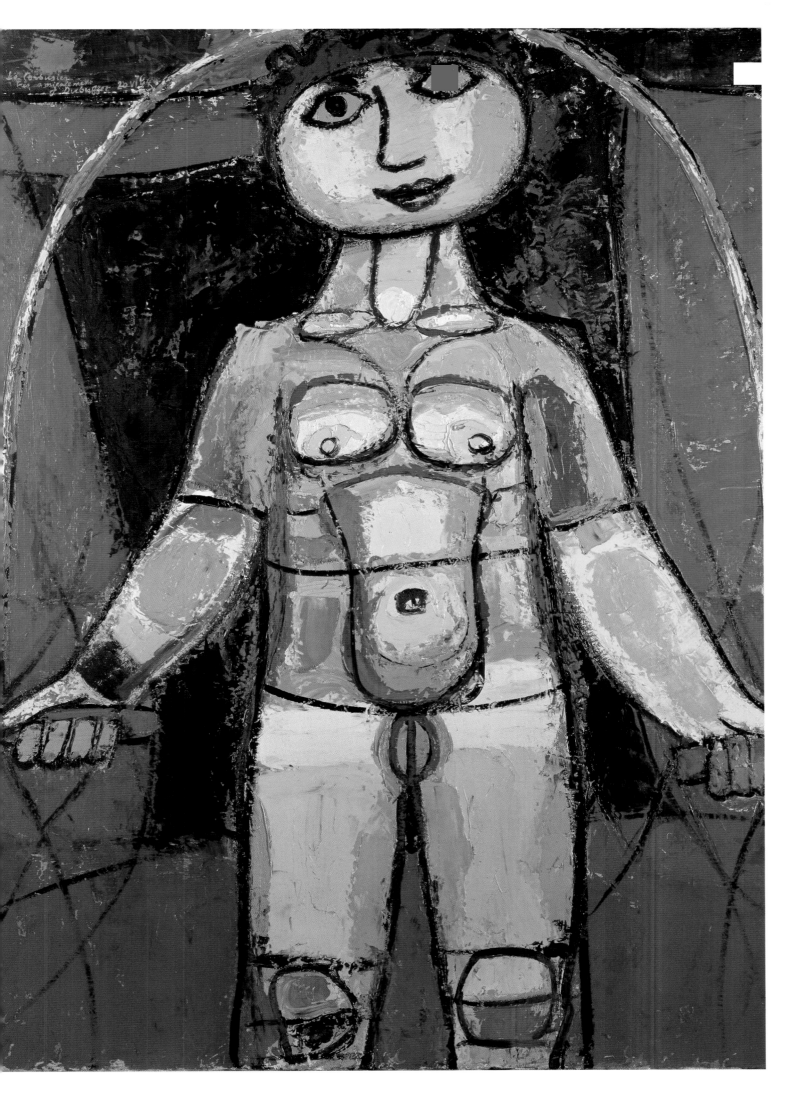

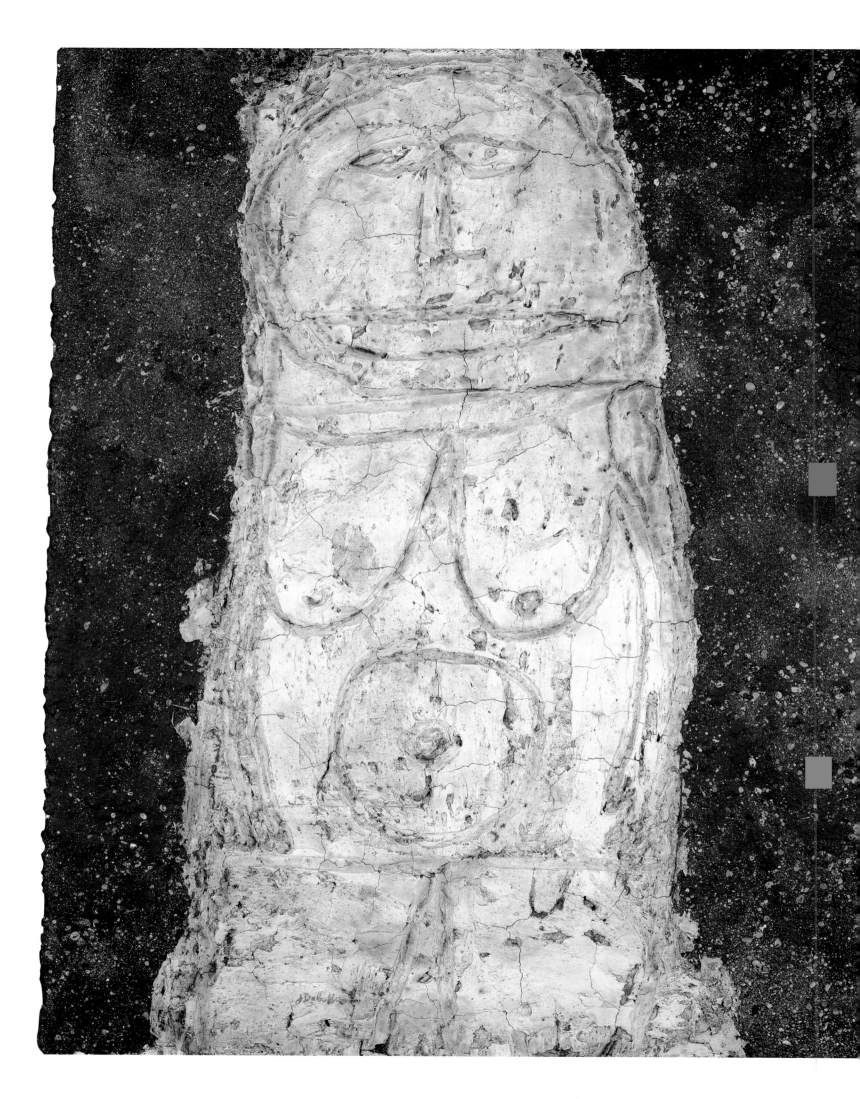

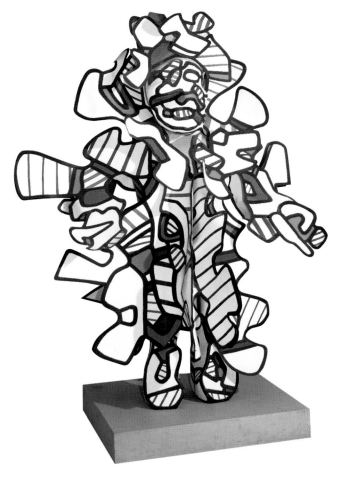

Vénus du trottoir
(Kamenaia-baba)
(Sidewalk Venus)
May-June 1946
Oil on plasterboard
102x82 cm
Musée Cantini, Marseille

Don Coucoubazar
1972-1973
Assemblage of painted
Polyurethane sheets
Unterlinden Museum, Colmar

Jean Dubuffet
sculpting polystyrene
with a hot wire in his studio
in the rue Labrouste
2 October 1970, Paris

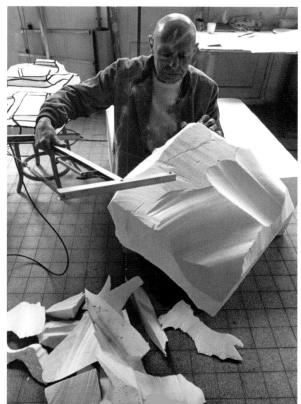

of which you can vaguely pick out a few words here and there: faces, objects, people, something that could be a man, a washbasin or a bottle, elsewhere a pair of scissors, a water tap, a coffee pot… All of a sudden the colors are stark: blue, black, red, pure white. Relief has gone completely, to be replaced by totally flat painted surfaces. Vinyl and marker pen, and sometimes even red and blue biro, have taken over from oil, gouache and lithographic ink. It is like a mental Lego game, building blocks with infinite possibilities – this is the swarming little human world of the *Hourloupe*. With its ambiguous characters and objects, its colored interlocking molecules populating a simple and comic universe, the *Hourloupe* eclipses everything that has gone before. We are now participating in the purest of formal games, obeying an arbitrary code that is easy to assimilate, and whose obsessive proliferation seems virtually irrepressible.

The last phase of Jean Dubuffet's work, seemingly more appealing but disapproved of by some, followed the *Hourloupe* from 1974 onwards. Jean Dubuffet was then seventy-three, and was beginning to have serious lumbar problems, which meant that he was no longer able to work outdoors and preferred to draw or paint sitting at a table. He returned for a while to a sort of grotesque figurative style, a world in which simple human figures, drawn in an even more free-flowing childlike manner than in the *Puppets of Town and Country* or *Paris-Circus*, are set against backgrounds of the most completely abstract nature. He now used bright acrylics, colored crayons, felt tips and black marker pens to create a flow of new series with obvious ease: *Doodles, Tales, Conjectures, Parachiffres, Meetings* or *Abbreviated Places*. Then he went back to his assemblage technique with his *Theaters of Memory* series, large canvases on which were juxtaposed and pasted simplified visual quotations from all his earlier periods.

Comic little human figures continue to proliferate on the checker-board surfaces of the *Sites with Figurines, Partitions, Psycho-sites,* and *Sites aléatoires* (Random Sites). Finally we come to the last two series, *Mires* (Sights) and *Non-lieux* (No Places or Non-suits), freely scrawled, indefinable subjects on yellow, white or black backgrounds, in which earlier themes are savagely crossed out and seem to fade and dissolve as if part of an organic process of dwindling to nothingness. This was the time when Dubuffet, having been obliged by the state of his vertebrae to reduce the scale of his work to just one format, 67 cm by 100 cm offset paper, decided to cease working. He was eighty-three. Methodical as ever, he prepared for death by putting all his affairs in order, tying up all the many loose ends of his correspondence and writing his famous autobiography.

TWO RIVAL ATTRACTIONS: INVOLVEMENT OR WITHDRAWAL?

Throughout his work, Dubuffet reflected a consistent conflict within himself, the simultaneous appeal of two opposing tendencies. One was to withdraw totally in the face of raw nature and matter, the other was the contrary impulse to leave his mark on them via signs and symbols emanating

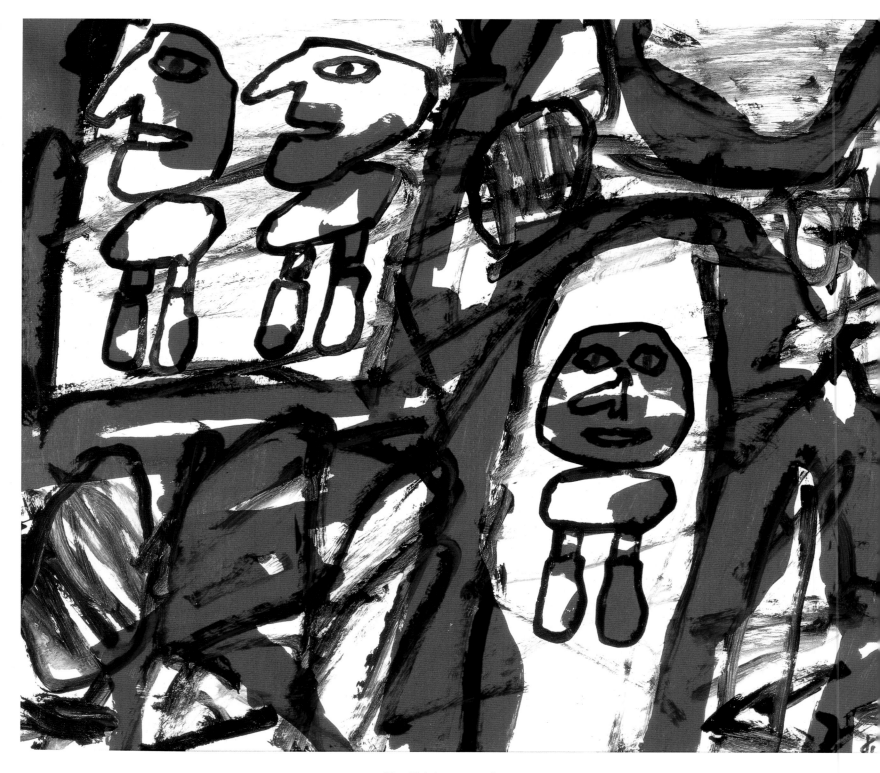

Site aléatoire avec quatre personnages F48
(Random site with four characters)
17 April 1982
(with 4 pasted pieces added)
Acryl on paper mounted on canvas
MNAM – G. Pompidou Center, Paris

Jean Dubuffet
Rue de Vaugirard in Paris
6 January 1982

After the Hourloupe

from his thought, his personal obsessions, his pure imagination, or to devise as in the *Hourloupe* a purely arbitrary writing and code. "As regards technique, I always feel myself pulled in two extreme directions whose effect can easily be seen in my paintings. One of them consists of using very striking outlines, whether by black brushstrokes or by scoring lines within the paint with a palette knife, whereas the other aims on the contrary to achieve pure painterly effects relying solely on internal textures and excluding all outlines and external forms. This idea of finally liberating painting from draftsmanship, of giving free reign to pure painting as a language of painted surfaces, has been haunting me for a long time." ("Reflections on the development of my work since 1952", *Prospectus II*, p. 131)

Jean Dubuffet's entire opus is conditioned by ambiguity and ambivalence. It results from an attempt to keep depiction in a disturbing, unstable state at midpoint between the most antithetical and incompatible polarities. A kind of level of Ying-Yang complementarity is being sought, which will simultaneously draw the onlooker's gaze in both directions thanks to the power of "scintillation" inherent in color, matter, sign and form. This the painter first noticed, curiously, when he was making his butterfly wing collages (in September and October 1953, after a trip to Savoy with Pierre Bettencourt, but above all in his house in Vence in the summers of 1955 and 1957). And it was this astonishing power, discovered by chance, that he endeavored to recreate more systematically in a great number of his works.

And so: deliberate confusion or even reversal of the horizontal and vertical planes, as in most of the landscapes, which are treated as ground surfaces viewed from directly above, or, on the contrary, tables represented as though they were walls instead of horizontal surfaces. Ambiguity about scale, whether macro or micro. Confusion of the human, organic and vegetal domains, as in *Ladies' Bodies*, which are handled like pieces of tree bark, ground surfaces or other natural substances. Confusion of the natural kingdoms, with the mineral or geological, as in the *Texturologies*, being capable of applying to both the cosmic and the galaxies of astrophysics. There is a constant mixture of the deliberate and the unintentional, of the planned and the accidental, of volition and chance, of virtuosity and amateurishness. And ambiguity of the subject and the background, solids and voids as in the whole *Hourloupe* cycle, or of the part and the whole, with some elements being capable of being seen as parts of different wholes. Finally there is generally confusion between the real and the imaginary, the realistic and the unrealistic, if not in fact between being and non-being, the specific and the undifferentiated, as we see with mixed results in the final series. Dubuffet in fact was never to deny the pleasure afforded him, sometimes to an unhealthy degree, by the ambiguity of certain of his works, paintings intended to educate the gaze, to challenge acquired habits, to make people "unsee" and then see anew with that sensitive and vivacious attention that is the essence of living vision.

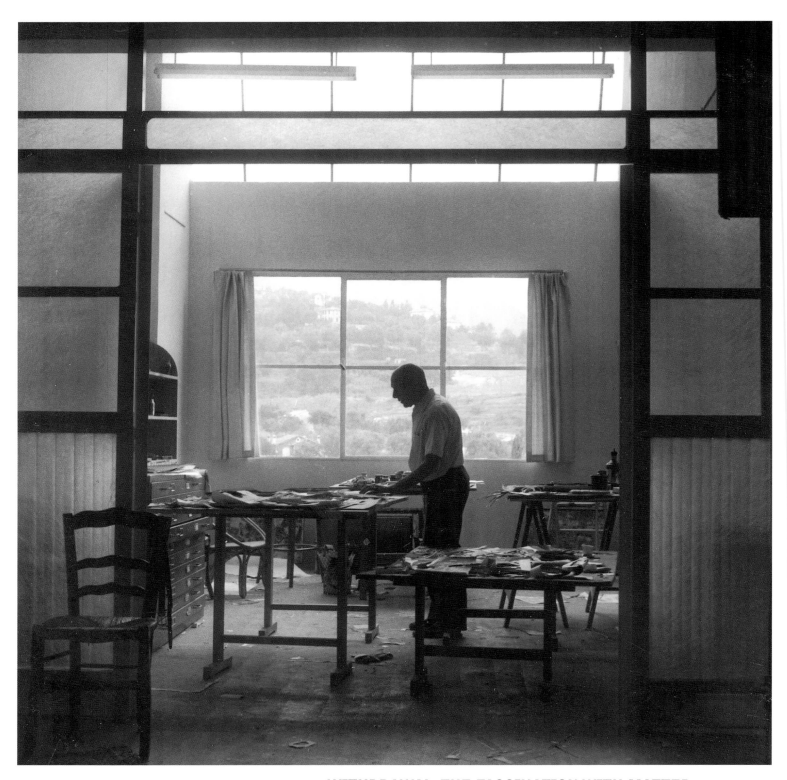

in his studio in Vence
1959

WITHDRAWAL: THE FASCINATION WITH MATTER

If we may rely on the recollections of the retired schoolteacher Philippe Dereux, who is remembered today for his pictures using peelings and who was an assistant to Dubuffet for several summers in succession from 1955 onwards, Jean Dubuffet's capacity for work was phenomenal. He never wasted a minute of the day and kept to a timetable worked out in advance with Spartan discipline. He would take a rest from one type of

work or experimentation by moving to another. Relaxation came in the form of making butterfly wing collages in the mornings, then he would move to different studios to get on with various works in Indian ink or make his *Assemblage pictures* or *Print assemblages*. Despite being constantly wanted on the telephone, besieged by letters every day and not neglecting the friendships that were so important to him, he appeared to be totally centered on his creative activity, the only thing that was really important to him in life.

It is quite clear, as is proved by any photograph taken in his studio, where stacks of materials are neatly laid out on paper on the floor or on tables, that we encounter something quite fundamental in Dubuffet: nothing less than a passion for every type of artist's material and an extreme curiosity about different types of matter, combined with an almost physical appetite for the process of mixing products and substances.

History would have it that he experienced a kind of revelation one day when he visited the *Jardin des Plantes* on the Paris left bank, and was overwhelmed by the sight of the huge blocks of anthracite, basalt and graphite. He promptly set aside the bright palette he had used for his first pictures and painted the *Big sooty nude*, a title as provocative as the work it described. Admirably provocative and poetic too was this declaration, which is typical of his early writings:

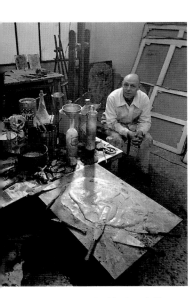

Jean Dubuffet's palette
in Paris
1951

Jean Dubuffet
in his garden
at "L'Ubac", Vence
Summer 1959

"It is true to say that in my grinding and mixing of materials and my way of applying them I have found myself more often referring not to the traditionally noble materials of art such as marble or precious wood but to very ignoble and valueless substances, such as coal, asphalt or even mud, or to the effects of rainfall on different sorts of the most ordinary ground surfaces, or of the passing of time on such banal things as scrap metal and crumbling walls, and in fact everything connected with dross of all sorts, junk and rubbish." He went on: "Perhaps some will immediately conclude from this that I have a nasty predisposition for filth. I would ask them rather to reflect on this: how does one explain, except perhaps because of the rarity factor, that man adorns himself with necklaces of shells and not of spiders' webs, with fox furs and not fox entrails, can anyone tell me that? Mud, rubbish and waste material accompany man throughout his life, so shouldn't they be more appreciated by him than they are? And is it not doing him a good turn to remind him of their beauty? Just look at the way little children play in gutters and rubbish heaps and find a thousand marvelous things." ("The rehabilitation of mud", *Prospectus II*, pp. 65-66).

This was in 1946 at the time of the *Mirobolus, Macadam and Co* exhibition, the series which he described as being in "high relief impasto". Even at this early stage Dubuffet was no longer content to explore this theme by pure painterly means, and he had already experimented with mixtures of media and materials of the most unusual, or, as it was seen at the time, unnatural sort. As Michel Ragon observed in 1958: "It was in fact from the high reliefs onwards that Dubuffet began to receive a lot of attention as a result of the enormously scandalized response from a public that nevertheless thought it had seen everything. The scandal resided in the physical composition of Dubuffet's canvases, the sacrilege he had committed in abandoning oil painting in the Van Eyck tradition and putting in its place a mixture of ceruse white-lead, Meudon whiting, sprayed-on sealing compound, sand, gravel, tar, painter and decorator's varnish, plaster, coal dust, pebbles, glass splinters, enamel, etc. As if that was not enough, like a schoolboy carving his name on his desk, Dubuffet had drawn on this "wall" with a scraper, and with a spoon and then a knife, and in fact with just his fingers." (*Dubuffet*, Georges Fall, le Musée de Poche, pp. 21-22). In post-war France it was less than ever the right time to hang fox entrails on the living-room wall; scandal was never to leave Dubuffet from that point on.

It is worth noting, incidentally, that the appearance on the market of new industrial products, beginning with certain types of glue and materials more appropriate for painters and decorators than for artists, gave an unhoped-for stimulus to those seeking to take painting as a genre in new directions, and Jean Dubuffet was precisely one of those who realized this and made his own exuberant inventory of what was available. It is one aspect of Dubuffet's genius to have been open-minded enough to break down the barrier between these two worlds, which had always been considered quite separate. He was willing to work as an artist with the materials of the working man, and he thus "proletarianized" and modernized the somewhat restricted

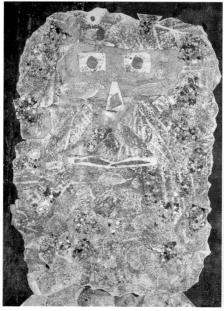

**Corps de dame
gerbe bariolée**
(Lady's body colorful bunch of flowers)
(and detail page 51 top left)
August 1950
Oil on canvas
116x89 cm
Emile Fischer collection, Landau

Claire eau de barbe
(Clear Beard Water)
(and detail page 51 bottom left)
June 1959
Assemblage and oil on paper
mounted on canvas
77x57 cm
Hamburg Kunsthalle, Hamburg

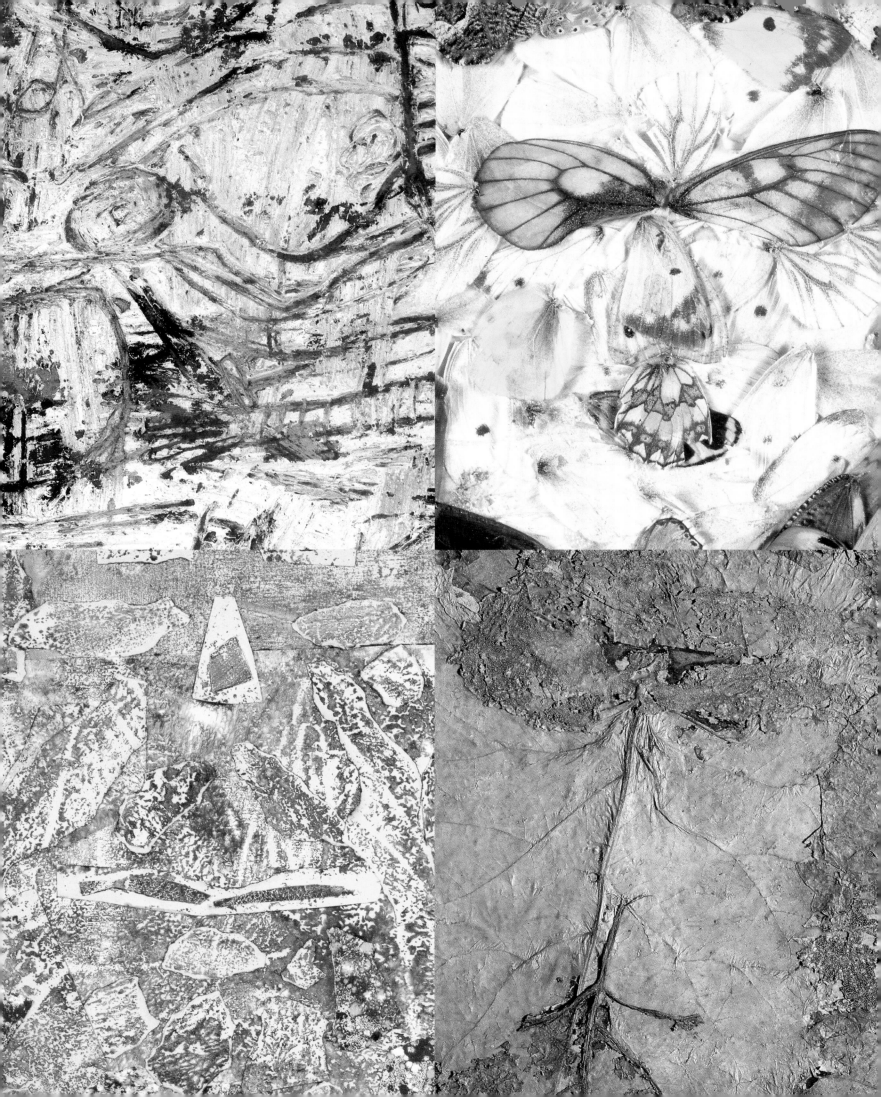

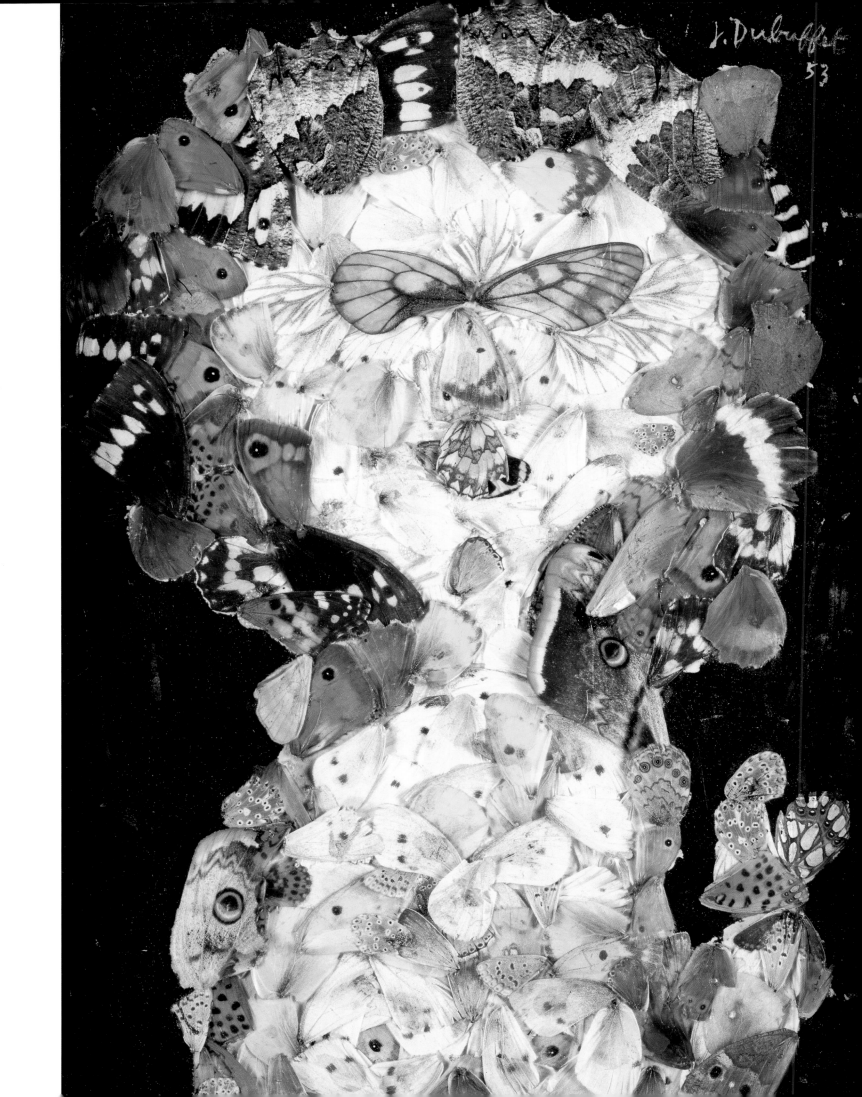

● **Belle au regard masqué**

(Masked Beauty)

(and detail p. 51 top right)

September 1953

Butterfly wing collage

25x18 cm

Hamburg Kunsthalle, Hamburg

● **L'Âne égaré**

(Wandering Donkey)

(and detail p. 51 bottom right)

September 1959

Collage of botanical material

68x51 cm

Musée des Arts décoratifs, Paris

Coursegoules
November 1956
Oil on canvas and assemblage
115x147 cm
Musée des Arts décoratifs, Paris

Following page:
Fruits de terre
(Earthfruits)
December 1960
Papier mâché and
vinyl impasto
81x100 cm
Musée des Arts décoratifs, Paris

"I think it's very important for an artist to make an effort to relate his thought to what he has done, instead of stubbornly relating his work to what he has thought. [...] rather than modify the work, modify the gaze."

("Rambling conversations", *Prospectus III*, p.100)

world of the artist painter, driven no doubt by the sheer pleasure of doing something that had never been done or seen before. It was an act of transgression that must have brought him profound pleasure in the sanctuary of his studio, and, since he was combining new materials and ancient practices, might seem in the eyes of an anthropologist to be a bizarre example of acculturation at a turning point in the history of the new industrial civilization. For a painter like Dubuffet, material is truly sacred and is a language, and so must in large measure be allowed to speak. This was proclaimed loud and clear in manifesto style as early as 1946 in *Notes for the Well-Read*: "The starting point is the surface to be brought to life – a canvas or sheet of paper – and the first blob of paint or ink that you drop on to it; this produces an effect, an adventure. It's this blob, as it gets developed and worked on by the artist, that must take his work forward. A picture isn't built like a house, as if it was designed in advance by an architect, but rather you grope your way towards it, and then back a bit, with your back facing the result!" ("Starting from the formless", *Prospectus I*, p. 54). And again: "Spirituality must use the language of the material. Every material has its language, is a language in itself." ("Material is a language", id, p. 58).

A particular effect for example may be obtained spontaneously and produce an interesting texture: so then it becomes a question of mastering that effect and learning how to produce it at will, and then creating variations and uses for it. All of which explains how an artist's work develops in series, as it requires a whole body of integrated work to exhaust the possibilities of a particular experiment.

Dubuffet in fact worked with great speed and preferred to leave a picture unfinished rather than keep on coming back to it laboriously. He was sometimes capable of painting one picture per day or even more, and followed an improvisatory method reminiscent of an art form he adored, jazz, or of Chinese music even more. "Let's do away with wearisome labor", the new painter wrote at the very beginning of his career. "It's not in man's nature, it goes all against cosmic rhythms, it's against man's instinct to toil when he doesn't have to." ("An end to toil", "Notes for the Well-Read", *Prospectus I*, p. 66).

On countless occasions Dubuffet confessed to the pleasure he derived from the deliberate imperfection or glaring defects of some of his works, as if they conferred upon the picture an extra ambiguity that enhanced it in some way: "It has often happened that thanks to failed works or ones put to one side unfinished, my eyes have been opened to new ways of representing that I have then gone on to develop deliberately." ("Rambling Conversations", *Prospectus III*, p. 108).

Something needs to be said at this stage about chance, the principal partner, which obviously plays an essential role in the whole stage of preparing materials and in observing what the material support conveys to the artist's eye: "The artist is harnessed to chance. [...] It pulls in the wrong direction, whereas the artist steers as best as he can but with flexibility, concentrating on making the most of every fortuitous occurrence that comes along. [...] The term chance is not accurate; we should speak rather of the whims and

inclinations of the material which kicks against the traces." ("Harnessed to chance", "Notes for the Well-Read", *Prospectus I*, p. 58).

But the risk of such an attitude is of being overwhelmed by the obduracy of the material or by the intrinsic logic of the technique being used: the artist is thus nothing more than a chemical engineer experimenting with mixtures and combinations of materials just to see what the results are going to be. In Dubuffet's work before the *Hourloupe* period, we definitely detect a temptation to set up a new kind of Mendeleyev periodic table of chemical elements, surveying the whole gamut of textures and effects that can be produced by particular processes.

This is especially the case with the lithographic series *Phenomena*. In a phase of frantic activity creating various print effects which were eventually to be used in his `assemblages', Dubuffet was so overwhelmed by the results that he decided to publish them just as they were. A similar desire to stand back and let matter and material take pride of place is to be found in a different genre, namely the *Texturologies* and *Materiologies* series. Their very names stress the artist's intention of drawing up an inventory of effects, in some cases bordering on illusionistic, *trompe-l'oeil* techniques simulating particular geological and topographical features. Taken to an extreme, this kind of exploration inevitably leads to an impasse.

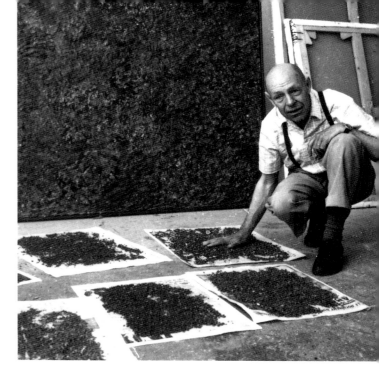

Preparation of
"Materiologies"
Vence, 1960

Chameaux
(Camels)
1948
Gouache on paper
54x42.2 cm
Deposit at Hamburg Kunsthalle, Hamburg

Dubuffet confessed in *Rambling Conversations* that "about 1959 and when I was launching my *Materiologies* series, I got so excited by the surface of paths and roads that I thought of having whole sections of them cut out with a pneumatic drill and then framed and hung on my wall. But I got cold feet. It would have meant giving up being creative and instead just contemplating the physical world ecstatically like a Buddhist monk." (*Prospectus III*, p. 103)

It seems fairly natural that this kind of art be considered more akin to Oriental meditation techniques than to representational art in the normal sense. It is a sort of zero degree of painting, and it corresponds in fact to the zero degree of civilization and culture that Dubuffet went off to look for at about that time in three long trips to the desert – to the vast expanses of the Sahara no less: four weeks to El Golea in March and April 1947, then six months there from November 1947 to April 1948 (just after the opening of the Art Brut Center) including an excursion to Ahaggar at Christmas, and finally a few weeks in Beni Abbes, Timimoun and El Golea in March and April of 1949. Here, on the edge of the known and charted world, just as he was always to situate himself in his art at the extreme of what was possible in painting, Dubuffet came to know Bedouin civilization, having been enthusiastic about it from some time back.

In 1952, just one year before Roland Barthes' famous *Zero Degree of Literature* was published, this is what Dubuffet wrote about this: "Perhaps my trips to the deserts of white Africa intensified my taste (which is so characteristic of the Islamic spirit) for what is minimal and barely perceptible, and in particular in my painting for landscapes where nothing can be seen but what is shapeless – endless expanses of stones that might be seedlings; landscapes devoid of any well defined features such as trees, roads or houses." ("Landscaped Tables, Landscapes of the Mind, Stones of philosophy", *Prospectus II*, pp. 79-80).

This is an essentially ascetic approach and reflects something quite fundamental in Dubuffet's character, but he was not to abandon it until much later, when he had exhausted his "materiological" explorations and published the hundreds of prints making up the *Phenomena*. Already before that point, following Michel Tapié's book *An Other Art* in 1952, people in the inner circles of the art world were beginning to talk of experiments in "non form". Dubuffet perhaps felt in some measure guilty at having helped to push painters in this direction – he had never had words strong enough to mock "Nonformism", "Vehementalism" and "Splash-and-splatterism" – and he was perhaps also keen to leave behind his horde of imitators and set off on a new path. So, being the inveterate rebel that he was, Dubuffet did what came naturally to him and abruptly adopted a stance at the opposite extreme. The result was first the *Paris-Circus* series with a return to a grotesque representational style reminiscent of the *Puppets* of 1942-1945, but this time enhanced by twenty years of substantial experimentation; then, from 1962 onwards, Dubuffet set off on an adventure into the purely mental cellular universe of the *Hourloupe*.

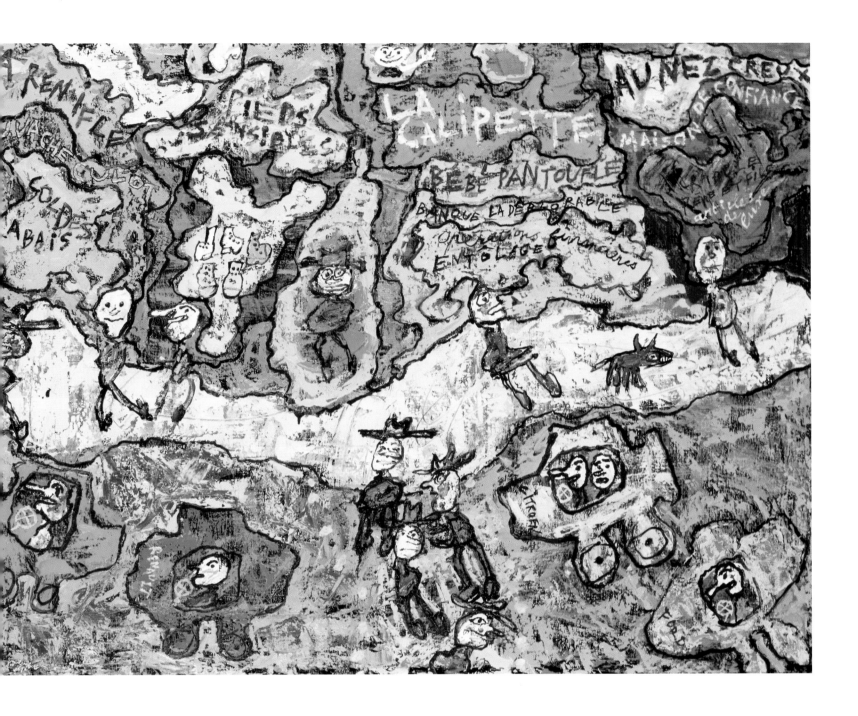

La Calipette
31 August 1961
Oil on canvas
89x116.5 cm
Daniel Malingue Gallery, Paris

INVOLVEMENT:
GETTING AWAY FROM ACADEMIC DRAWING

Throughout the history of painting, in no matter what country or at what time, there has always been a distinction between draftsmen and colorists, and only artists of the greatest talent have been both at the same time. Deciding whether Jean Dubuffet is as great a draftsman as he is a handler of pigment is not at first sight easy. Of course, just like Picasso and Klee, Dubuffet always liked to draw and was good at it. Even if from the very first he showed a taste for caricature and demonstrated a deep understanding of color as well as a fascination with experimenting with materials, we can

form an idea of what he could have achieved in the classic manner from what remains of his "prehistorical" works. It so happens that although he felt bound to hide or destroy these works because they were all too evident proof of his tentative beginnings, it was also because the whole issue of drawing in particular had been problematic for him for a long time.

As so often with modern and contemporary art, it is not possible to understand Jean Dubuffet's style other than as a reaction to the art that preceded it. The entire impetus is a rejection of traditional academic drawing, the discipline that calls for the most faithful and realistic reproduction possible of the outline and external appearance of objects.

When asked "how important do you think good draftsmanship is in painting?", Dubuffet replied: "When they speak of drawing something well, people usually mean getting as close as possible to a photographic reproduction, and that strikes me as drawing badly or not even drawing at all. All artistic effort, however humble it is, is expected at the very least to be creative. A photographic outline is in no way creative. If we have to use the kind of language that equates drawing well with reproducing exactly what the eye sees, then I would say that art only begins when you draw badly: the worse you draw the more there is a creative input." (*Prospectus III*, p. 109).

Even allowing for the provocation intended, it is clear that for Dubuffet it is really a question of defining a specific role for drawing, completely distinct from the machine – like realism of industrial media. And far from being an indispensable foundation for the painter's profession, a traditional apprenticeship is a handicap for the creator, to be avoided at all costs.

If we accept these presuppositions, then anything goes, provided that traditional realist techniques are avoided. Like the self-taught practitioners of outsider art but with access to a greater range of possibilities, Jean Dubuffet discovered several creative channels that he explored in turn or sometimes combined. The main ones amount to six or seven in number. First, children's drawing, then graffiti and carved inscriptions; and then something bordering on the hallucinatory akin to Rorschach blots, a form of mental projection onto complex relief textures serving as stimulants for mediumistic experiences. For these Dubuffet coined the excellent term "metapsychic visions", when he wrote about the *Landscapes of the Mind* in his "Biography" (*Prospectus IV*, p. 497).

Then there is the frequent recourse to collage. To avoid the strong Cubist connotation no doubt, Dubuffet preferred to call this "assemblage". Being adept with scissors to cut out and arrange the pieces of paper into what amounted to a *montage* replaced the role of the draftsman and gave the composition its structure. To this list we can add the use of various kinds of imprint, made for example by molds or tools, or even bits of vegetal matter which print their message in the thick impasto covering the canvas, just as Dubuffet did with his studies of ground and garden surfaces. And finally there is a process that is most conspicuous from the time of the *Hourloupe* onwards, the use of drawing rather as a form of calligraphy sometimes bordering on scrawl and "automatic" writing. By means of this Dubuffet created a whole code of symbols, an arbitrary system of signs

"Art speaks to the mind, not to the eyes. This is how 'primitive' societies have always understood it, and they are right. Art is a language: an instrument of knowledge and an instrument of communication."

("Anticultural Positions", Chicago Arts Club lecture, 20 December 1951, *Prospectus I*, p. 99)

resembling new hieroglyphs. In so doing he gave expression to something that had fascinated him from his earliest years and followed him throughout his life when at various times he had learnt the Cyrillic alphabet, a few rudiments of Chinese, some Mayan and Egyptian hieroglyphs, and finally the Arabic script.

Quite separately, there remains the already mentioned phenomenon of the physical material of the paintings being the sole custodian of speech as it were, seeming to be devoid of all representational import, as in the *Texturologies, Phenomena* and *Materiologies*. On these anonymous and undifferentiated surfaces, even at the preliminary stage, there is no human shape to be seen, no remotely recognizable trace of a living being. At this stage there is one last process, and a totally unexpected and paradoxical one, which is intended to make up for the complete absence of representational elements. This could be called the title factor, that is to say the artist's recourse to the word or to writing to compensate for the awesome silence of matter.

These are generally strange and comic and are the fruit of Jean Dubuffet's extraordinary verbal inventiveness. As titles to his pictures they have first and foremost a purely practical purpose, as they often point to their ambiguity by being based on incongruities, hence *Landscaped Tables, Stones of Philosophy* or *Grotesque Landscapes*. In a conversation with Françoise Choay in February 1961, Dubuffet explained that "the titles are always given to the pictures after they're completed, and in the same way that you give a name or a surname to someone you know. How could it be otherwise when you want to talk about those people or just refer to them in your own mind? It's mainly for my own convenience that I give them a title. Of course a really good title, one that's particularly appropriate, adds a lot to the picture's effect." (*Prospectus II*, p.220).

Here are some examples, taken more or less at random. There are strange, absurd ones, intended to provoke: *Hair-eating Dog* (1943), *Naked Cyclist*

From left to right:
- **Campagne aux cyclistes** (detail)
 (Cyclists in the country)
 July 1943
 Gouache on paper
 25x15 cm
 Musée des Arts décoratifs, Paris

- **Touring club** (detail)
 February 1946
 Thick impasto on canvas
 97x130 cm
 Richard S. Zeisler Collection, New York

- **Pierre de vie** (detail)
 (Stone of life)
 July-August 1952
 Oil on hardboard
 77x105 cm
 Kunsthaus, Zurich

- **Georges Dubuffet in the garden** (detail)
 December 1955 (signed 1956)
 Oil on canvas (assemblage)
 155x92 cm
 Private Collection

(1944), *The Bird-eaters* (1944). Then there are poetic, allusive titles: *Paris Scene with Stealthy Pedestrians* (1943), *Wastage of Existence* (1950), *Hermitage in Sticky Country* (1952), or just prosaic, factual or grotesquely trivial: *Blue and Red Cow* (1943), *Sporty Lady Taking off her Knickers, Woman Mending Socks, Birth of a Child* (1944), *The Ejaculator* (1951), *Wall with Pissing Dog* (1955), *Person with Hat in a Landscape* (1960).

Other titles are occult or mediumistic: *The Tree of Fluids* (1950), *Stone with Figures, Metapsychic Landscape* (1952), *Landscape Fantasies* (1953); or technical and surrealistic: *Dhôtel Shaded Apricot* (1947), *Landscape with Jelly-frosted Sky* (1952); ludic and purely verbal: *Foutriquet, Gigoton, Grouloulou* (*Little Statues of Precarious Life*, 1954), *Gode à la tronche* (1963), *Canotin mâche-oeil* (1967); mysterious and philosophical: *Exemplary Life of the Ground* (1958), *Illuminating Beard* (1959), *Bank of Ambiguities* (1963), *To Be and To Seem, The Illusory Site* (1963). And then at the very end, as though it were no longer important to individualize the works, they are simply named and numbered in archival manner: *Parachiffre XLIX, Meetings XIII* (1975), *Memoration VIII* (1978).

Just by looking at these titles it is quite easy to see that the light-hearted or absurd, playful manner of Dubuffet's early puppet theater slowly gives way over the course of time to an increasingly intellectual approach, and metaphysical concerns crowd out the high-spirited poetic style of the early years. Likewise although verbal inventiveness is still in evidence when it comes to specifying the buildings and environments of the *Hourloupe* and the last series (the *Villa Falbala*, the *Monument with Phantom, the Logological Cabinet*, the *Theaters of Memory, Psycho-Sites, Sights,* etc.), there is less effort made to be original with the titles of works within a series (*Site with three…four… seven characters*, for example).

But it was particularly when Dubuffet was fascinated and totally carried away by his search for new materials and textures, at the time of the lithographic series *Phenomena* (1958-1963) or in the *Materiologies* (1959-1960),

From left to right:

L'Offreur de bouquet (detail)
(Man offering bouquet)
January 1957
Indian ink on paper
and prints assemblage
50x33 cm
Musée des Arts décoratifs, Paris

Cristallisation du rêve (detail)
(Crystallization of the dream)
October 1952
Indian ink on paper
50x60 cm
Musée des Arts décoratifs, Paris

Fruits de terre (detail)
(Earthfruits)
December 1960
Papier mâché and vinyl impasto
81x100 cm
Musée des Arts décoratifs, Paris

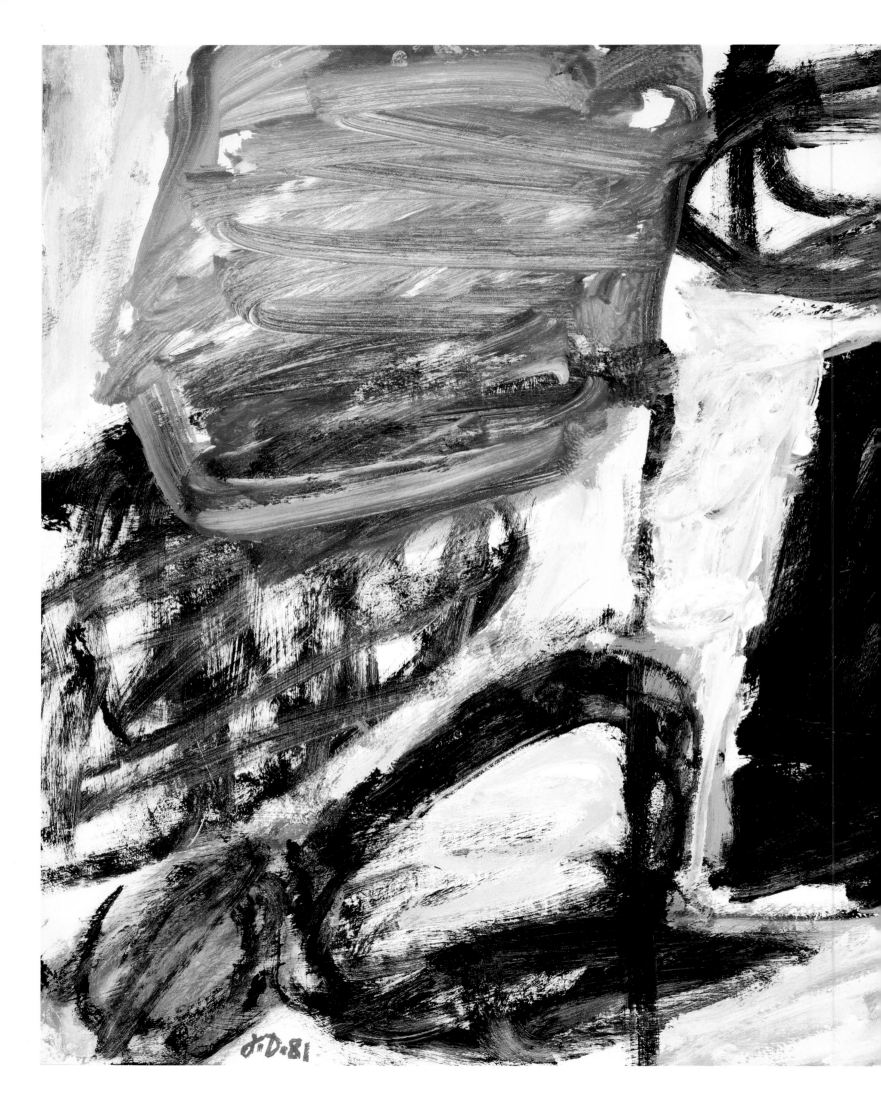

Site avec 1 personnage
(Site with 1 character)
E 365, (*Psycho-sites*),
1981
Acryl on paper mounted
on canvas
MNAM - G. Pompidou Center, Paris

"I consider creation from within itself [...], it's creation that interests me, not the work."

(Letter to Gaiano, 30 October 1981, *Prospectus IV*, p. 414)

that the title as a significant factor in Dubuffet's work assumed the greatest importance. With prints and canvases creating a bio-chemical world of an entirely new sort in art; a repertory of new natural elements and previously unknown images of the cosmos, of works produced by various processes completely devoid of representational content, it was inevitable that they had to be given a name in order to find one's way around among them and tell the difference between them.

"Something important should be noted," Dubuffet wrote, "it's how very much more evocative the plates became from the very moment when they got their title. The image irresistibly acquired immense meaning as a result of the title that was conferred upon it, even if the latter was sometimes a little arbitrary. How instructive it is to realize that the artist's role, although it is to create images, resides just as much in *giving them a name*. I even believe that this function of reading and seeing within every image, and endowing it with associations of ideas, and discerning within it the keys for transcribing things and suggesting new modes of representation, even new themes and new plastic and poetic areas to work in – all of this is much more important for an artist than the actual creation of the images in the first place." ("Notes on assemblage and transfer-based lithographs", *Prospectus II*, p. 174).

In this context we are better placed to understand the point of such a strange undertaking as the publication of the *Catalogue*, which was begun with the *Hourloupe* in 1964. The whole of Dubuffet's work was reproduced in photographic form and published complete with practically exhaustive commentaries and notes. This was done both to counter the inevitable dispersion of Dubuffet's work by explaining its series structure and to supplement the image with an indispensable written text and critical apparatus for its interpretation.

It so happens that Dubuffet, who had been for such a long time uncertain about his vocation and tempted as much by words as by pictures, was one of those artists just as gifted at writing about their work as at painting inventively. Whether in his poetic or in his philosophic vein, he naturally comes across to the reader as a rare example of the artist-writer, although he constantly denied that this was what he was, and despite the fact that his writings were never anything other than a late off-shoot of his painting rather than the opposite. Georges Limbour summed it up very well:

"These little *literary* works and the principles behind them never preceded the *artistic* works that they may happen to be about; they do not anticipate the pictures, as if the latter were the illustration and application of theories. Quite the contrary, it was while he was painting that Jean Dubuffet formed his ideas and feelings: they were first experienced and lived during the process of painting. Take the case of the *Prospectus for art-lovers:* it was after painting the first series of his exhibited work that the future Satrap took some rest and stepped back a little from his work in order to reflect about what he had just accomplished; he then became aware of some of his intentions. Theoreticians write first and paint afterwards, which makes for bad theory and bad application of the theory. In painting, as in other matters,

awareness must follow action." (*Quelques introductions au Cosmorama de Jean Dubuffet Satrape, op. cit.*, pp. 20-21).

From a historical point of view a lot could be said about this inflation of the importance of language in parallel with the act of painting that we find in a great number of artists today: they feel a need to supply a key and list of references, secretly fearing perhaps that their images are inadequate on their own. We live in a strange era, in which we lack a common culture or mass consensus or ideology encompassing all individuals, hence every artist has to develop his or her own *a posteriori* discourse to explain and justify the work created. In times long past the Bible or the *Iliad* were illustrated. Today we create images and then seek their meaning afterwards.

Site avec 4 personnages
(Site with 4 characters)
E 227 (*Psycho-sites*)
27 july 1981
Acryl on paper
mounted on canvas
50x67 cm
MNAM - G. Pompidou Center, Paris

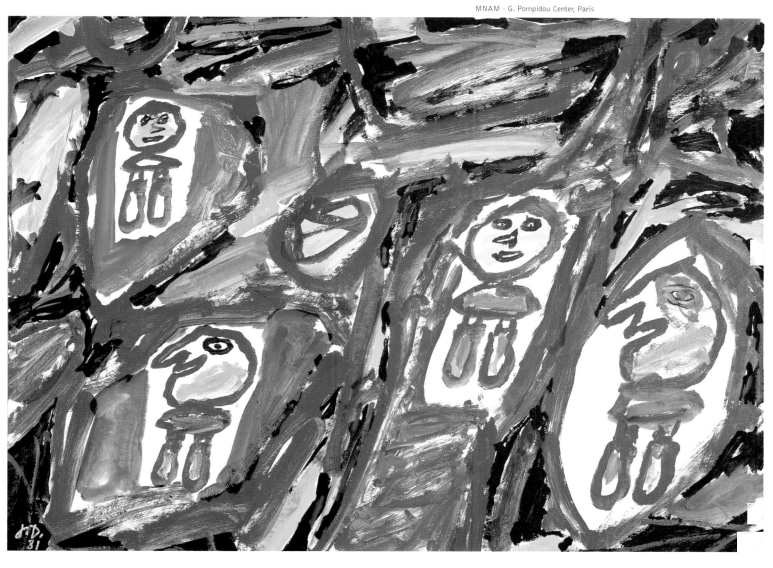

"I have always had a high regard for gags; it's always seemed to me that there is a relationship between the quintessence of art and those absurd simplifications which provoke laughter."

Jean Dubuffet, *Cahiers Alexandre Vialatte*, n° 3
Preface, 2 November 1975.

Jean Dubuffet
pataphysician ————————————•
1958

3 Children's drawings, graffiti, Rorschach blots, assemblages: unusual ways of getting away from traditional drawing

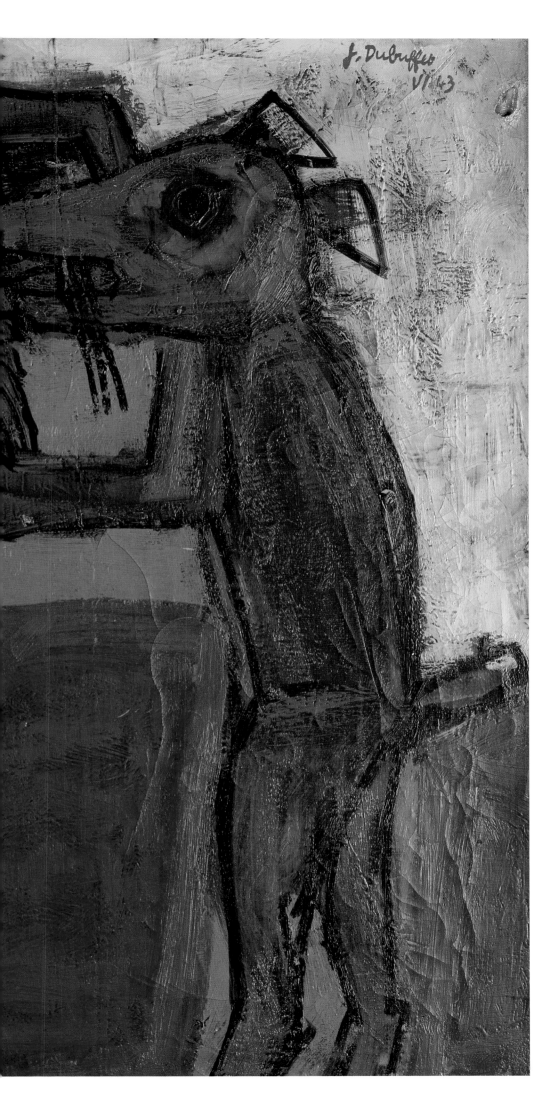

● **Le Chien mangeur de cheveux**
(Hair-eating Dog)
June 1943
Oil on canvas
51x67 cm
Private collection

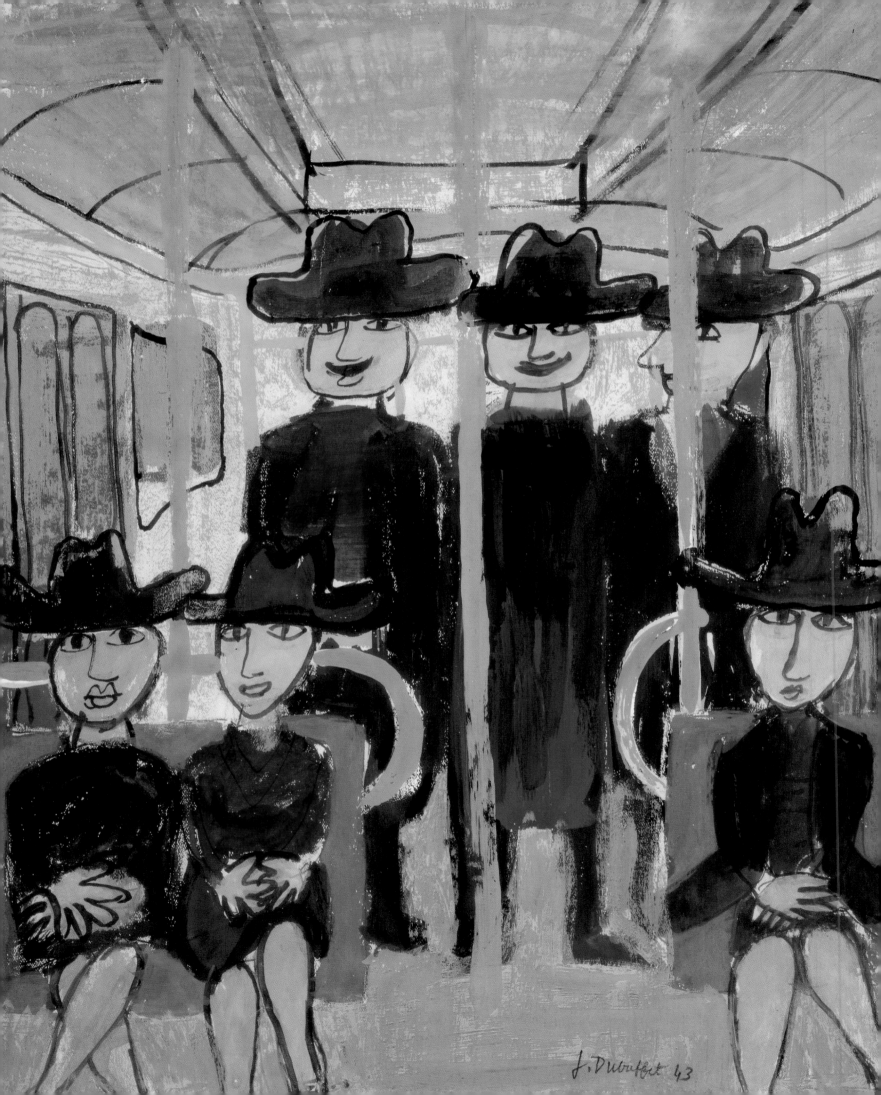

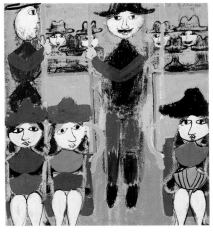

Metro

March 1943
Series of gouache on paper
37x30 cm
MNAM - G. Pompidou Center, Paris

"I am a Sunday painter for whom every day is Sunday."

(Letter to Pierre Carbonel, 6 April 1961, *Prospectus IV*, p. 175)

PUPPETS OF TOWN AND COUNTRY

To get a more detailed view of what lies behind the first series of Dubuffet's paintings, those of the twenty years before the *Hourloupe*, we must return to chronology. We left off at the point when the Bercy wine merchant decided in the Autumn of 1942 to shut himself away in his studio in the rue Lhomond to devote himself once and for all to being creative. Georges Limbour had the privilege of witnessing Dubuffet's debut as a painter, and he later described the latter's euphoria on leaving his business in 1942 and suddenly throwing himself into what was to become the *Puppets of Town and Country* series. Under the title "A business for sale: a world to paint", we read: "He did not go back to painting, he started to paint [...] He forced himself to behave as if he had never ever looked at a painting, never known or remembered anything, as if he had no rules or principles or the slightest regard for what is considered to be good taste. Being above all a colorist, and very refined by instinct and by virtue of his education, he made his colors sing out from mustachioed guards and hairless nymphs; and if he felt like it, he also made his colors creak, scream and rave, sometimes with barbaric accents. By means of color – enthusiastic, tender, burlesque, jovial and pitiless all at the same time – he carried out a sort of general purging of his system, ridding himself of his former opinions and preferences, his learning, his sense of history, civilization and culture. He created characters for us to look at contemplatively – or to knock down like skittles." *(L'Art brut de Jean Dubuffet..., op. cit.,* p. 20).

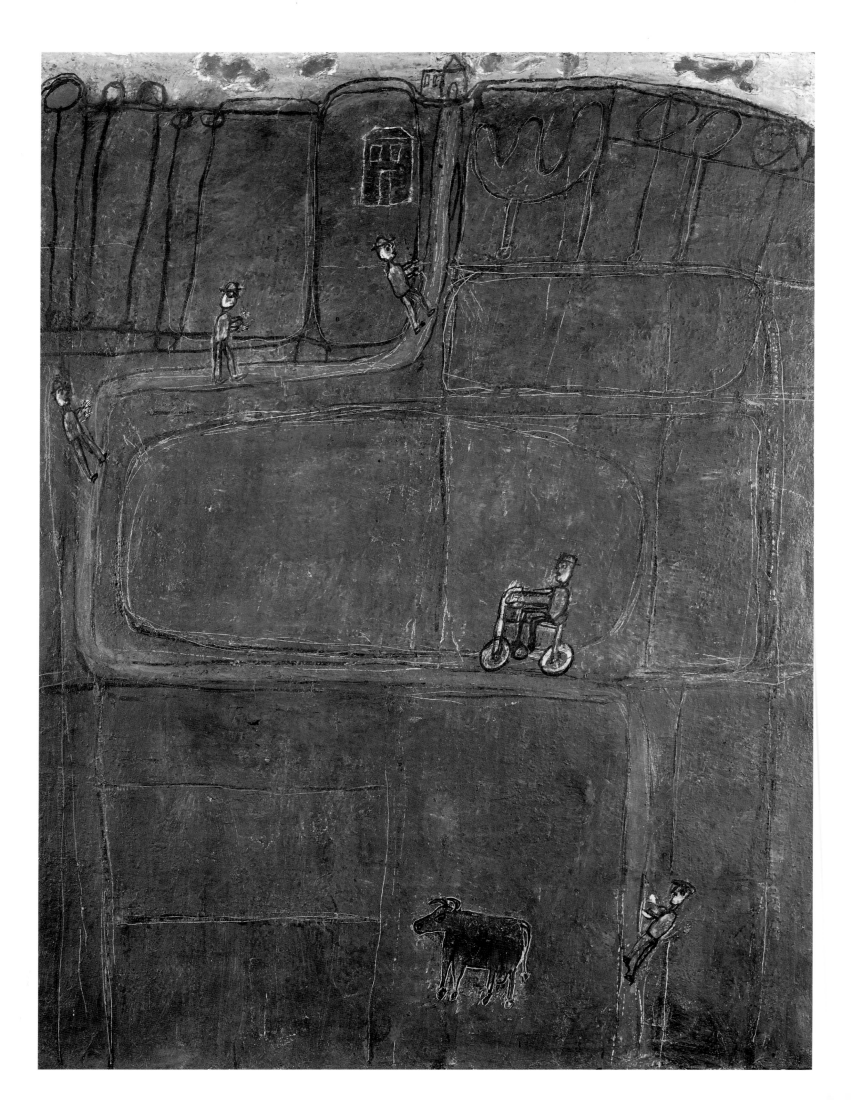

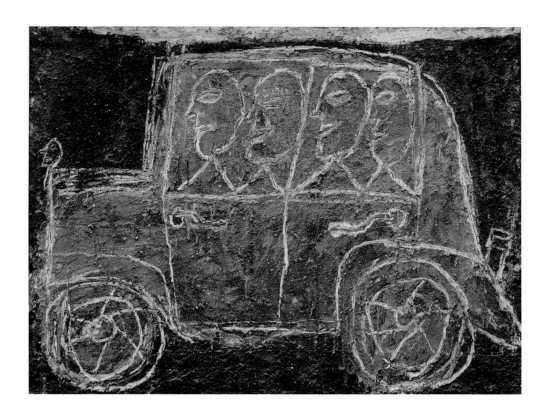

So Dubuffet turned his back on his acquired culture and traditional figurative painting, and went off to rediscover the world of the times he lived in by exploring first of all the possibilities of children's drawing. This was a predilection that he was to indulge periodically, and curiously at all the turning points in his work from the *Puppets of Town and Country* (1942-1945) to *Paris-Circus* (1961-1962). This last series, coming after the non-representational asceticism of the *Phenomena* and the *Materiologies*, marked the end of his obsession with materials. Then, after the long period of delirium that was the *Hourloupe*, it made its reappearance in all the late series, which are populated by droll human figures, namely the *Abbreviated Places* or the *Theaters of Memory* (1975-1979), *Sites with Figurines, Partitions,* the *Psycho-sites* and the *Random Sites* (1980-1982).

Why this interest in children's drawing? "Children are beyond society, beyond the law, asocial, alienated: in fact what an artist should be. This is why their drawings are so piquant, inventive and bold, and so carefree in line and form. And above all – and this is the essence of painting – a child has the power to see deep within the painted image (even if it's something trivial) without a critical reflex immediately blocking it off, as happens with adults. At all times a child is equally happy to see or to envision, and moves easily from the real to the imaginary, from the physical to the conceptual (and vice versa)." ("Little Wings", *Prospectus II*, p.54).

It is difficult not to regard this statement as a profession of faith, a sort of artistic credo. But then Dubuffet immediately moderated his admiration: "Yet it cannot be denied that children's art, like everything they do, is a bit lacking in something. Children tackle everything superficially. Whether they're on the receiving end or actually doing something themselves, their attention span is very short. They are not able to get passionate about anything for any length of time, or to concentrate hard on some project and

Touring Club
February 1946
Thick impasto on canvas
97x130 cm
Richard S. Zeisler Collection, New York

"Art should always make us laugh a little, and be frightened a little".

("Introduction to a public lecture on painting",
1946, *Prospectus I*, p. 53)

Previous page:
La Route aux hommes
(Road with Men)
August 1944
Oil on canvas
130x97 cm
Ludwig Museum, Cologne

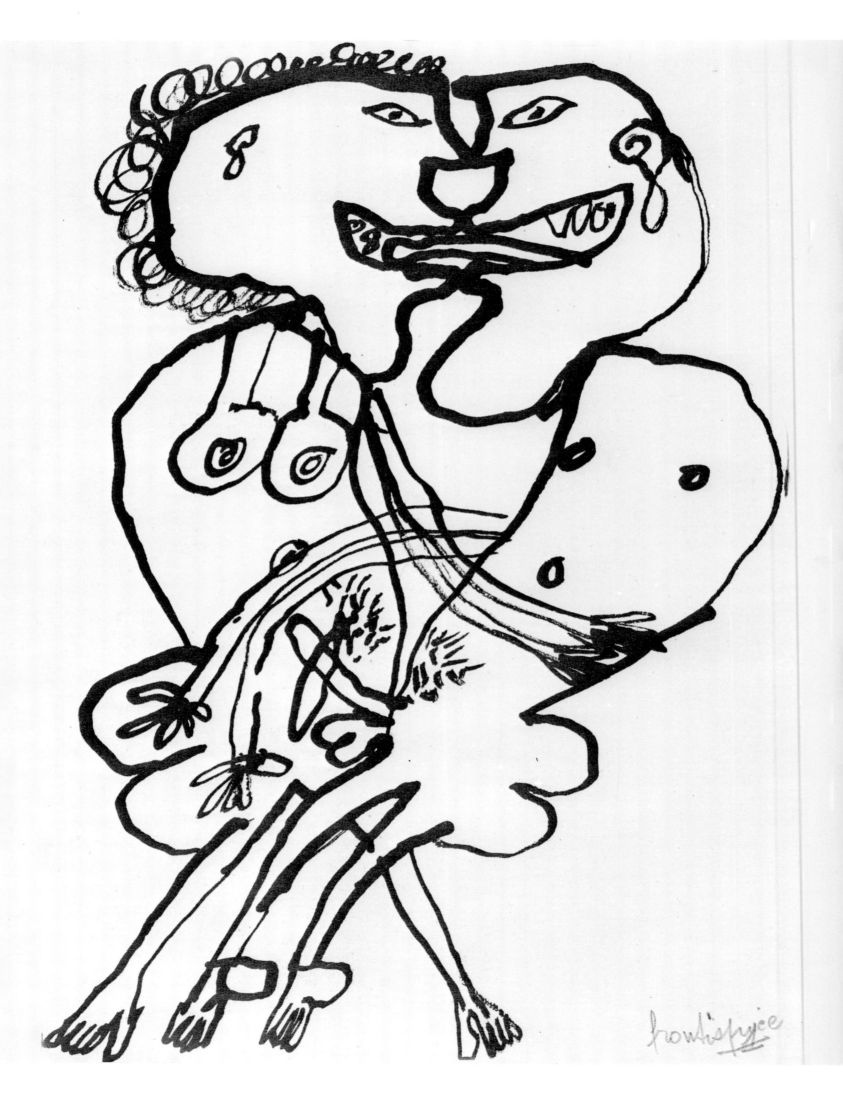

labonfam abeber.
,antele tankoler
Kianfil inbou
unltrin safedubiin
smar estemo rula
rindile sitem pasa
fe boure dantou
ekouin kesal
putinxe sella

take it very far before it gets bogged down. There's no doubt that they fly, no doubt that we're delighted to see them flap their little wings on short journeys, whereas the adult, despite having much more powerful wings, unfortunately can't bring himself to use them," (*Id.*, p.55).

A lot could be said about the pseudo childlike nature of Dubuffet's work, which obviously creates only an artificial, tongue in cheek childhood, and is more akin to an absurd and grotesque vision of existence than to an authentically innocent evocation of the marvelous and the naïve that we associate with childhood. Dubuffet is a *faux naïf,* just as he is to a certain extent only a pseudo outsider artist. What this simulated childhood provided Dubuffet with was a radical way of sweeping away the whole of artistic culture; it was a new and powerful way of freeing himself to explore the world round about him.

Right from the start, in the same way that he was later to rehabilitate the artist's humblest or even most despised materials, Dubuffet was totally "modern" and "contemporary" in his themes. Being consistent with his philosophy of existence and faithful to his natural inclination towards social simplicity and modesty, he favored the most humdrum daily activities of ordinary people: Paris street scenes with shop fronts and automobiles, buses and cafés. And there are some passengers in the metro, looking like comic puppets staring into space, that he painted to illustrate a

"When governments start protecting the Arts, it is the beginning of the end. […] When art is in good shape, it has no need of protection."

("Introduction to a public lecture on painting",
1946, *Prospectus I,* p. 53)

DPAPI YON DCHOU
LIVER IAN NAPA
DPAPI YON IARI
INQ DEMITE
DLAMITE IAN
NA TOULTAN
DLAMOUCH IAN
NAANCOR PABO
COU DETOILE

Ler dla canpane, page 8-9
(country air)
by "Dubufe J",
calligraphic text on stencil,
with engravings on lino, wood,
camenbert boxes,
hand-printed by the artist
Éditions L'Art brut, Paris
Christmas 1948
13.5x11 cm
Fondation Dubuffet, Paris

book by Jean Paulhan, who became a close friend of his via Georges Limbour at the end of 1943. Paulhan immediately introduced him to his own circle of literary friends who met every Thursday in his studio. He was quite taken with Dubuffet's work and defended him against indignant and mocking reviews in the French press. These new acquaintances were mainly poets, such as Pierre Seghers, Paul Éluard, Francis Ponge, René de Solier, Eugène Guillevic, for whose published volumes Dubuffet provided illustrations, before eventually illustrating his own books later.

This first series of *Puppets* had a very apt title: just like in children's coloring-in books or in the folk art of so many countries, the cows are red and the dogs blue or green. Men wear broad-brimmed trilby hats with a dip in the middle which then becomes the shape of the head itself; the women with their jutting calves and bulging bosoms are perched on high heels and crowned with ridiculous hats.

Caricatural men, monstrous women, grotesque bodies and decors, these are what we find in Dubuffet's first pictures and they follow straight on from the Punch and Judy characters that he made with his wife Lili in the spring of 1936 and which now appear to be completely lost. No doubt influenced by memories of his first profession, when he sold wine to mustachioed coal

merchants, the new recruit to painting preferred to represent that laboring sector of the human race that he had so often been close to. So it is not surprising that his canvases almost always portray active people: business men on the telephone, a stenographer at her type-writer, a woman with a coffee-grinder, etc. Dubuffet was already revealing that fondness for accessories that was to be prominent even more at the beginning of the *Hourloupe*: the bicycle, for example, or the wheelbarrow and the coffee pot.

As for the locations, such as Bercy, they seem to be a stylized resurfacing of the decors – to which Dubuffet will give the name "sites" – that he had been so familiar with in the earlier part of his life, or places where he had gone on brief cycling holidays with his wife. Sometimes he chose the most anonymous and deserted little country roads, at other times old quarters in working class Paris, or the no-mans-land of the industrial suburbs, little unidentifiable streets far from the city center, court yards with no way out, waste land, factories with no windows… It is an escapist's or dreamer's world, more surprising than virgin forest with its grimy walls, unrepaired road surfaces and pavements ready for hopscotch yet peopled only by phan-

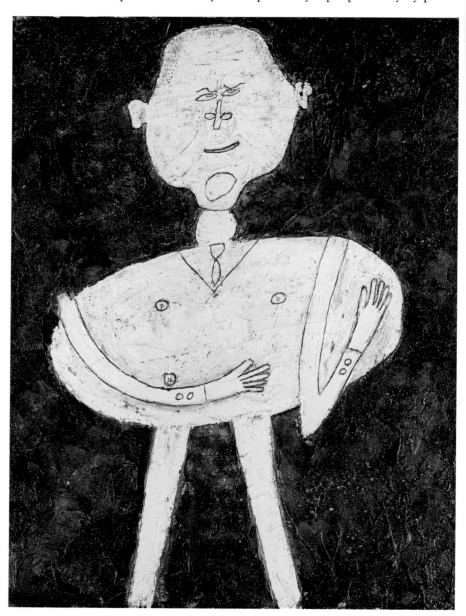

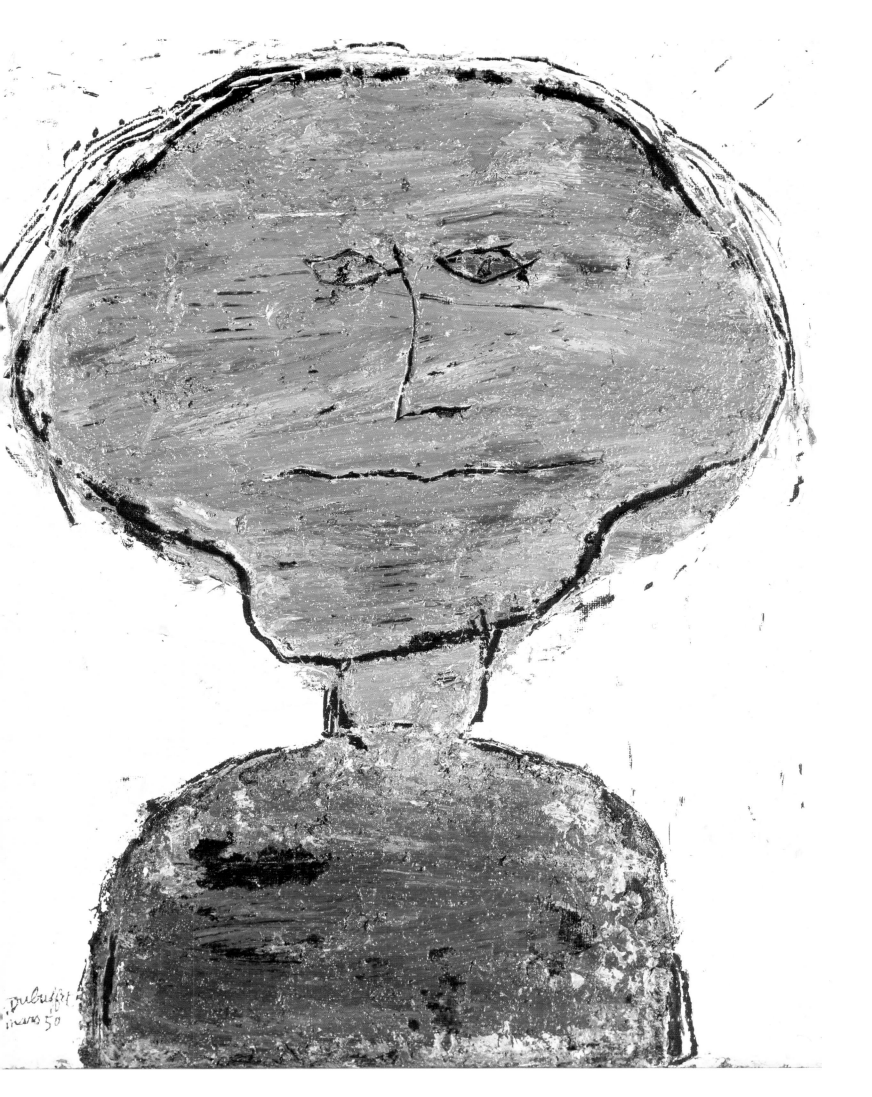

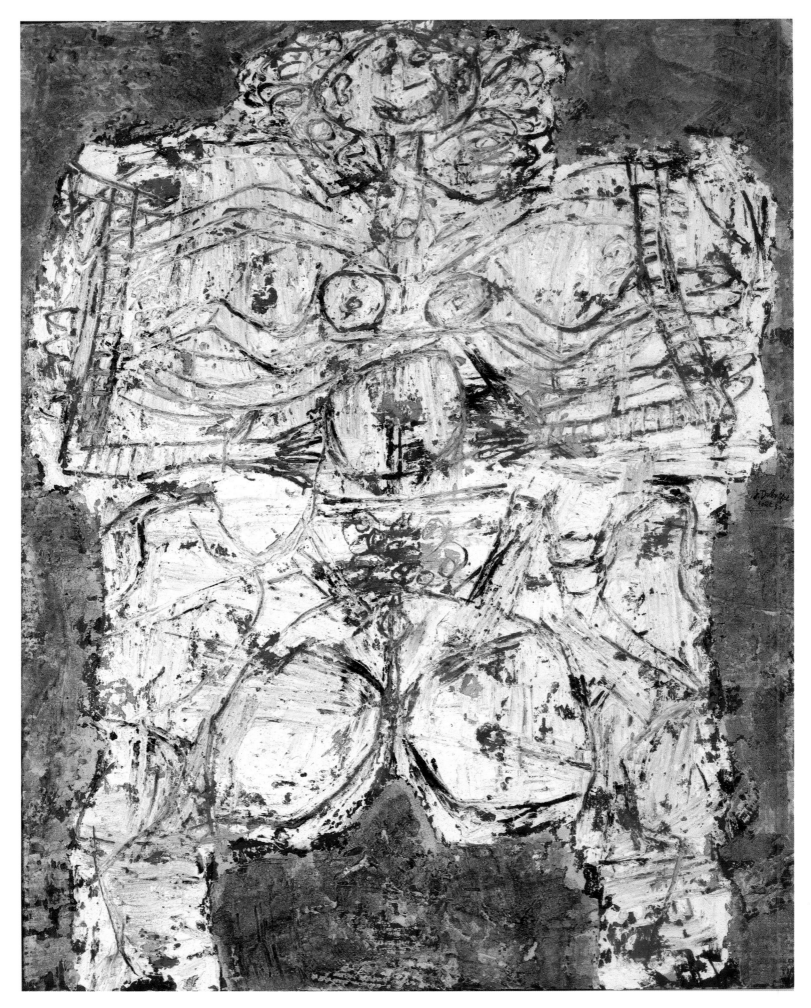

tom-like figures, exiles from lonely crowds. From his memories of his earliest childhood and of his father Dubuffet retained his taste for labyrinths and enclosed spaces: Arab cities and mazes, places where you could shut yourself in or become lost.

During this first period, Dubuffet's themes are far from conventional and are of course handled in an extremely schematic, hence interior, manner, opening up new possibilities for illustration. And Dubuffet's pseudo-child-like style is the exact opposite of that of "naïve" painters, despite the fact that they were the only ones before him bold enough to illustrate the banality of the industrial world. In this taste for the innocent and the mundane, the Dubuffet of the early years was modern in every sense of the word. In his work he showed a clear "predilection for the world of objects", just like his friend Francis Ponge, whose book on this theme, *Le Parti pris des choses*, was published by the *Nouvelle Revue Française* in 1942. Dubuffet's work was not futurist – we are not talking about 1914 after all – but, to coin a term, "contemporist", devoted to the contemporary. Dubuffet seemed euphoric in his celebration of the present, which began to change profoundly in France once the war ended and reconstruction began.

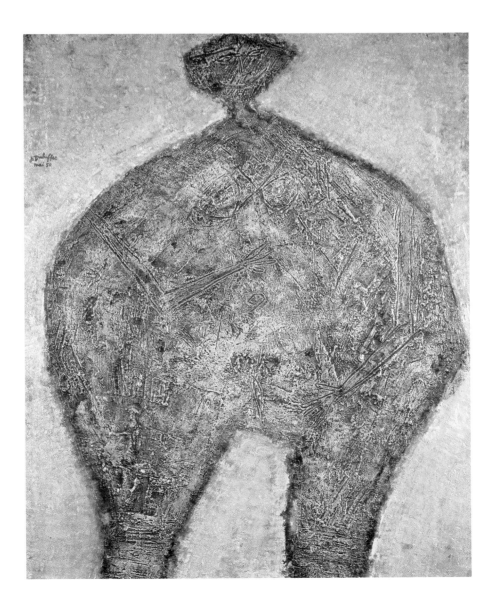

Corps de dame
(Lady's body)
August 1950
Indian ink on paper
27x21 cm
Private collection

Femme au sexe oblique
(Woman with slanting sex)
May 1950
Oil on hardboard
116x89 cm
Private collection

Previous page:
**Corps de dame
gerbe bariolée**
(Lady's body
colorful bunch of flowers)
August 1950
Oil on canvas
116x89 cm
Emilie Fischer collection, Landau

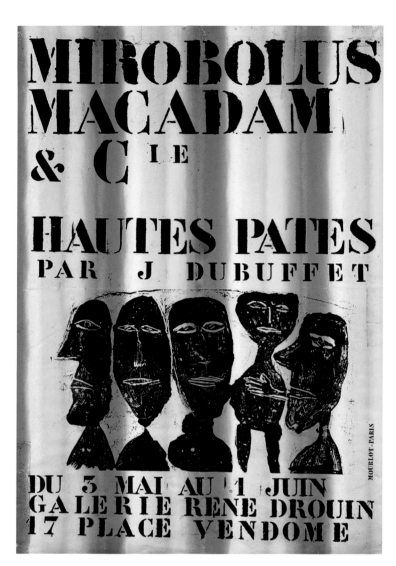

Poster for
● **"Mirobolus, Macadam & Cie"**
exhibition at the Drouin Gallery,
place Vendôme, Paris
3 May – 1 June 1946
Fondation Dubuffet, Paris

This was a wonderful time for Jean Dubuffet, blithely productive and culminating in his first public exhibition, which opened in October 1944 in the René Drouin gallery in the place Vendôme. A friend of Jean Paulhan and an inspired art lover, Drouin went on to become one of Dubuffet's regular Paris dealers, and played a key role when it came to launching outsider art. The exhibition made its mark and provoked a scandal, despite which, and the fact that sales were not impressive, this new art was well received. There were even a few fervent admirers, such as Henri-Pierre Roché who would soon be publishing his novel *Jules et Jim*, and Le Corbusier, who had visited Dubuffet's studio a year earlier to buy a picture – one of the first to do so – and gone away with a picture for nothing.

In the Spring of 1944 Dubuffet moved to new studios in the rue de Vaugirard and then set up home there a year later. 1945 was also the year when he met Pierre Matisse, the New York gallery owner who was to be his exclusive dealer in the States for the next fifteen years and the author of his success there. Dubuffet could thank Charles Ratton, the Paris expert on primitive art for this introduction to Matisse, which took place at a time when he had already set off on a totally new track in his art and was starting to be a serious collector of *art brut* in psychiatric hospitals.

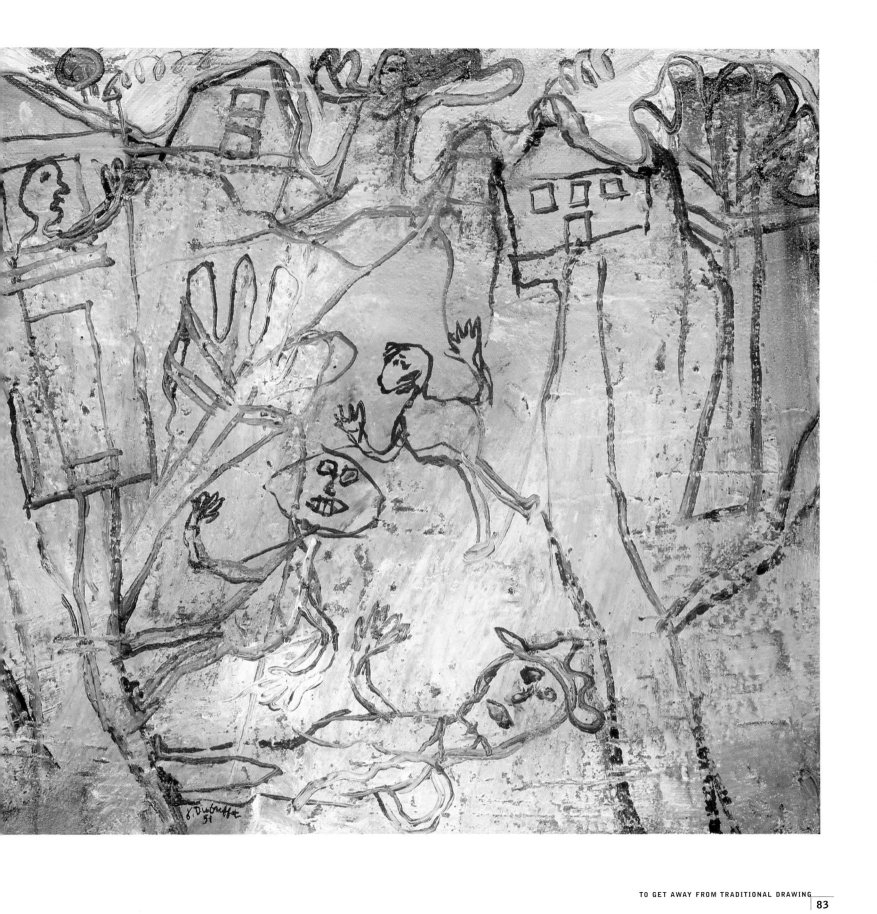

THICK IMPASTOS AND BEATEN PASTES:
THE GRAND GRAFFITI CIRCUS

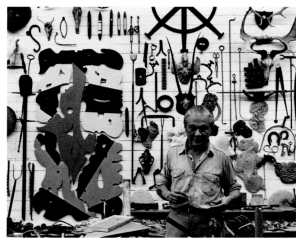

Alfonso Angel Ossorio y Yangko
in his East Hampton studio
circa 1950

If in the *Puppets of Town and Country* series, where the characters and places are handled in a colorful and amusing manner, one can still detect a fleeting desire to be representational, it is in the following series, *Mirobolus Macadam & Co* (1945 – 1946) that what Dubuffet was looking for in children's drawing comes across most unequivocally. This was at a time when he discovered two features of a new technique that was to prove almost inexhaustible. The first was what he called impasto, a thick layer of paint to which he happily added all sorts of other substances – sand, soot, plaster, ashes, coal dust, hemp fiber, broken glass – to create a tactile quality and an illusion of raw material. Along with this went a graphic device, graffiti and incision, which provided him with an unexpected answer to his search for innovation and one that he was to have sole recourse to for almost eight years.

From *Mirobolus* to the series called *Beaten Pastes* of 1953, another sort of thick creamy medium applied with a pallet knife over a colored ground to be revealed by the incised drawing, this graffiti technique takes Dubuffet further and further away from traditional representational painting. Out of this development will come the extraordinary series of portraits, *More Handsome Than They Think* (1946-1947), the *Roses of Allah, Clowns of the*

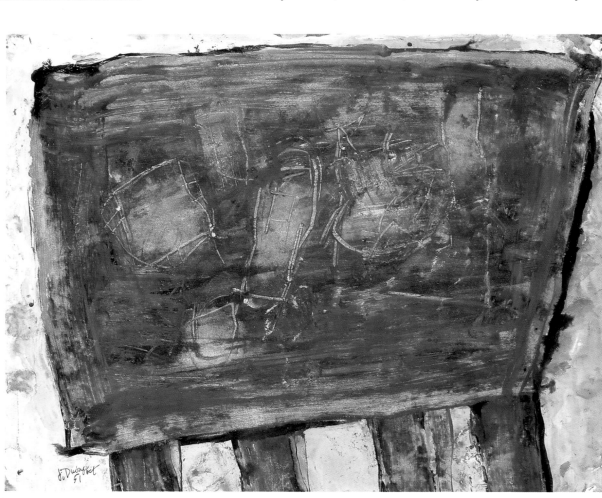

Table avec objets
(Table with objects)
1951
Oil and gouache on paper
28x36 cm
Musée des Arts décoratifs, Paris

Desert (1947-1949), inspired by the three trips to Algeria, the *Grotesque Landscapes* (1949-1950), the *Ladies' Bodies* (1950-1951), and even the *Landscaped Tables* and *Landscapes of the Mind* (1951-1952).

Throughout the whole of this period Dubuffet was no longer applying brush to canvas, as in the puppets series, so we can easily imagine the pleasure he derived from preparing his extremely varied and original surfaces and then reaching for a pointed object, say a nail or a piece of broken glass. With this he improvised his picture in outline as his imagination dictated, and this had to be done rapidly. This is because speed is a vital factor, assimilating the process to that of "automatic" writing, as incision-drawing makes virtually no allowance for corrections or second thoughts.

With reference to the *Ladies' Bodies* series, Georges Limbour had this to say: "These paintings were followed by a series of profile drawings on paper, also of ladies, and executed almost in a frenzy and with the spontaneity you associate with automatic writing. This precedence of the paintings relative to the drawings (which we find elsewhere in Dubuffet) is curious, for with most artists drawing is a preparatory stage for painting. But in this case they signal an attempt to detach themselves from the paintings or take them in a new direction." (*L'Art brut de Jean Dubuffet, op.cit.*, p. 67). So with Dubuffet the starting point for everything is not an idea but rather the painting process itself, experimenting with matter and colors, without any preconceived plan; an intention gradually makes its appearance at a later stage of the process.

What is also strange is that we find in Dubuffet's work all the classic themes of painting: portraits, nudes, landscapes, still life. They are handled in the simplest possible way, and are like symbolic abstractions surviving only as a notional vestige of the great traditional genres and subdivisions of art. Most striking of all, the one dominating theme to which the artist returns in all media – in lithography or in butterfly wings, assemblage and painting, drawing, printing, incision and cut-out, every conceivable process – is the human face and profile of the body. After the *Hourloupe*, it is this population of grotesque little figures that makes identifying the artist's style so easy.

As he never tired of proclaiming, Dubuffet had only one aim: not the specific but the general, not the detail but the universal. What he wanted to dig out was the profound inner being, or, to use the title of the first picture in the *Mirobolus* series in 1945, the *Archetype*: "When I'm painting I prefer to avoid the one-off; I prefer painting generalities. If I paint a sunken lane, I want it to be an archetype of all such things, a quintessence of all the sunken lanes in the world, and if I paint a human face I'm quite happy for my painting just to suggest a human face, but without specific features, which are pointless." ("Notes for the well-read", *Prospectus I*, p. 74).

But because the result may seem at first sight innocent and grotesque, the pictures of this period, as much because of the materials used as because of the willful couldn't-care-less graphic style, tend all too often to be considered as nothing more than a provocation to the public. We should clear up a misunderstanding here, and Dubuffet was forthright on the subject:

Raisons complexes
(Complex reasons)
March 1952
Oil on hardboard
68x33 cm
Musée des Arts décoratifs, Paris

Pierre de vie
(Stone of Life)
July-August 1952
Oil on hardboard
77x105 cm
Kunsthaus, Zurich

"A lot of people seem to imagine that out of a wish to blacken everything, I prefer to paint miserable subjects. How wrong they are! What I wanted to show them was that the things they thought were ugly, or had forgotten how to see, were also wonders in their way. I really hope this error will end, and people will stop talking about humor and satire, like some fools do, or about gloomy bitterness, which I've also heard, when in fact what I'm trying hard to do is rehabilitate objects considered to be unpleasant (please, I beg you, do not dismiss these objects out of hand): my work is always done in an attitude of celebration and incantation. But it's a lucid celebration, once all smokescreens and camouflage have been eliminated. A painter has to be honest. No veils! No ruses! Naked; everything at its worst from the outset." ("Perceiving", 23 March 1958, *Prospectus II*, p. 62).

"Celebration": the word occurs frequently in Dubuffet's writings, and he increasingly conceived painting as an activity associated with spells and magic. Hence his immediate enthusiasm in December 1950 or January 1951 for the "initiatory paintings" of a wealthy American who had come to buy from him some of the *Ladies' Bodies* pictures at a time when he was just about to start his own *Landscaped Tables* and *Stones of Philosophy*. This was the painter Alfonso Ossorio, a friend of Jackson Pollock, and Dubuffet got on so well with him that he wrote a fine set of commentaries about his art, and even seriously thought about col-

La Vie des sous-sols

(Underground life)
September 1951
Oil on canvas
81x100 cm
Private collection

Cristallisation du rêve

(Crystallization of the dream)
October 1952
Indian ink on paper
50x65 cm
Musée des Arts décoratifs, Paris

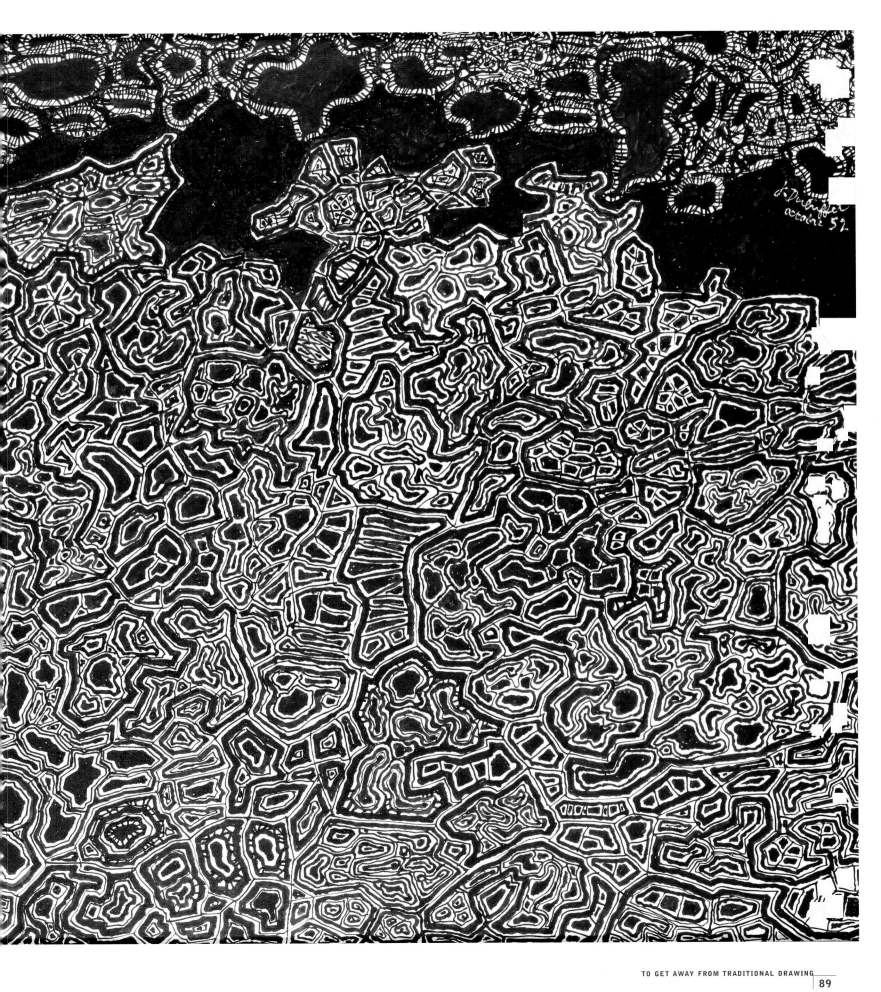

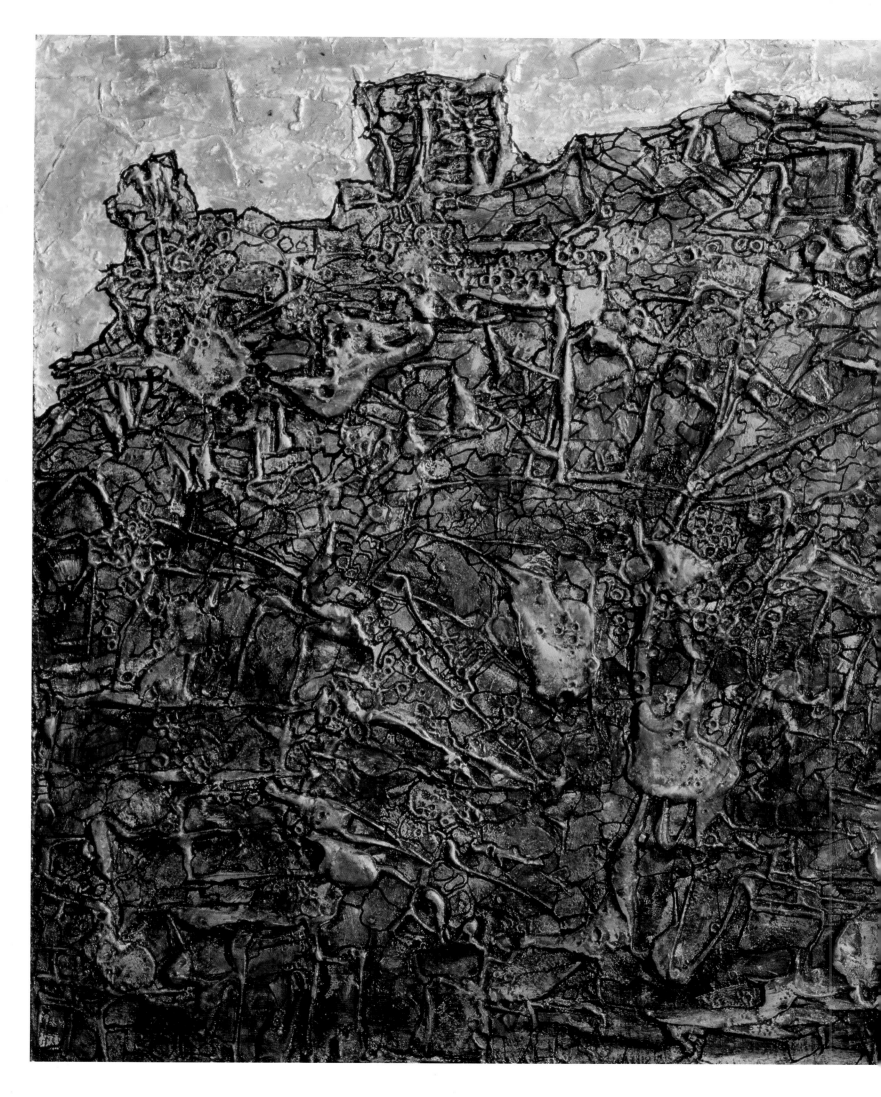

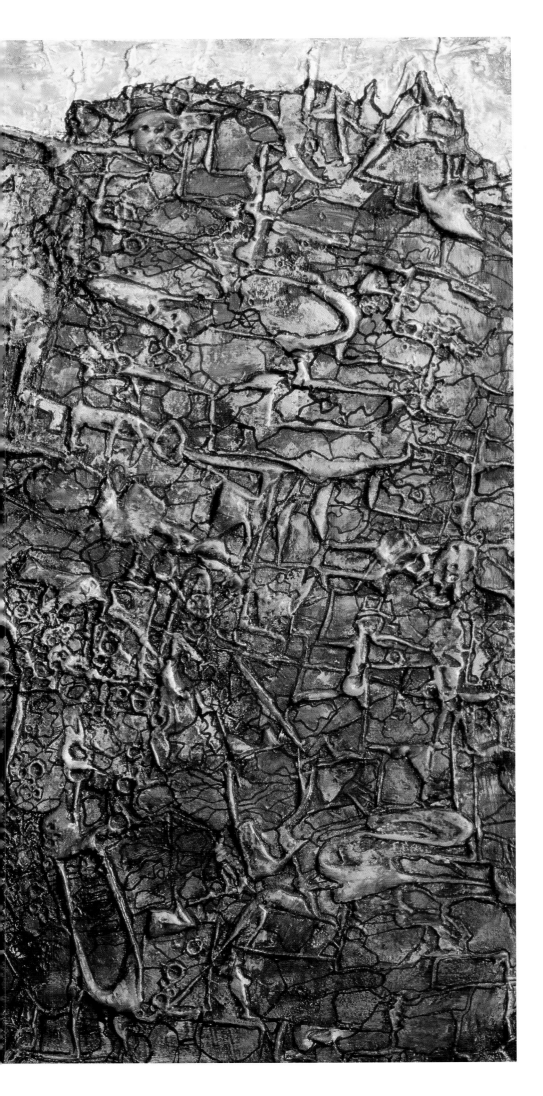

● <u>Le Voyageur sans boussole</u>
(Traveler without a compass)
8 July 1952
Oil on hardboard
118x155 cm
MNAM - G. Pompidou Center, Paris

"Personally I have the highest regard for the values of savagery: instinct, passion, caprice, violence, delirium."

("Anticultural Positions", 1951, *Prospectus I*, p. 94)

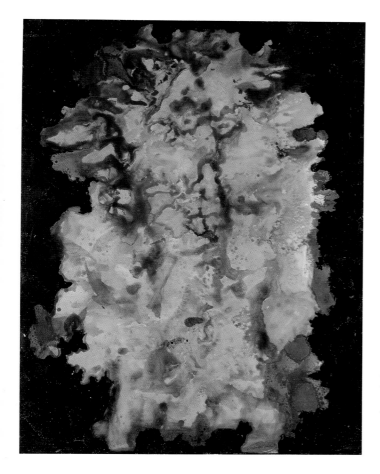

laborating with him to revive his study of outsider art, which was at the time stalled in France. This would have involved him in going to live with Ossorio in East Hampton near New York, and that is in fact where his *art brut* collections were sent at the end of 1951, and remained for twelve years!

Dubuffet was one of the first French painters to be sensitive to the lure of the US and to toy with the idea of establishing a base there at least part-time, as so many European artists had already done. The temptation was all the greater as although his work was not yet going down too well in Paris it was meeting with success across the Atlantic, thanks to Pierre Matisse; Clément Greenberg's article praising Dubuffet's "lumpen art" in March 1949 also had a big impact. So he went with his wife Lili to spend six months in New York from November 1951 to April 1952. Here he continued to experiment and discover new materials, and also met Jackson Pollock, Léo Castelli, Marcel Duchamp, Yves Tanguy and his wife Kay Sage. He gave a memorable lecture at the Chicago Arts Club, *Anticultural Positions*, and above all pushed himself to the limit, his third such experience since living in the Sahara and investigating psychotic art. But in the end his sedentary nature and need for isolation, and doubtless also his somewhat provincial attachment to his European roots, got the better of him and the possibility of moving to America was never raised again. Thus it was that, with the exception of a few short trips in connection with exhibitions, he was never again to leave Paris other than for the Normandy coast and Provence (the latter for quite a while in fact because of Lili's bad health).

As Hubert Damish points out, from the 1950s onwards Dubuffet's vision became philosophical rather than social, and stemmed from a sort of superior sense of realism without illusions. The critical direction in which this way of looking at things led Dubuffet is particularly perceptible in his treatment of the human figure, the ever-present feature of his work, and the way these wretched, pitiful human puppets are stylized. This new direction can also be perceived in a very specific series, the *Cows*, which was created fortuitously in the summer of 1954 while Mme Dubuffet was being treated in a sanatorium for a serious lung condition.

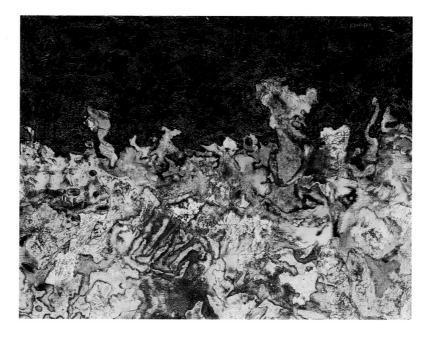

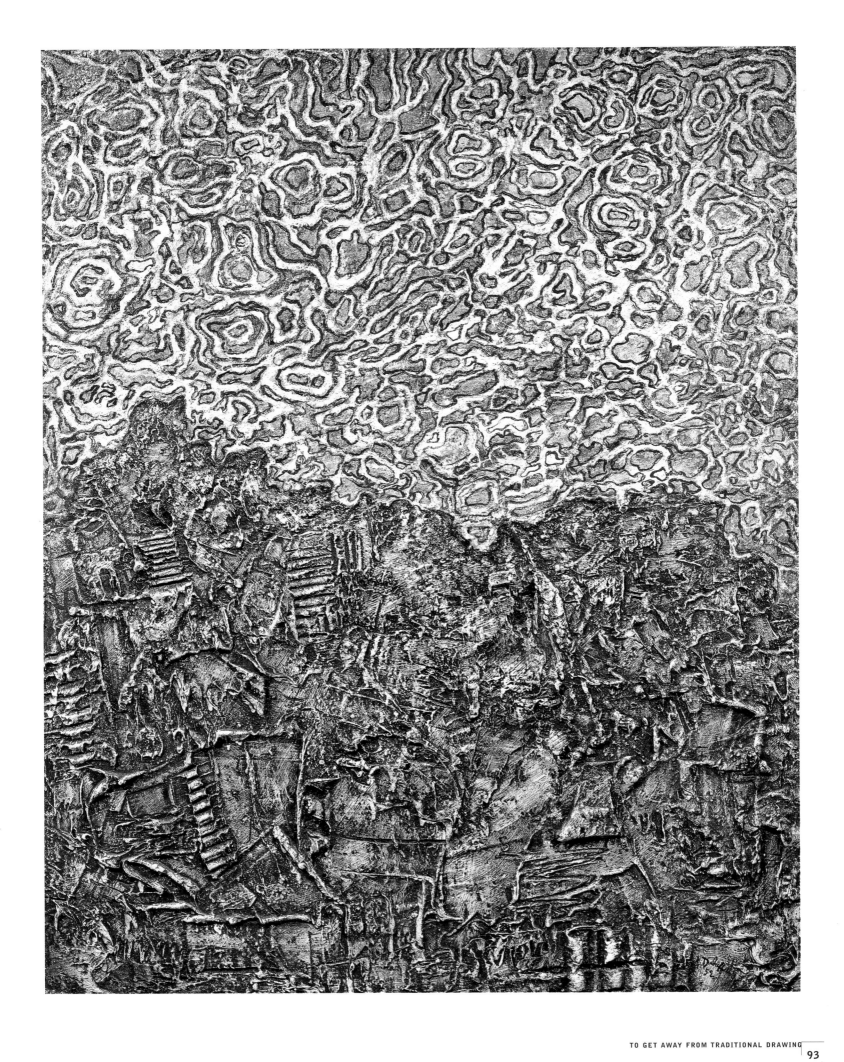

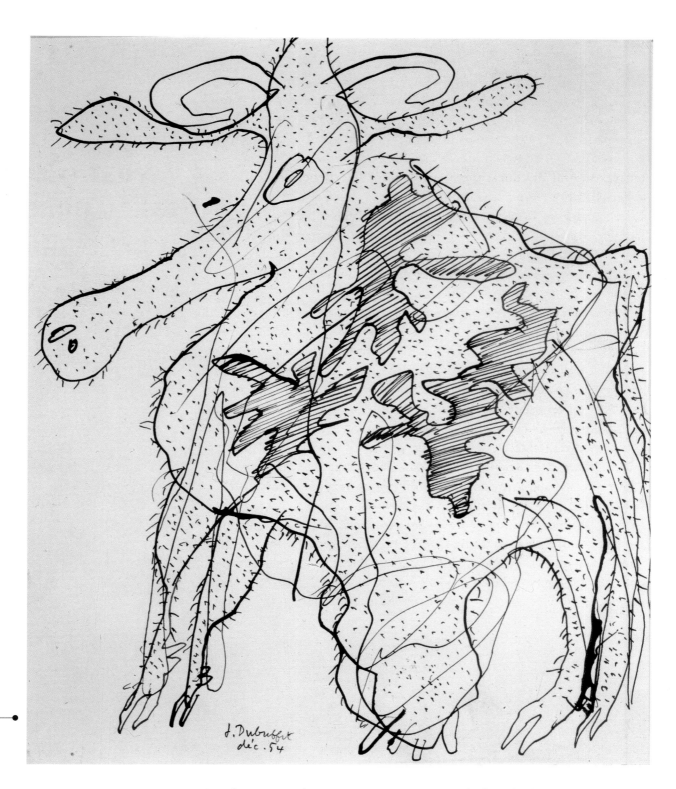

Vache aux taches déchiquetées

(Cow with ragged spots)
December 1954
Indian ink on paper
28x25 cm
Musée des Arts décoratifs, Paris

Another quite distinct series some time before had exemplified this quest for both lucid abstraction and generalization, the portraits *More Handsome Than They Think* of 1946-1947. Dubuffet had been invited to paint or draw a large group of important contemporary writers and artists, after Jean Paulhan had introduced him to the literary lunches hosted by Florence Gould. As a result he had an impressive galaxy of established or rising stars as models: Pierre Benoît, Marcel Jouhandeau, Paul Léautaud, Henri Michaux, Francis Ponge, Jules Supervielle, and the painter Fautrier. In addition to these, there was the bed-ridden poet Joë Bousquet, whom he had already visited at his home in Carcassonne.

And there was also Antonin Artaud, whom he had not only met for the first time in Rodez in September 1945 but also often met in Paris from May 1946 onwards in his capacity as treasurer of the society set up to support him. Dubuffet also painted Gaston Chaissac, the outsider artist, with whom he had just started a correspondence that was to go on for ten years. And of course there were people like René Drouin, whose gallery had housed his first exhibitions.

He worked from memory and not from live sittings, because with every face and every personality he wanted to focus on archetypal features that had struck his imagination. Dubuffet became completely absorbed by the project and the result was a series of astonishing canvases. They were exhibited at the Gallery Drouin in late 1947 (jointly with some *Pictures of the Sahara*), and the result was controversial, even if the individuals concerned were generally quite amused. Paul Léautaud alone was not; in fury he lashed out with a walking stick or umbrella, trying to destroy the appropriately entitled picture *Léautaud White Scratches*. And yet these were not strictly speaking caricatures, but rather they resulted from Dubuffet's taste for theatrical generality (the theatre, an ancient art, just like painting, being an invariable in Dubuffet's inspiration).

But it is in relation to cows that we find perhaps the most revealing comment: "I have often enjoyed turning cows into a sort of absurd Punch and Judy show, and all the features of the country, meadows, trees and suchlike, into a sort of grotesque theatre or circus clown act. This is perhaps governed by the principle of putting more and more obstacles in the way of conjuring up objects, with a view to making their appearance all the more dynamic when it happens. After all, this is also the goal that is sought – and in the best examples, achieved – in good clown acts and good theatre," ("Memo on the development of my work…", *Prospectus II*, p. 105).

"What is commonly called philosophy is art making no headway. It is art like dough that has not risen."

("The initiatic painting of Alfonso Ossorio", 1951, *Prospectus II*, p. 34)

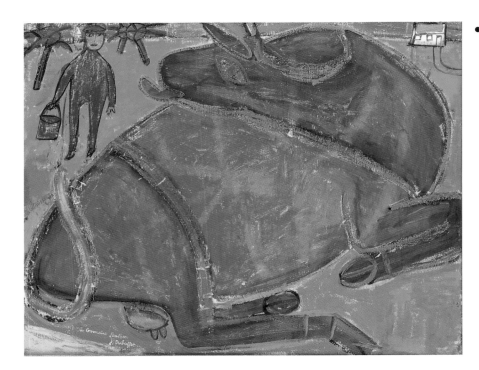

Vache rouge
(Red cow)
August 1943
Oil on canvas
65x92 cm
Private collection, Germany

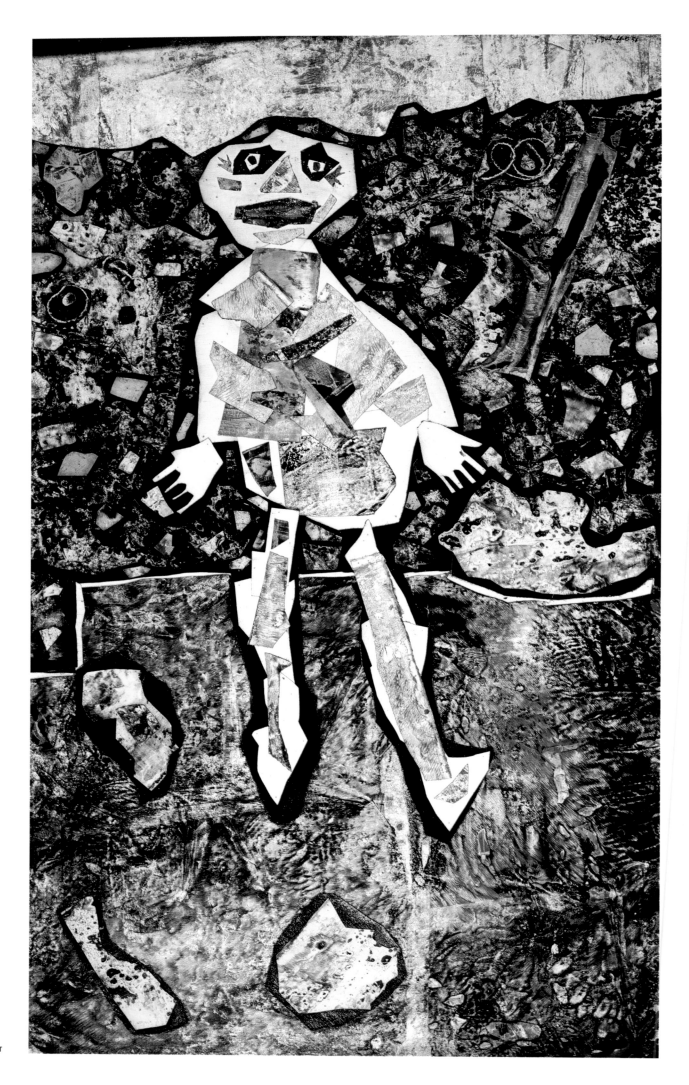

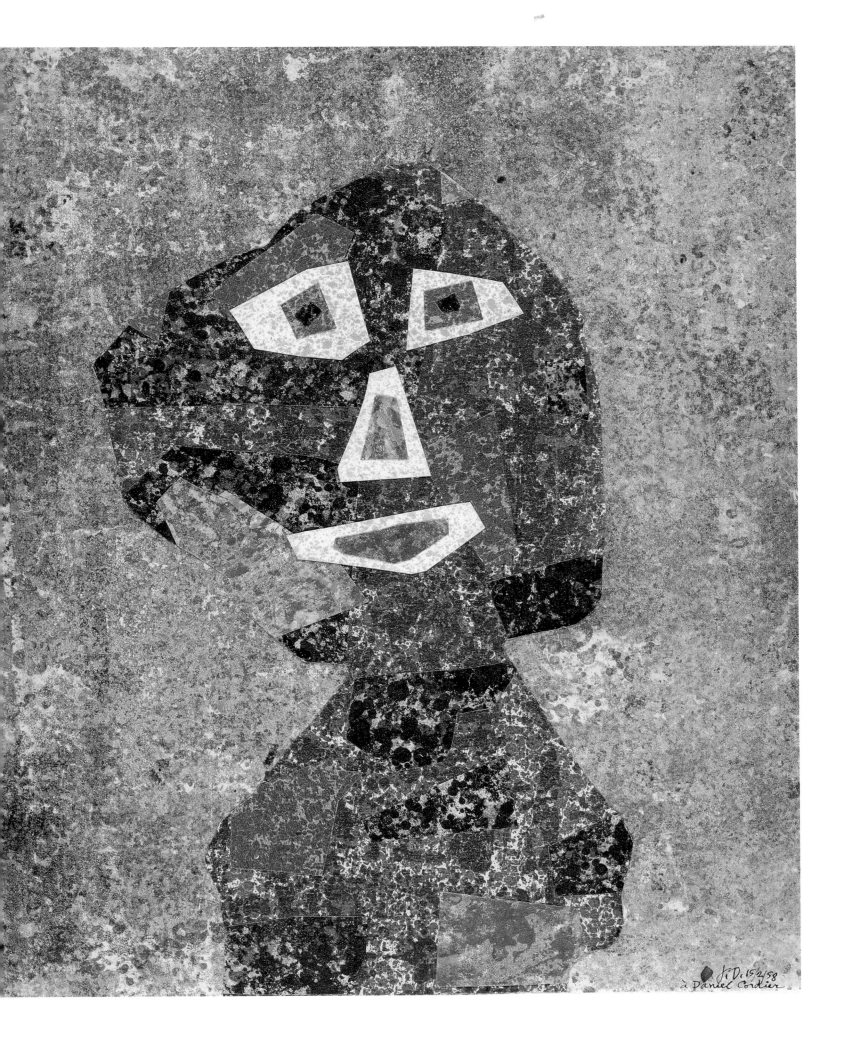

à Daniel Cordier

● **Georges Dubuffet in the garden** (page 96)

December 1955 (signed 1956)

Oil on canvas (assemblage)

155x92 cm

Private collection

● **Portrait au mur** (page 97)

(Wall portrait)

15 February 1958

Lithographic assemblage on paper

34x29 cm

MNAM - G. Pompidou Center, Paris

couleurs du personnage

1ere couleur
rose
à faire un peu plus clair
et avec moins de jaune

2e couleur
Chine jaune — bon

3e couleur
violet
à faire plus gris
(un peu plus de noir
et moins de jaune)

4e couleur
sanguine
un peu plus clair

5e couleur
bistre
mettre du rubis à la
place de vermillon
et tirer un peu plus
foncé

du vêtement

Le Guerrier et la Plaignante

(The Warrior and the Plaintiff)
21 February 1958
Lithographic assemblage
with transfers
(Try-out board)
32x41 cm
Musée des arts décoratifs, Paris

Dubuffet was as nihilistic as a Zen master, and, albeit with the greatest seriousness, he took childlike pleasure in painting the puppets of the Human Comedy: his *oeuvre* is the cast list of extras in the great clown theatre of existence. If it really had to be compared to another artistic universe of the same era, we would have to look to literature, to the theatre and to cinema more than to painting. For it is there that we find comparable masterpieces of the absurd, those of Camus, Antonioni, Fellini, Beckett, Ionesco and the like, who in a variety of ways dramatized the pitiful human adventure in the depths of meaninglessness and the void.

TABLES AND STONES OF CLAIRVOYANCE, PRINTS, CUT-OUTS AND ASSEMBLAGES

Let us remind ourselves of the way in which Hermann Rorschach (1884-1922), the inventor of the famous inkblot projective test between 1918 and 1921, suddenly got the idea for his technique. This is Didier Anzieu's account: "Rorschach […], wrote his wife, was stupefied one day when they were reading the Russian author Dmitri Merejkowsky's work on Leonardo da Vinci together. It was on coming to an extract from Boltraffio's journal in which the latter recounted how one evening he came across his master in the rain, lost in contemplation before a wall with patches of damp on it. Leonardo pointed out to him the profile of a splendid chimaera with gaping jaws, surmounted by a benign, curly-haired angel. He went on to tell Boltraffio that he often happened to see beautiful landscapes and scenes in cracks in walls, in the ripples on the surface of water at low tide, in cinders powdered with ash and in cloud shapes, and how the sound of a distant bell could call to mind a familiar name or word. In another passage Leonardo gave Botticelli the credit for this idea. Frau Rorschach then told her husband that when she was a girl, she and her friends loved to look at the clouds and imagine shapes. At this her husband sank into deep thought." (Didier Anzieu, *Les Méthodes projectives*, P.U.F, p. 41).

What is less well known is that the very same psychiatrist was the son of a painter, a drawing teacher in Zurich, and was talented enough to have actually pondered for a long time whether to take up a career in art himself. Victor Hugo's experiments with wash drawings are well known about of course, as is Baudelaire's fascination with clouds. The relationship between art and the phenomena of clairvoyance and hallucination has been the subject of much study, as a result of which a lot is now known about the mechanisms of what we call the imagination.

Starting with the series entitled *Landscaped Tables, Landscapes of the Mind* and *Stones of Philosophy* (1951-1952) and throughout the whole of the period culminating in the *Phenomena* and *Materiologies* – just before *Paris-Circus* and then the *Hourloupe* – something new emerges in Jean Dubuffet's art. Rather as in the manner of Rorschach blots, his pictures are a quest for a new type of representation, even further away from traditional painting than graffiti or children's art, and sometimes seem to come close to a process of free mental association of images, virtually like controlled hallucinations. This period corresponds with a change in his "humors", to use his

refined term, when he had had enough of outsider art for the time being and went off to study Alfonso Ossario's wax paintings and Jackson Pollock's cut-outs and action painting. Dubuffet changed his techniques and tools, thanks to the development of extremely hard synthetic resins (pierrolin and sparkel), which made all manner of new engraving and incising processes possible. At the same time as this, beginning with his first butterfly wing collages, and then his fascination with the infinite possibilities of assemblage, he ventured even further by perfecting lithographic techniques for combining transfers and assemblage.

At first it seemed that Dubuffet was attaining a sort of modern equivalent of the ancient cave dweller's attitude when contemplating the unevenness of a rock surface or the knots in a piece of wood from which

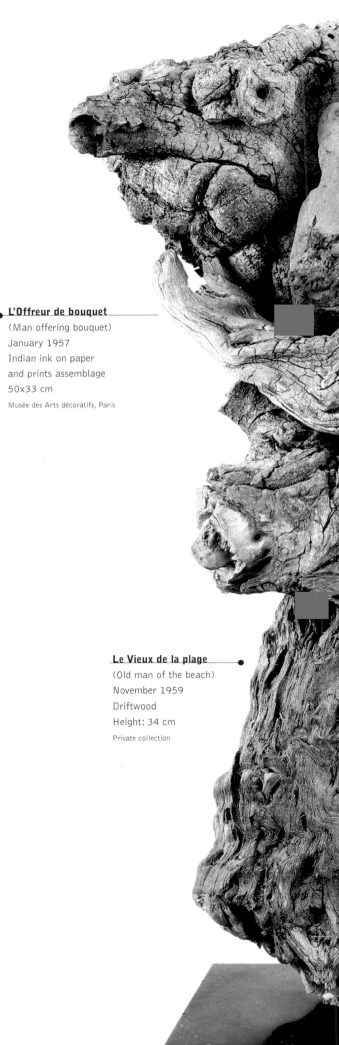

L'Offreur de bouquet
(Man offering bouquet)
January 1957
Indian ink on paper
and prints assemblage
50x33 cm
Musée des Arts décoratifs, Paris

Le Vieux de la plage
(Old man of the beach)
November 1959
Driftwood
Height: 34 cm
Private collection

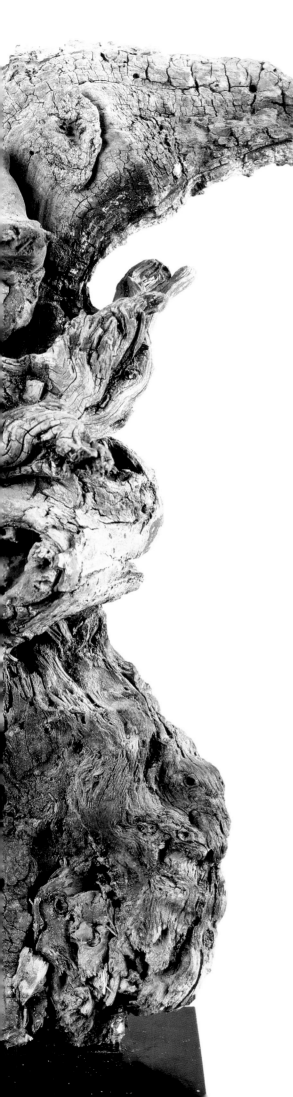

he will fashion a staff, namely that state of receptiveness in which the sub-conscious appears to submit spontaneously to what is suggested by the raw material. It then becomes a matter of just going along with the obvious – or perhaps bringing out something more, something in which one can perhaps trace an intention, the face of an old man or a sorcerer here, the head of a devil or a frog there, a battle of Titans or procession of nymphs, etc. Child psychologists tell us that of all shapes it is the structure of the face that is the first one to be formed in the brain. Little surprise then that in Dubuffet's new phase of painting, the face or the human body is far and away the dominant represented subject, apart from a few animals.

As with a great number of contemporary artists, it would thus appear that what Dubuffet did at this stage copies in reverse the whole evolution of art from the first cave paintings to the invention of perspective and consequent advances in realism. Moving even further away from an illusionist representational style, Dubuffet ended up creating an art more appropriate to divination than to illustration. The vagaries of the materials contribute to this art, where suggestivity sometimes counts for more than precision, enabling us to make out, dimly, a range of vaguely sketched and deliberately ambiguous figures and shapes, as fleeting and illusory as in a mirage. They are just so many ephemeral specters coming and going on the limit of our perception, existing on the boundary between being and non-being, the which state was to become one of the major concerns of Dubuffet in his declining years.

"Between being and not being there are many different stages" was what one could read as early as 1946 in the "Notes for the Well Read" (*Prospectus I*, p.81), and indeed Dubuffet was constantly at pains to spread confusion, and create ambiguity and multiple levels of interpretation: he took a malevolent pleasure in this, and on a number of occasions described himself as a "mediaeval occultist" or "weary magician" ("The Painter's Notes", 1953, *Prospectus II*, pp. 439-440). He also had this to say: "I believe that the most fruitful discoveries come not from creating images but from interpreting them. And I also believe that this faculty of seeing deep within images can be learned by anyone, and that whosoever aspires to be creative would be

**Jean Dubuffet
and Asger Jorn:
Musical experiments**
Early 1961

well advised to cultivate it at least as much as his manual skills." ("Notes on transfer assemblage lithos and on the continuation of the *Phenomena*", January 1962, *Prospectus II*, p. 174). With a minimum of training on the part of the onlooker, even the most "non-formal" picture can stimulate this faculty of clairvoyance; whatever its degree of "abstraction", painting is transformed into a source of revelation for its author as much as for his public. For it is practically impossible to remain purely non-formal without the mind sooner or later projecting or hallucinating some form, perhaps just two eyes or a vague expression; or else the painter's hand succumbs to the frantic urge to outline something with a pointed object, pallet knife or brush, anything in fact, in the same way that others do drawings in the sand or put chalk marks on a sidewalk.

It was only when all the possibilities of these techniques were exhausted and he had tired of them that Dubuffet found a way of renewing himself: he would give up drawing and try his hand at assemblage, which, as we have seen, he learnt at the end of 1953 from watching Pierre Bettencourt make collages. As in everything he was to turn his hand to, this was a medium that he was to experiment in radically. He did not cut and glue pre-existing materials, which he did only with his butterfly wings and a few fine botanical collages, but instead used specially designed pieces of canvas. To this he added another replacement for drawing and figurative processes, namely print, produced by tools, moulds, fabrics, botanical specimens, etc. This provided him with an inexhaustible variety of printing formulae (and no more anguish about "what to draw?"), that he was to exploit feverishly in every imaginable way, culminating in an ultimate period of delirious creation, lithography.

Coinciding with this change of direction, Dubuffet had a big retrospective exhibition in Paris, covering everything he had done up till March 1954, organized by René Drouin at the Cercle Volney. Dubuffet had practically exhibited nothing in Paris for seven years (since the *Portraits* series at the Gallery Drouin in October 1947), and now had one hundred and ninety-three works on show. But suddenly there was a bolt from the blue: Lili was discovered to have a serious lung condition and had to be hospitalized for five months in a sanatorium at Durtol near Clermont-Ferrand. It was while he was there with her during the summer of 1954, suddenly with some time on his hands, that Dubuffet painted the *Cows* series. And he decided to go in for a major change of existence as soon as Lili got out of the sanatorium. They would leave Paris and go to live in Vence, where the climate of the Côte d'Azur would help her to recuperate.

At first they rented a house, "Les Roures" ("The Oaks"), and then had their own spacious place built, "le Vortex", together with a studio complex "L'Ubac" (an "ubac" is the shady side of a mountain), containing a set of five workshops. To begin with the couple spent more or less three complete years in Vence, from January 1955 to December 1957, at which point Lili was completely cured. Then for the next ten years they had a seasonal pattern to their life: usually the summer in Vence, and the

Claire eau de barbe
(Clear Beard Water)
June 1959
Assemblage and oil on paper
mounted on canvas
77x57 cm
Hamburg Kunsthalle, Hamburg

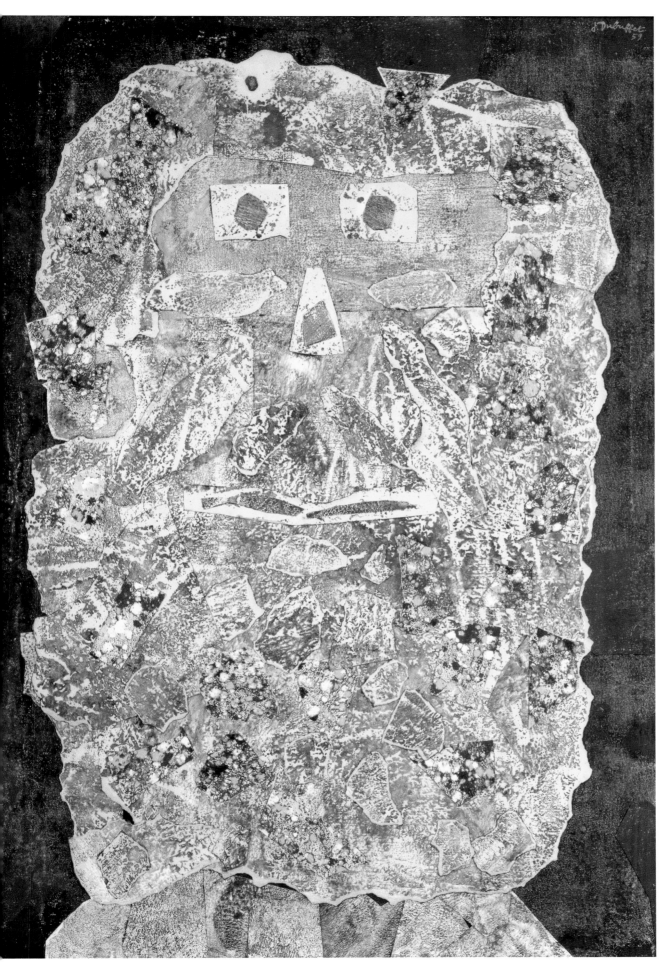

Little Statues
of Precarious Life:
The Maestro —————————•
May 1954
Sponge
Height: 43 cm
Private collection

Le Dépenaillé —————————•
(The raggedy Man)
April 1954
Furnace clinker
Height: 77 cm
Museum of Modern Art, New York

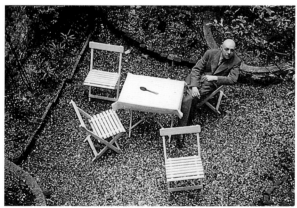

**Jean Dubuffet in the garden
of his house, rue de Vaugirard, Paris**
Between 1948 and 1952

winter in Paris. So it was in Provence that Dubuffet, after a first series of *Print Assemblages* dating from 1953-54, threw himself feverishly into exploring his new universe: "Mountain Vegetations", "Nooks in Gardens Run Wild", "Bare Ground of Metalled Roads", and similar titles, such as "Stony Sites with Miserable Vegetation" ("Biography…", *Prospectus IV*, p.502 and 505), from which he derived his series, *Carts, Gardens, Monolithic Characters* (1955), his *Assemblage* pictures (1955-1957) and his long series *Celebration of the Ground* (1957-1959). The latter will lead him to the experiments on the limit of what is possible, *Texturologies, Topographies, Materiologies* and *Phenomena,* inspired by feverish labors with lithography carried out in Vence or in his new Paris studio in the rue de Rennes.

This is about the time that Dubuffet's work began to sell in France. Since 1947, when he sold his shares in the Bercy wine company, Dubuffet could not live from his art alone. But as a shrewd business man he devised an original way of selling his work by holding an annual double sale in his studio, the purchasers being Pierre Matisse for the American rights alongside whoever was his French dealer at the time.

"Every existing thing exists immensely profusely, it is to be found everywhere, it is abundant in yourself. Genius, the gift of creativity, is as common as carbon and hydrogen, and no human being is without it."

(Letter to Philippe Dereux, 16 March 1956, *Prospectus IV*, p. 155)

In succession, the latter were René Drouin (1944-1946), Michel Tapié (1947-1953), then Drouin again (1953-1954), Augustinci (1954-1958) and Pollock and Ossorio's dealer, Facchetti (for a few months in 1958). Each in turn selected a picture, the first to choose being drawn by lot. Then from January 1960 Daniel Cordier took over for both countries, as Dubuffet had quarreled with Matisse, accusing him of hoarding his pictures instead of exhibiting them. Via his assemblages the painter in his Vence exile established a formal link with a long established twentieth century tradition, but, once again, his collages were quite different from those of the artists that preceded him, the Cubists, the Surrealists, Max Ernst, the Dadaists. And in contradistinction to the trite use also made of it by certain writers and poets like Prévert, he appropriated the medium in a totally original way and made it his own. The first difference is that his basic materials were painted or made by himself, not cut in the usual manner from a pre-existing source such as newspapers, magazines and photographs, hence the relationship with painting and lithography was not broken. These

La Mer de peau
(Sea of skin)
December 1959
Botanical items
(blue agave) stuck on hardboard
55x46 cm
MNAM - G. Pompidou Center, Paris

**Terre pourpre
(Texturologies)**
(Crimson earth)
18 December 1958
gouache on paper
41x54 cm
MNAM - G. Pompidou Center, Paris

Terrain terreux
(Earthy land)
(plate 1 from the album
"L'Arpenteur" (The Surveyor),
"Phenomena" series)
September 1958
Four color lithography
on hand-made
Arches vellum
Published 1960, 30x38 cm
MNAM - G. Pompidou Center, Paris

Following page:

Nez carotte

(Carrot nose)

April 1961

Four color lithography

with assemblage transfer

Published 1962

60x38 cm

MNAM - G. Pompidou Center, Paris

"When I get to be president I'll change a lot of things, and straight off I'll set about making life poorer and simpler. I'll do away with television, I'll do away with automobiles, I'll do away with practically everything."

(Letter to Remi Messer, 21 November 1973, *Prospectus IV*, p. 333)

Vire-volte

(Circling)

31 may 1961

Oil on canvas

97x130 cm

Private collection

preliminary experiments were eventually continued for their own sake and assumed an independent existence, so to speak, in the *Phenomena*. The first point of interest with assemblage of course is that no drawing is involved: like children in primary school the artist just has to cut and paste. The scissors make the figure and the composition. But Dubuffet also immediately discovered the infinite range of permutations made possible by assembling pre-formed units, and he was alive above all to the possibility of creating composite "organisms" that were much more complex than anything he had done before. Jean Dubuffet's dealer at the time was the owner of the Rive Gauche gallery who had among his customers the collector Jacques Ulmann, who happened to be a shoe manufacturer. It was Ulmann who supplied Dubuffet with the glue that enabled him to perfect his technique. There were four phases involved: making the painted material, cutting it up, fixing the pieces to the canvas with pins, followed by the gluing process. It was a delicate operation, for which help from one of Dubuffet's neighbors, a retired policeman, was more than welcome!

It was especially in the ground and land studies making up the *Assemblage Pictures* of 1955-1957 and the *Celebrations of the Ground* and *Topographies* series of 1957-1959 that the effectiveness of this new technique was most striking. It became almost a fundamental part of Dubuffet's approach to painting from that moment onwards, and he had recourse to it regularly from the *Print Assemblages* of 1953-1954 to the *Theatres of Memory* of 1975 to 1979 or the *Sites with Figurines* of 1980-1981, nearly thirty years later. It is also a particularly pleasing feature of the *Little Statues of Precarious Life*, those moving little assemblages of furnace clinker, cleaning pads, sponge and charcoal made after a trip Dubuffet made to the Morvan region with Alexandre Vialatte in 1954. And we find it again in 1959 in the very fine *Botanical Elements*, which are portraits and landscapes made out of vegetal matter stuck on canvas.

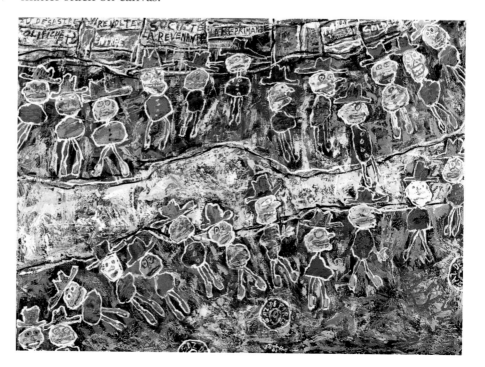

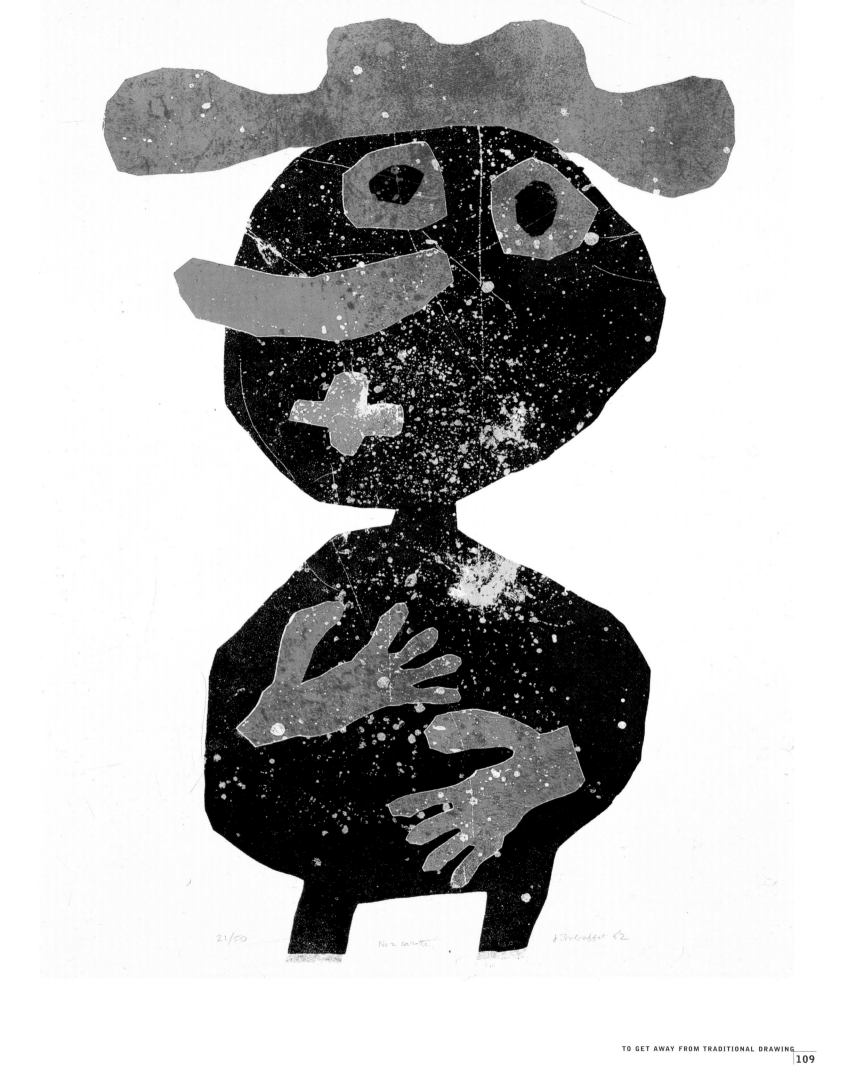

21/50 Nez carotte J Dubuffet 52

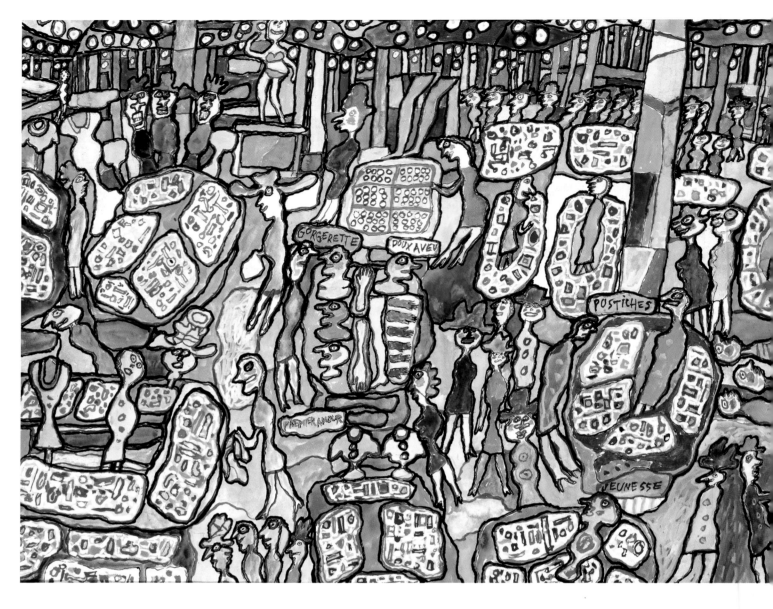

Galeries Lafayette

8 May 1961

Gouache on paper

49x66 cm

Musée des Arts décoratifs, Paris

Jean Dubuffet 's style was increasingly complex, inscrutable and technically refined and yet still respected the raw essence of the natural materials. It was enhanced more and more by a range of new possibilities – incision and scraping, thick impastos and high relief, printing and assemblage – culminating eventually in a magnificent impasse, experimentation with pure matter, from which all figurative design, even projective or hallucinatory, was absent. This was the time of the lithographic series *Phenomena* (1958-1963) and the exuberance of the *Materiologies* (1959-60) using "panels sometimes reinforced with wire mesh, liquid plastic, papier mâché and other materials such as screwed up tinfoil or mica granules which bricklayers use for making light cement" (*Prospectus IV*, p.505-506).

Coinciding with this abstruse alchemy, on which this "dehumanizing" and "non-interventionist" mode of Dubuffet's ends, mention must be made of some strange musical experiments, even if they are only marginal to the art. These began in December 1960 in collaboration with Asger Jorn, an ex-member of the Cobra group and resulted in the creation of the incantatory poem *La Fleur de Barbe* (beardflower), a "drunkard's psalmody accompanied by the yapping of a dog, animal snorts and other unusual music" ("Biography", *Prospectus IV*, p. 505 and 508). This activity stemmed from

experiments with sound and was similar to concrete music, yet it cannot strictly be termed music as it is once again an assemblage, in this case acoustic material produced by a variety of utensils and instruments, recorded by Dubuffet and then sound mixed in different ways.

This *Barbes* series, "pictures of faces with a texturology hanging from the chin", a playful response to a letter from Georges Limbour calling his friend, who had just become a member of the College of Pataphysics, a "stoic sage", was to be exhibited in the Daniel Cordier gallery at the end of 1960. But the big event of the time was the major retrospective organized by François Mathey at the Musée des Arts décoratifs, in the Pavillon de Marsan from December 1960 to February 1961, showing four hundred of Dubuffet's works for the first time in Paris. A similar retrospective was held a year later at the Museum of Modern Art in New York.

And then came the abrupt about-turn represented by *Paris-Circus*: in returning to the themes of the street, shops, automobiles, crowds, Dubuffet the artist of matter emerged once and for all, on coming back to the capital, from his absorption in the chemistry of textures. This is how the author in his *Biography* was to explain this sudden return to the objects and bright colors of his early years: "After allowing myself to be obsessed for such a long time with the vegetation around Vence, and the surfaces of tracks and roadways, and the haunting atmosphere of places void of human beings, I found myself possessed by the opposite urge once I was back in Paris: I wanted to get back to the festive rituals of city streets, which I had drifted further and further away from over the years and ceased to celebrate." (*Prospectus IV*, p. 508). Once again, constructing his work like a book, the painter turned the page and began a new chapter. But a return to earlier themes seemed this time to be purely a pretext and transitional, as we see from the increasingly fragmented surfaces of the pictures and their resemblance to jigsaw puzzles. What we have now is a bizarre mitosis, a cell-division, of the objects on the canvas anticipating the *Hourloupe*, and the rhythm and progression of which could be clearly followed if we could see the whole of the production of this period in fast-forward mode.

"Taking my bear to dance in all the fairgrounds doesn't seem dignified to me. I prefer my exhibitions to happen not too often, and for them to be just rare and isolated little celebrations."

(Letter to Giuseppe Raimondi, 16 December 1959,
Prospectus IV, p. 632)

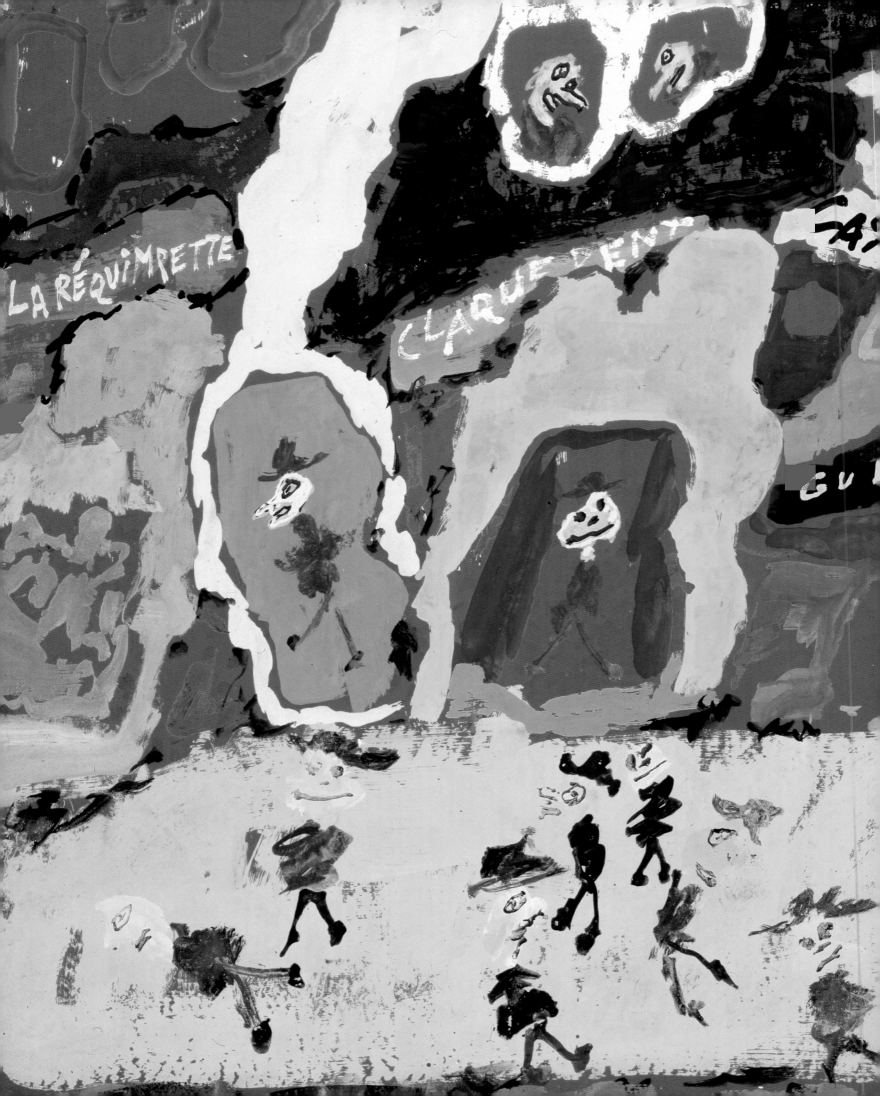

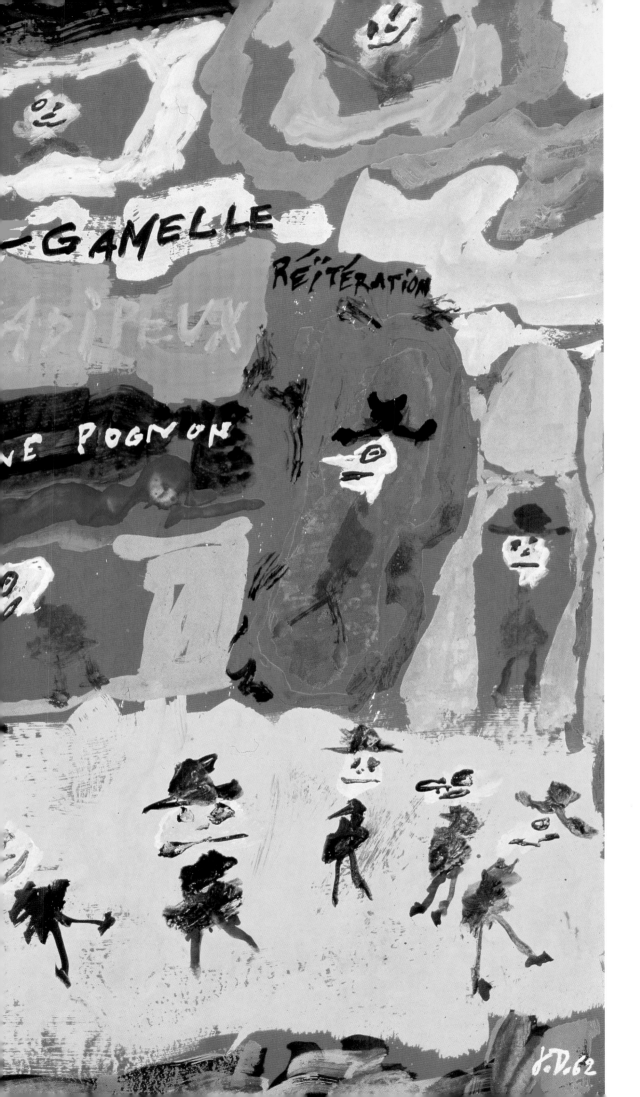

Casse gamelle
7 June 1962
Gouache on paper
50x67 cm
Musée des Arts décoratifs, Paris

> ## "Really inventive works of art are rare – just as rare in psychiatric hospitals as outside. The international fashion for encouraging the sick to produce art never results in interesting work and most exhibitions of such pictures are distressingly poor."
>
> (Letter to Dr Mario Berta, 17 September 1972, *Prospectus IV*, p. 327)

Dubuffet and l'Art Brut

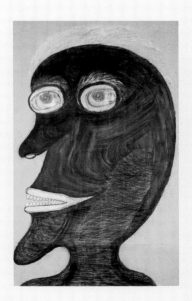

Adolf Wölfli (1864-1930)
The Ballroom of Saint Adolf
1916
Colored crayons on paper
100x63 cm
Collection de l'art brut, Lausanne

Heinrich-Anton Müller (1865-1930)
Man with drip on his nose
Between 1917 and 1922
Carpenter's pencil and chalk
on wrapping paper
75.4x45 cm
Collection de l'art brut, Lausanne

The definitions of outsider art – the original French term "*l'art brut*" appeared for the first time in a letter to René Auberjonois dated 28 August 1945 – are plentiful and have evolved over the course of time. "What is meant by this," wrote Dubuffet in *Art brut in Preference to the Cultural Arts* in October 1949, "is work made by people without any formal artistic culture, work in which mimeticism, unlike what happens with intellectuals, plays little or no part. So the creators of this work derive everything (subjects, choice of materials employed, means of transposition, rhythms, ways of writing, etc.) from within themselves and not from the conventions of classical art or fashionable contemporary art. So what we see is totally pure artistic activity, raw, reinvented throughout every entire phase by its author just according to his own impulses and nothing else. In other words art in which invention alone is in operation, and not, as always in mainstream art, the modes of the chameleon and the monkey." (*Prospectus I*, p. 201-202). Elsewhere the painter spoke of "all manner of work, drawing, painting, embroidery, carved or modeled figures, etc, of an extremely spontaneous and inventive nature, and owing as little as possible to traditional art and cultural platitudes; the creators of it are obscure and unknown, from outside professional artistic circles." (Note on "The *Art Brut* Company", written in January 1963 updating a text of September 1948, *Prospectus I*, p. 167). "It's only in that "outsider art" that I believe you find the natural and normal pro-

cesses of artistic creation in their elementary and pure state. It's watching that process that seems to me fascinating, [...] a hasty little sketch often seems to me to have an infinitely greater content and meaning than most grandiose canvases which are so often completely empty and fill up so many museums and art galleries", ("All Honor to savage values", *Prospectus I*, p. 215).

It was at the beginning of the thick impasto period that Jean Dubuffet and a few friends began a systematic search for creative work produced in psychiatric hospitals. He went with Jean Paulhan and Le Corbusier to Switzerland for a few weeks in 1945 (5-22 July) and returned there in December of the same year, followed by further visits in the next years. They inspected the collections of work in the institutions, first at the famous Waldau University Clinic in Bern, then Doctor Ladame's "little museum of madness" at Bel-Air near Geneva, next the La Rosière asylum in Gimel near Lausanne, and finally the penitentiary center in Basle a few years later. Dubuffet discovered some of what were to become the "classics" of outsider art: Adolf Wölfli's unending illustrated musical scores; the mad inventor Heinrich-Anton Müller's pictures and impossible machines, which will inspire Tinguely's kinetic sculpture; Aloïse Corbaz – "Aloïse" – who had to hide in the toilets when she first started drawing, and an artist criminal, Joseph Giavarini, known as the "prisoner of Basle", who made sculpture out of bread crumbs. Back in France the psychiatrist Gaston Ferdière put him in touch with Auguste Forestier, a sculptor confined in Saint-Alban-sur-Limagnole, whose work was collected by Paul Eluard and also an artist suffering from paranoia, Guillaume Pujolle, who used stolen medicine to paint watercolors.

In 1946 Paulhan drew his friend's attention to Gaston Chaissac, a cobbler painter, who lived as a recluse in a little village in the Vendée and was the author of astonishing letters. Dubuffet began a friendly correspondence with Chaissac that they kept up regularly for nearly ten years, and he acquired a number of his works for his *art brut* collection until the beginning of the 1950s. The following year René Drouin provided the premises for what was first known as the Art Brut Center (le Foyer de l'Art Brut) and officially opened in the basement of his Place Vendôme gallery on 15 November, 1947. The collection contained drawings by Aloïse, work by Joseph Crépin, a spiritualist painter discovered by Dubuffet and introduced by him to André Breton, cement medallions by the inn-keeper Salingardes, a few canvases by a Spanish anarchist Miguel Hernandez, and a hundred or so anthropomorphic flints by prince Juritzki, alias Juva.

After this it became possible to form a society, the Art Brut Center, whose existence was announced on 11 October 1948; it included all the sympathetic spirits in the artistic and literary world, such as Jean Paulhan, Charles Ratton, Henry-Pierre Roché and Michel Tapié. André Breton, whom Dubuffet had met in the spring of that year, was also one of the founder members; it was he who told Dubuffet about the seashell masks of Maisonneuve, a rebellious Bordeaux junk shop dealer and the pen and ink drawings of Scottie Wilson, a small time shady dealer who had become the darling of the London Surrealist milieu.

Heinrich-Anton Müller
Machine
(destroyed by order
of the hospital director)
Between 1917 and 1922
Collection de l'art brut, Lausanne

Heinrich-Anton Müller
Man with flies and snake
Between 1925 and 1927
Colored crayons
on drawing paper
Collection de l'art brut, Lausanne

In the course of time the collection took on a new dimension and the Gallimard publishing firm lent a house for it in the rue de l'Université from September 1948 onwards. The outsider art center moved in, complete with an employee in charge, a Croat painter called Slavko Kopac. The initial collection was supplemented by Joachim Vicens Gironella's cork sculptures, Adolf Wölfli's great drawings and some embroidered work by Jeanne Tripier. When René Drouin organized the first collective exhibition in October 1949 over two hundred works by sixty-three artists were on display. It was on the occasion of this exhibition, which was visited by such a variety of public figures as Francis Ponge, Henri Michaux, Victor Brauner, Tristan Tzara, Joan Miro, André Malraux, and Claude Lévi-Strauss, that Dubuffet launched his famous manifesto *Art Brut in Preference to the Cultural Arts*.

In September 1950, Dubuffet the painter of the *Ladies' Bodies* series finally visited Heidelberg University's psychiatric clinic, which housed the famous Prinzhorn collection, the only comparable undertaking that existed before his own. Shortly afterwards, in January 1951, he gave a lecture in the Arts Faculty of Lille University entitled *All Honor to Savage Values* in homage to "five little inventors of painting", all patients of Dr Paul Bernard of Saint-André-Lez-Lille.

It was in this context that Dubuffet received an invitation from his friend Alfonso Ossorio: that he and his wife should go and live with Ossorio in

Aloïse Corbaz (1886-1964)
Untitled
1943
Colored crayons
and toothpaste on paper
59.5x42 cm
Collection de l'art brut, Lausanne

Pascal-Désir Maisonneuve (1863-1934)
Circa 1927-1928
Exotic seashell assemblage
Height: 42 cm
Collection de l'art brut, Lausanne

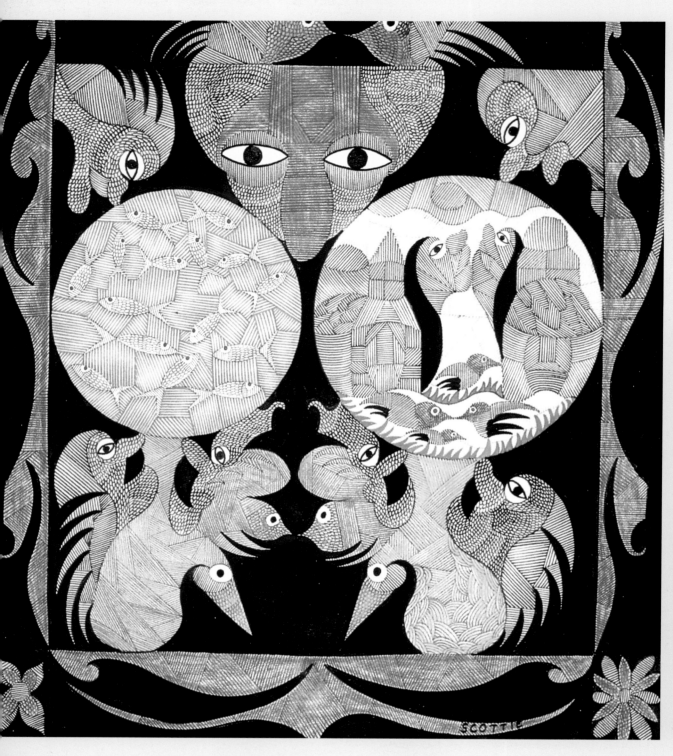

"There is no more an art of the insane than there is an art of dyspeptics or of those with knee problems."

("*Art brut* in Preference to the Cultural Arts", October 1949, *Prospectus I*, p. 202)

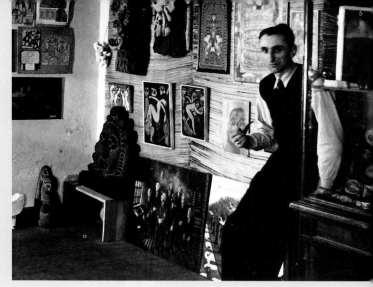

the luxurious house that he was in the process of fitting out in East Hampton, near New York. Dubuffet's own painting was better appreciated in the States than in France, and Ossorio offered to house the outsider art collections, which could not be accommodated for ever in the premises lent by Gallimard. Dubuffet immediately imagined that there were further *art brut* discoveries waiting to be made across the Atlantic, and accepted Ossorio's offer. André Breton resigned, the Company was dissolved, and the collection was crated up to accompany Dubuffet to America, where it was to remain in a sort of exile for more than eleven years.

For some time Dubuffet appeared to become lukewarm about his collection, and it was only when he moved to Vence in 1955 that, thanks to Alphonse Chave, he collected it again, and the result was an exhibition in the Les Mages gallery in August-September 1959. At this time too, directly influenced by the collages of botanical matter in which he had been involved, Philippe Dereux began to make art from peelings: pictures made entirely from fruit and vegetable peel. It was the return of the collections to France in 1962, shortly before the birth of the *Hourloupe*, that allowed the Art Brut Center to be reformed and reactivated. This time it was housed in a four story building in the rue de Sèvres, constituted as an institute and museum with Slavko Kopac as curator. Dubuffet meanwhile had recently acquired three hundred and ninety mediumistic drawings by the postman artist Lonné, the whole of the spiritualist output of Laure Pigeon, drawings by Pujolle, the notebooks of Charles Jauffret, and especially the first and historic canvas painted by Augustin Lesage in 1912-1913. He was thus able to achieve an aim he had had for a long time, publishing a series of short monographs on the creators of outsider art, with most of them written by himself.

From this point on, the movement gathered its own momentum, after the initial impetus provided by Dubuffet. Fresh sources and donations of work accumulated, and when an inventory was drawn up in 1971 an updated catalog listed more than four thousand works by a hundred and thirty-five artists. This was not counting several thousand others, which were considered marginal, half way between outsider art and the conventional sort. They were cataloged as an "Annex Collection" and then rebaptized "Fresh Invention" eleven years later in 1982. It was at the time of the major cataloging exercise, in 1971, that Dubuffet announced his intention of donating the collection. After turning down several unsatisfactory offers, Dubuffet finally chose Switzerland, the historic site of his early search for outsider art, and which had the advantage of offering a measure of provincial tranquility, far from the cosmopolitan hustle and bustle of Paris. Negotiations went on with the city of Lausanne, which undertook to provide and equip an eighteenth century mansion, the Château de Beaulieu; a charter setting out the terms of the donation was duly signed on 13 July 1971. The Art Brut Center was dissolved for the second time, and the works were transferred to Switzerland some time after. On 26 February 1976 the "Art Brut Collection" was finally inaugurated in Lausanne, to be curated for the next twenty-five years by Michel Thévoz, with the assistance of Geneviève Roulin. Michel Thévoz

Michel Tapié

in the Art Brut Center
René Drouin gallery,
17 place Vendôme, Paris
End of 1947, early 1948
Loaned by Musée de l'abbaye de Sainte-Croix
Les Sables-d'Olonne

Fatima Haddad, known as Baya (1931-1998)

Woman in yellow dress
Circa 1947
Gouache on stiff cardboard
63x48 cm
Collection de l'art brut, Lausanne

was an art critic and philosopher, and author of the first comprehensive study of outsider art to be published in France.

The history of all the developments of outsider art since the end of the 1970s to the present day is strictly speaking a separate matter from Jean Dubuffet's destiny and is already part of what came after him. Parallel collections, new museums, festivals and even fairs are to be found in various places, promoting the most extreme or eccentric types of contemporary folk art. Examples are La Fabuloserie, opened in 1983 at Dicy in the department of Yonne to display the inventions of the architect Alain Bourbonnais; the Aracine museum opened in 1984 in Neuilly-sur-Marne and now linked to the Musée of Villeneuve d'Ascq; the Site of Free Creation (Création Franche), opened in 1989 in Bègles in the south-west, and dedicated to the work of self-taught artists in all its forms. An outsider art market including everything associated with it developed in the United States, boosted by a specialist magazine *Raw Vision*, launched in London in 1989, and there is an Outsider Art Fair in New York in January every year since 1993. None of these activities would be what they are today, if it had not been for the enormous energy expended by Jean Dubuffet between 1945 and 1976 on discovering, displaying and conserving *art brut*.

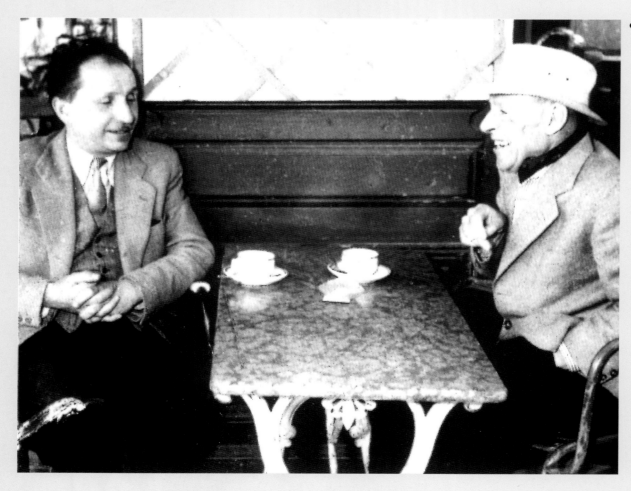

● **Jean Dubuffet**
At coffee time
with the gallery owner
Alphonse Chave,
in Vence, circa 1959

Augustin Lesage
(1876-1954)

Symbolic composition
on the spiritual world
1925
oil on canvas
205x145 cm

Collection de l'Art Brut, Lausanne

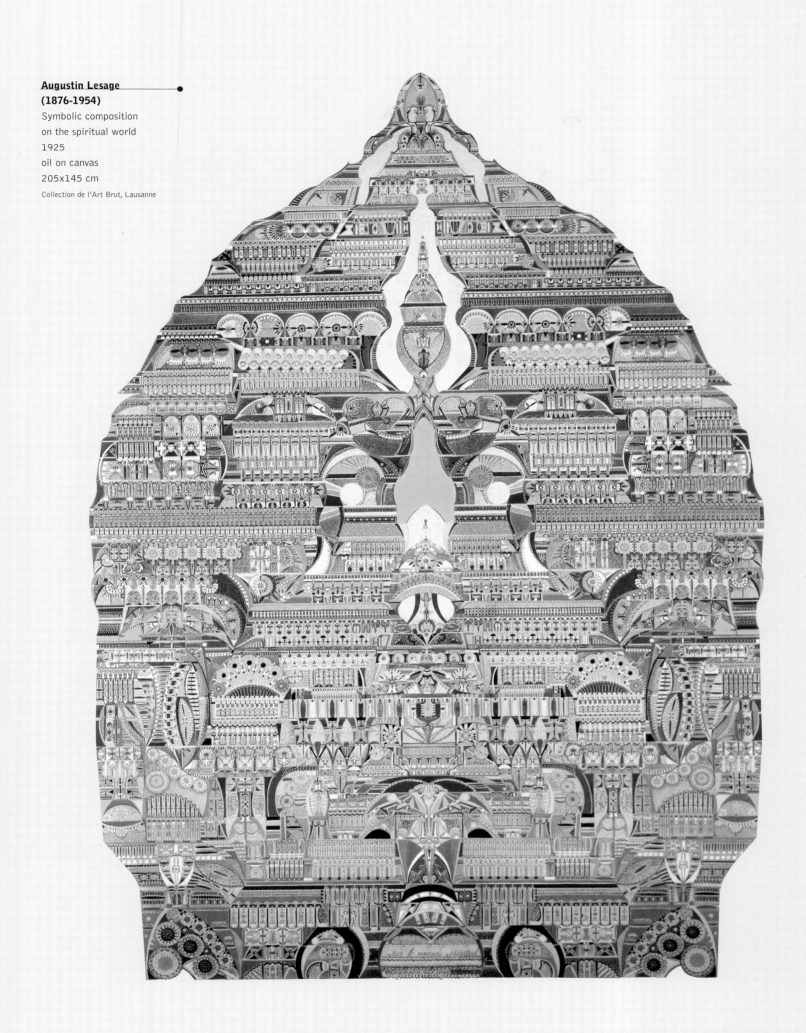

"It's the direction in which you walk that is efficient, it's the tendency, the posture. As for what lies at the end of the road, just don't worry about it. There is no end of the road, no end that you ever reach."

Jean Dubuffet, "Asphyxiating culture" (1968), *Prospectus III*, p. 69

Dubuffet Exhibition preview
Museum Of Modern Art,
New York
19 February 1962

4 From the *Hourloupe* to the *Non-lieux*: painting or metaphysics?

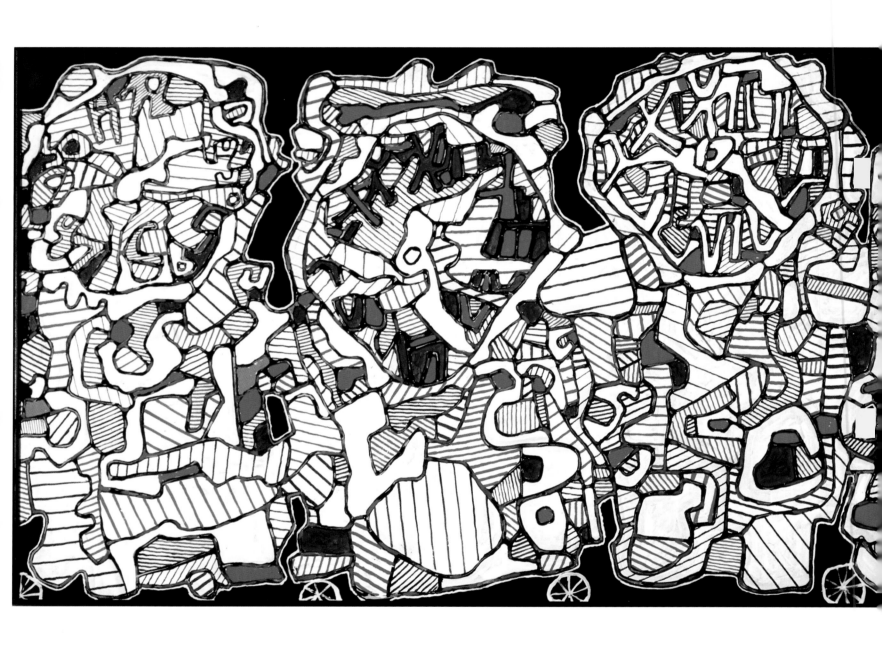

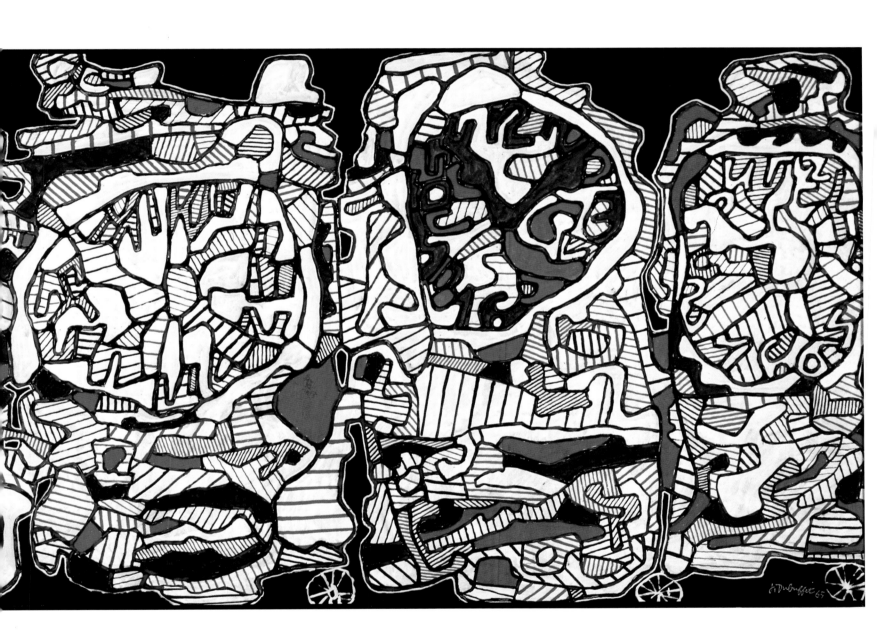

● **Le Train de pendules**

(Train of clocks)

24-28 April 1965

vinyl on paper mounted on canvas

125x400 cm

(painting composed

of two joined canvases)

MNAM – G. Pompidou Center, Paris

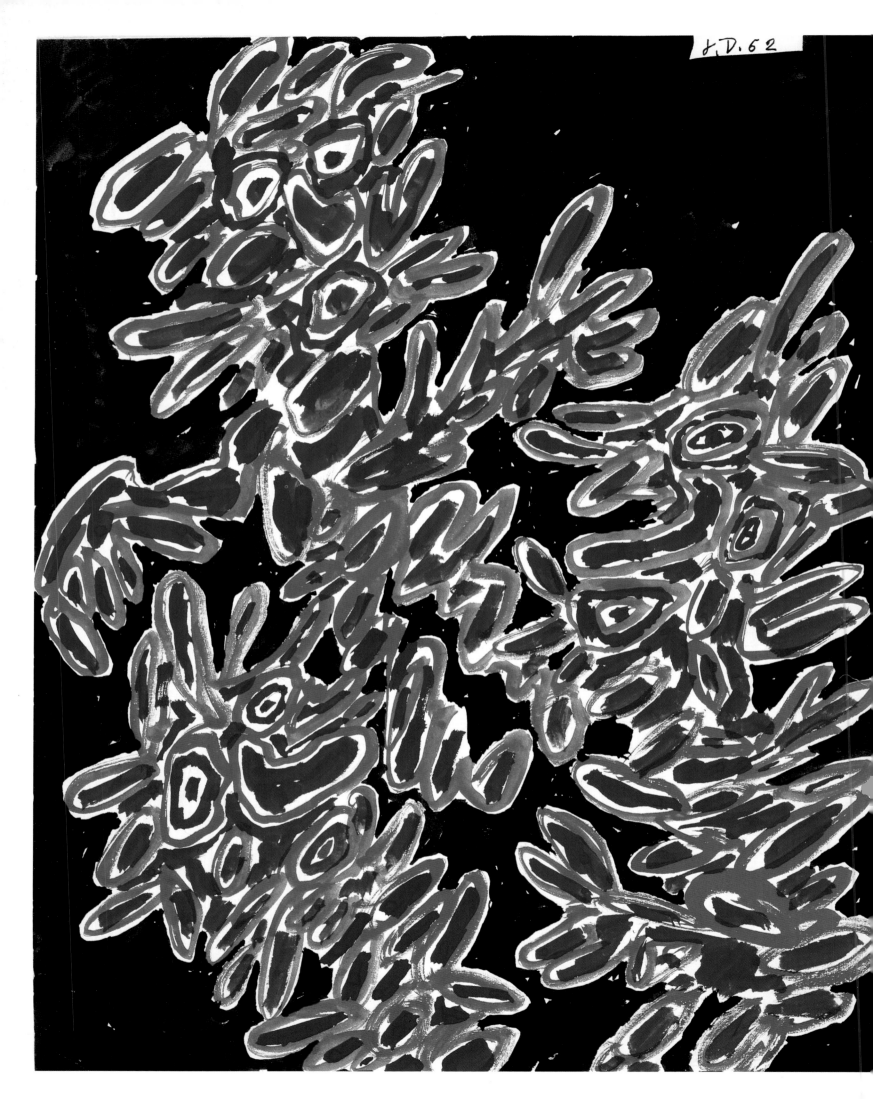

"The whole of my career has been a race to get away from that digestion of the cultural stomach that runs after every work as soon as it is completed."

(Letter to Alan Bowness, 1 July 1966, *Prospectus IV*, p. 210)

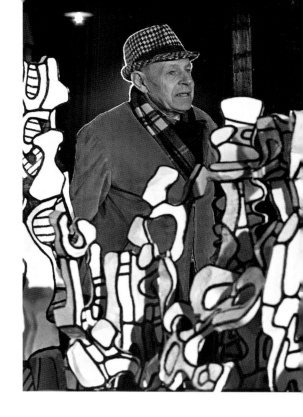

Jean Dubuffet
at the Cartoucherie
de Vincennes Theater, Paris
1972

Trois personnages
(Three Characters)
1962
Gouache (Indian ink
ground) on paper
29x23 cm
MNAM – G. Pompidou Center, Paris

THE HOURLOUPE:
A TWELVE-YEAR LONG ARTISTIC PASSION

The time has come to discuss the *Hourloupe*, the longest, most peculiar, and best known cycle in Jean Dubuffet's work. It marks the half-way stage of his career and is also transitional: a preposterous and almost autistic undertaking which imprisoned the artist's mind, as if he were trapped in the psychological machinery of it, for some twelve years. The *Hourloupe*, with its atoms and molecules, cells and bacteria, just popped up one fine day from nowhere, and spread like a virus to invade the whole of Dubuffet's output. After the more sensual experiments with pure matter, the cerebral triumphs in the end, as drawing and line, now totally automatic, become pure script, a sign system, a calli (or caco-?) graphy of an imaginary absurd alphabet, infinitely proliferating in a display of limitless combinations.

The principle of the automatic writing of the *Hourloupe* is well known, a jigsaw puzzle-like grid in which it is impossible to distinguish between figure and background, solids and voids. The pictures are made up of sections either striped or fully colored in primaries, red, blue, yellow, black, before being simplified to the tricolor system red, white and blue. While these are the national colors of France, more importantly blue and red are, with the black that Dubuffet also retains, the most commonly used biro pen colors. These units interlock on the canvas to form vaguely

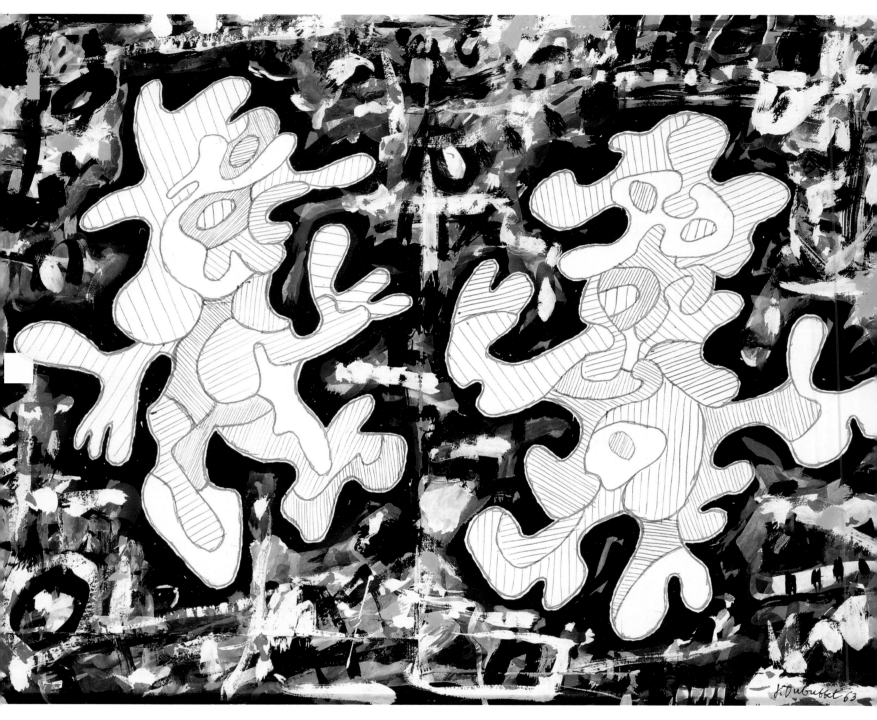

**Preparatory maquette
for Gaya Scienza**
1963
biro and gouache
27x35 cm
Musée des Arts décoratifs, Paris

recognizable composite creatures in random fashion: faces, familiar utensils, objects of various sorts, even self-portraits by way of a signature. As a deliberately delirious and ambivalent script, the *Hourloupe* evolved first of all two-dimensionally, without any suggestion of depth, then bizarrely into a third dimension from the moment when Dubuffet by chance discovered the qualities of expanded polystyrene in July 1966. Because it seemed as arbitrary and almost as childish as a game of Lego, albeit a mental version, and more straightforward and amusing than anything he had done before, this construction game very quickly came to be seen as Jean Dubuffet's artistic signature in the eyes of the public. History would have it that the origin of the *Hourloupe* organic units lies in a series of biro doodlings done absent-mindedly while Dubuffet was on the telephone in July 1962. So they are figures that the artist created automatically with his mind on other things, and which subsequently, like everything else that turned up unexpectedly in his work, he found sufficiently interesting to want to perfect and take further. The result in this case was a little book published in the summer of 1963 by Noël Arnaud, a fellow member of the College of Pataphysics and his secretary for a while. Here we find these prototype figures presented one by one and standing out against a black background. The *Hourloupe* thus owes its genesis to two truly contemporary media, the biro pen and the telephone.

To be precise, the graphic principle of the *Hourloupe* was not of course born in an instant: every phase of Jean Dubuffet's work contains the embryo of the following one, and the various series, although somewhat arbitrarily classified for the sake of neatness, in fact merge and flow in and out of one another in seamless succession. As early as 1952, in a picture such as *Ecstasy in the Sky* in the *Landscapes of the Mind* series, in every respect a turning point in the flow of series, the sky was already curiously "hourlouped". That is to say, it is filled with spontaneous swirls of paint resulting from the different viscosity of the oils and the varnish, which reacted when they were mixed. And the technique of assemblage, which is a montage in jigsaw puzzle fashion of pieces cut out from printed sheets of paper or canvas, was increasingly a process of building up surfaces by placing units side by side, so that the *Hourloupe* may in this respect be regarded as another variant of assemblage. Even the black and white series of 1960, which were graphic transpositions of materiological experiments, had strangely fragmented bases and backgrounds.

As for the word "hourloupe" itself, which may seem totally incongruous at first sight, it originated in another of Jean Dubuffet's activities, his experiments with language that began in 1948 and to which he gave the name "jargon". This was a purely ludic activity, consisting essentially of a comic spelling of popular French expressions on phonetic lines, and had resulted in five illustrated publications: *Ler dla canpane* (l'air de la campagne / country air), *Anvouaiage* (en voyage / traveling) and *Labonfam abeber* (la bonne femme à Bébert / Bebert's good lady), which were all grouped together in *Plu kifekler mouinkon nivoua* (plus qu'il fait clair, moins qu'on y voit / the clearer it is the less you can see). With the fifth, *Oukiva trèné sebot* (où qu'il

> ## "I hardly have any more relationship with what is commonly called nature than with the orange juice that Lili is making me."

(Letter to Henri Michaux, 12 January 1969, *Prospectus IV*, p. 257)

Jean Dubuffet ●
in his studio in 1972

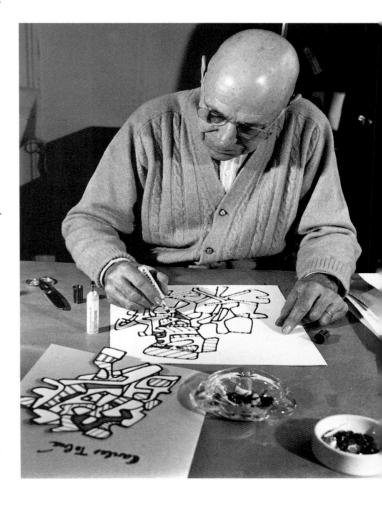

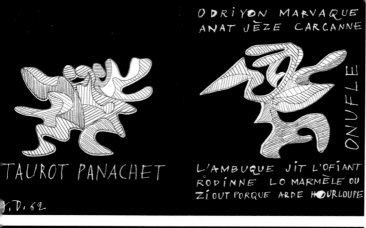

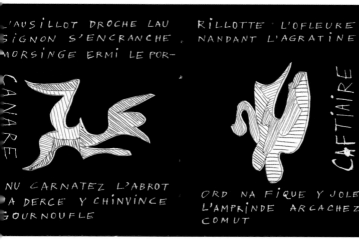

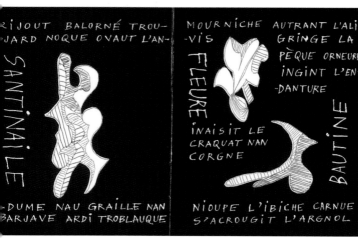

L'Hourloupe

N° 10 of "Le Petit Jésus"
Intimate journal published
by Noël Arnaud
Summer 1963

va traîner ses bottes? / where's he hanging around?), these are titles to be envied by Raymond Queneau. "This cycle of work," wrote Dubuffet apropos of the *Hourloupe*, "was characterized by a much more seriously arbitrary and irrational mood than anything I had done before. This was a plunge into fantasy, into a phantom parallel universe. My renewed interest in outsider art was no doubt not unconnected with this sudden new development. The word 'hourloupe' was the title of a recent little book containing 'jargon' language accompanied by reproductions of red and blue biro drawings. I associated it in my mind by assonance with the words 'hurler' (scream), 'hululer' (ululate, owl hoot), 'loup' (wolf), 'Riquet à la Houppe' (a Perrault fairytale) and the title of Maupassant's story *Le Horla*, which is about madness." ("Biography at Running Speed", February-March 1985, *Prospectus IV*, p. 509-510).

From the end of the 1950s in fact, in Vence, Dubuffet began collecting outsider art again with the encouragement of Alphonse Chave, who organized a small exhibition of it in his gallery in August and September 1959. Shortly afterwards the artist insisted that Alfonso Ossorio return his *art brut* collection, which duly reached Paris in the spring of 1962, shortly before the *Hourloupe* was born. This context also explains why, despite the antecedents, the rapid and systematic development of the composite creatures making up the *Hourloupe* should appear so very abrupt. This can be seen not just in the colors but very soon in the media: gouache and oil to begin with (until the artist gave up oil painting for good in 1964) and then vinyl, biro, felt tip, marker pen, etc. Finally, when Dubuffet became three dimensional in July 1966: polystyrene, polyester, laminated plastics, epoxy resin, concrete and polyurethane paint.

The first *Hourloupe* pictures were made in Le Touquet, in the native region of Dubuffet's wife, which was closer and more convenient than Vence, in a purpose built house where the artist frequently worked in the summer. With these pictures and then the sculptures and constructions of the *Hourloupe*, we leave nature completely behind and move straight into an organized urban world, into the decoration and design of the civilization of plastic materials. In fact it is thought that Dubuffet simply discovered expanded polystyrene one day when he and his wife were taking a kitchen appliance out of its packaging.

As the principle of the *Hourloupe* is totally arbitrary and resides in the *ad lib* combining of extremely simple units, its potential development was at the outset literally infinite, taking into account amongst other things variable factors such as support medium, materials and dimensions. Without intending to, Dubuffet had invented a sort of very recognizable graphic

FLERCE ALEU CRAGNE
NOURICHON GRANDEUX
N'ARBOUFLE ORDEAU

CRANDON LA CACHANE

VENICE

CERVITEURE

L'ARAPETTE RÂCHE AU
TILLEUX MOURTIGUE

ARTOQUE NORT FLITURGUE

NANCIOUT BAUBALAR
CALEMUTE MARDICHOT
NAVAITE ACRET NACHE
PORNORÉ CAVI-
 -GULE
NAN- ARNAC
-SAUD ROSGOR
CARBON BOULOU-
-CHE

ANDAIS MARGNOUFE ORE
RUMUCHE PERME

CHAGEURD

PIAIJE

N'ORNIRAI QU'ANANT S'Y TROCHE

ANFIOLE ARDIGEON BROUDUT
LA NULA FOURQUE OUD
RAMPONNE

NA VOT L'ONFLE ARGACHE
AU MOURNE RADIT L'ORFIAUD
BORLINGUE

RIZÈTE

CANDIPIOTE NOCHETON
LA HAULE CRADASSE LEU
FAÏTULE NANGIN L'URFLE

L'ACROFIAT FARGONNE

ACROFIAT

NABOUQUET OT GRINGUE

alphabet: just as at the beginning of every new cycle, he had to explore all the possible applications and try out all the variables of the system. This time, however, because the resources of language are never exhausted, he will end up being totally overwhelmed by the experimentation; it will take hold of him completely, as if possessed of its own logic. This explains partly why the mode lasted for such a long time, twelve years, as if the artist were prisoner of the system he had created, and above all why painting quickly escaped from its traditional constraints and acquired a three-dimensional character: first sculpture then architectural structures and environments effects. As if the *Hourloupe* molecules were a DNA spiral or a genetic code suddenly out of control and sweeping across the planet.

Once again developments in materials are the source of an unexpected evolution in Dubuffet's art. Polystyrene, which is extremely light and can be cut quite easily with a hot wire or an electric kitchen knife, came along just at the right time to allow Dubuffet to extend his painting experiments into fresh terrain. He now had the opportunity to work three-dimensionally with the same skill and inventiveness as in his previous pictures. "It must be noted that the term painted sculptures is hardly the right one for

these works," Dubuffet pointed out, "as they are really sculpted paintings, paintings which have been liberated from their frame and flat support dimension and gone off into space, 'expanded' paintings, if you like" ("Canvas for Georges Limbour", July 1967, *Prospectus III*, p. 321). Later he would talk of "monumented paintings" and then describe his first architectural experiments in this vein as "inhabitable sculptures".

From this time on the swarming universe of the *Hourloupe* took on almost surreal proportions, and Dubuffet's new experiments quickly moved in the direction of the environmental. Starting with expanded polystyrene maquettes, representing mainly "human figures, but more often [...] places or landscapes and also buildings" (*Prospectus IV*, p. 519), two techniques were used to achieve work of monumental proportions. With the first of these, the original was reproduced in epoxy resin or polyester by means of a mold, and the resulting replica, more durable than the maquette, was painted with vinyl. The second technique was to "transfer the painting of the original polystyrene maquette directly on to a polyester proof." (*idem*, p. 517). In the first case, the "sculpted polystyrene maquette" (*idem*, p. 524) remained intact, whereas it was destroyed in the second. Shortly afterwards, in 1969, Dubuffet discovered the pantograph, a device for magnifying shapes, and he combined this with the use of epoxy resin, very resistant polyurethane paint and concrete. This is how he was able to create gigantic works in sections, sometimes on a scale of twelve meters high, such as the *Group of Four Trees*, which was unveiled in New York in October 1972, or even twenty-four meters, as with the *Tower of Figures* on the island of Saint-Germain on the Seine at Issy-les-Moulineaux which was presented to the public posthumously in October 1988.

Dubuffet now became virtually the head of a manufacturing company, directing a whole team of technicians in a new workshop that he rented in 1968 in the rue Labrouste in Paris. A year later he was working in purpose built premises at Périgny-sur-Yerres in the department of Val-de-Marne, to the south-east of Paris. Then in 1971 and continuing until the beginning of 1979, he occupied an immense space at the "Cartoucherie de Vincennes" (a Paris theater and arts complex situated in a disused ammunition factory, *cartoucherie*). To further his investigation of the artistic and architectural potential of the new synthetic materials, at different times he hired mold-makers, engineers, French and American architects, various sculptors and even a neighboring agricultural worker who was a boat-builder, two boilermakers, three seamstresses and a stage designer. All of this absorbed Dubuffet's energies so much that for seven years, from 1967 to 1974, he even gave up painting completely. He was to come back to it only in the *Burlesque Novel* series and especially in a new way: using his assistants

Le Bateau I
(The Boat I**)**
12 August 1964
Oil on canvas
146x114 cm
Private collection

● **Chaîne de mémoire** III

(Chain of Memory III)
3 December 1964
Vinyl on paper with collage
100x131 cm
MNAM – G. Pompidou Center, Paris

Le Verre d'eau v ●

(The glass of water V)

21 March - 3 May 1967

Vinyl on canvas

250x129 cm

Musée des Beaux-Arts, Lyon

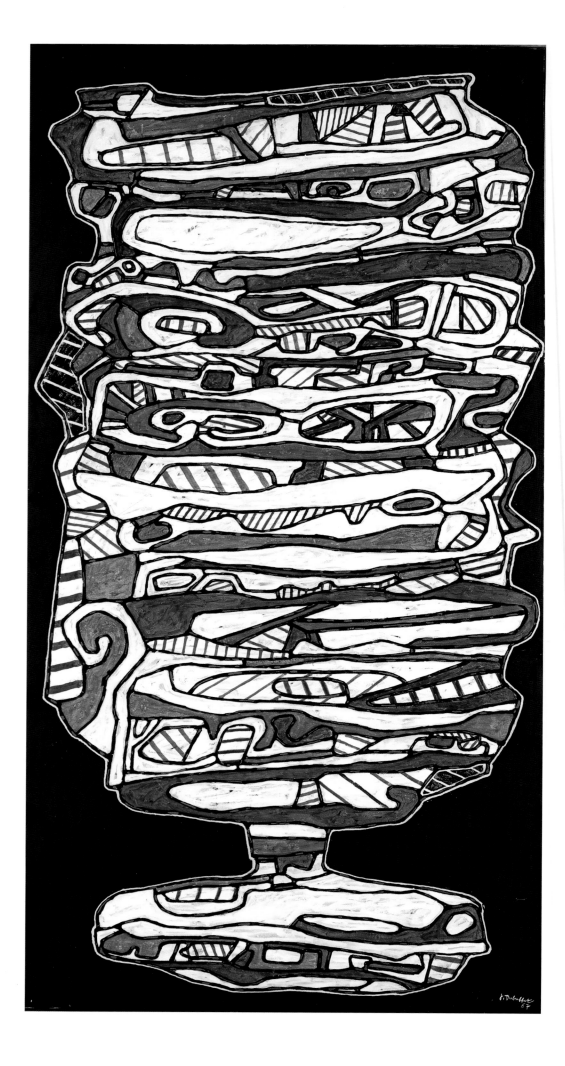

"I refuse to possess any objects whatsoever; I want to live in empty and bare surroundings without any ties to anything, just like a vagabond; I have an aversion to property and to permanence."

(Letter to Graham Ackroyd, 7 June 1965, *Prospectus IV*, p.196)

to make large flat tint paintings derived from photographic projections of original drawings. These were the *Castilian Landscapes* and *Tricolor Sites* of 1974, the last series in the *Hourloupe* cycle.

The whole of this production from 1969 onwards included some monumental commissions in Holland, France, Belgium and the United States, although a few were aborted (*Welcome Parade*, a group of figures for the entrance to I. M. Pei's National Gallery in Washington, a sixteen meter tower for outside the Lambert Bank in Brussels, and the *Site Scripturaire* commissioned for the Esplanade de la Défense but cancelled just as the site was being prepared). The most famous are doubtless the *Villa Falbala* construction in Périgny to house what Dubuffet called his *Logological Cabinet*, and the "living picture" *Coucou Bazar*, a sort of fantastic ballet derived from the characters and creatures of the *Hourloupe*. This burlesque spectacle, which had only moderate success, was performed by a troupe of American and then Italian dancers in New York, Paris and Turin successively. The first production was from April to July 1973 at the Guggenheim Museum, to coincide with a big Dubuffet retrospective (there had already

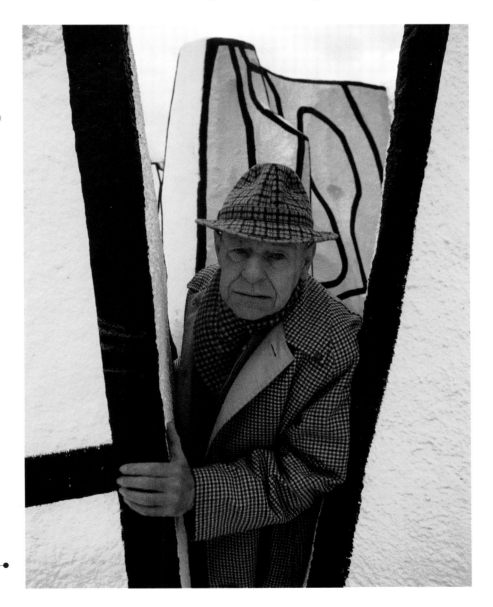

Dubuffet in 1978

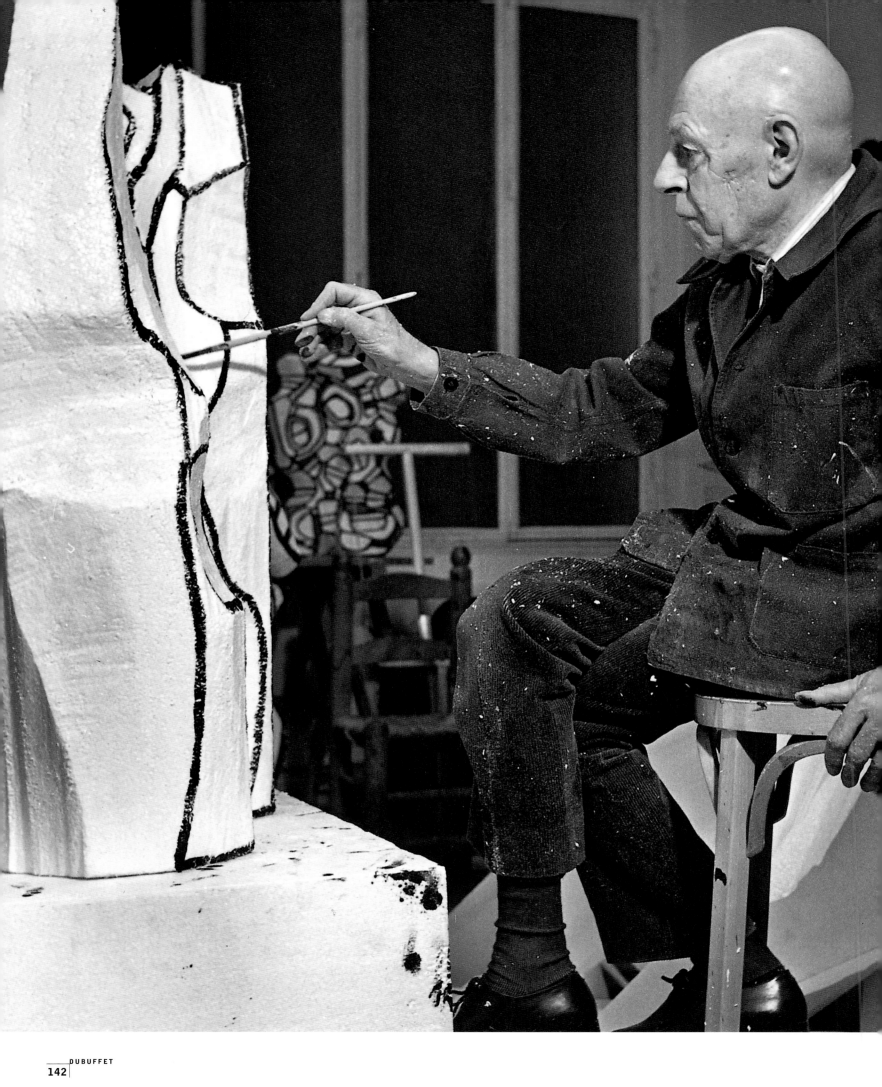

"The construction phase of a project, now that's a wonderful phase. The phase of its completion is less interesting."

(Letter to Rémi and Tom Messer, 7 August 1971, *Prospectus IV*, p.306)

Dubuffet in his studio
Circa 1972

been one in 1966 -1967), the second taking place in autumn of the same year in the Museum of the Grand Palais, Paris. The final production was five years later on the occasion of an unusual exhibition organized by Fiat in the capital of the Italian automobile industry.

In France the author of the *Hourloupe* was less fortunate and his relations with industry became catastrophic. This was the famous disaster of the *Summer Salon* between 1973 and 1975, an "environmental" décor commissioned by the Renault automobile company and then destroyed on the orders of the management before it was finished. It was a distressing matter and the occasion of a very public lawsuit stretching from 1977 to 1983, passing through the range of Appeal processes in Paris and Versailles. Dubuffet eventually won his case, but it was too late. He was eighty-two and beyond caring about the construction of the work, being so demoralized after nine years of litigation.

And yet the fame of the aging artist was at its peak, and the scandalous case provoked an outcry on an international scale. Retrospectives were now taking place throughout the world: at the Tate Gallery in London in 1966; in Paris the year after, at the Musée des Arts décoratifs, to which Dubuffet made a large gift of paintings and which had just exhibited seven hundred works from the outsider art collection; at the Museum of Modern Art in New York in 1968. And so it went on: Berlin, Vienna and Cologne in 1980 and then a third retrospective at the Guggenheim in 1981. Meanwhile various "environments" were inaugurated or were about to be in New York, Otterlo, Düsseldorf, East Hampton, Houston and Chicago. By now the Dubuffet organization was running very smoothly indeed, with a secretariat systematically filing the whole of his output. The first volume of the descriptive catalog, edited by the philosopher Max Loreau, was published in 1964, and the series had reached volume twenty-eight in 1978 when Dubuffet quarreled with him.

It was at this stage that the editorship was taken over by Armande de Trentinian, who had been working for Dubuffet since July 1967. The artist's writings – his technical notes and pamphlets, and inexhaustible correspondence – were published in two volumes by Hubert Damish on

Following double page:
Closerie and Villa Falbala
1971-1973
(final form 1976)
concrete and polyurethane
painted epoxy resin
1610 sq. meters
Fondation Dubuffet, Périgny-sur-Yerres

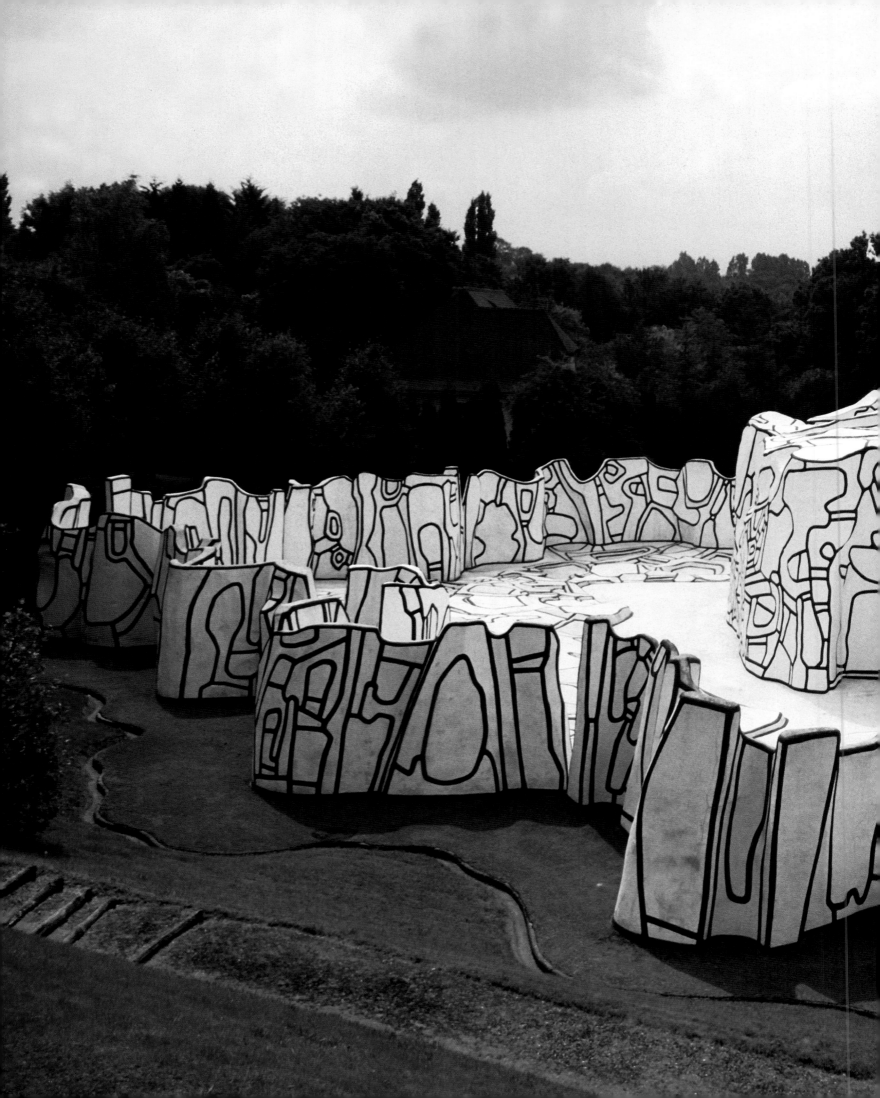

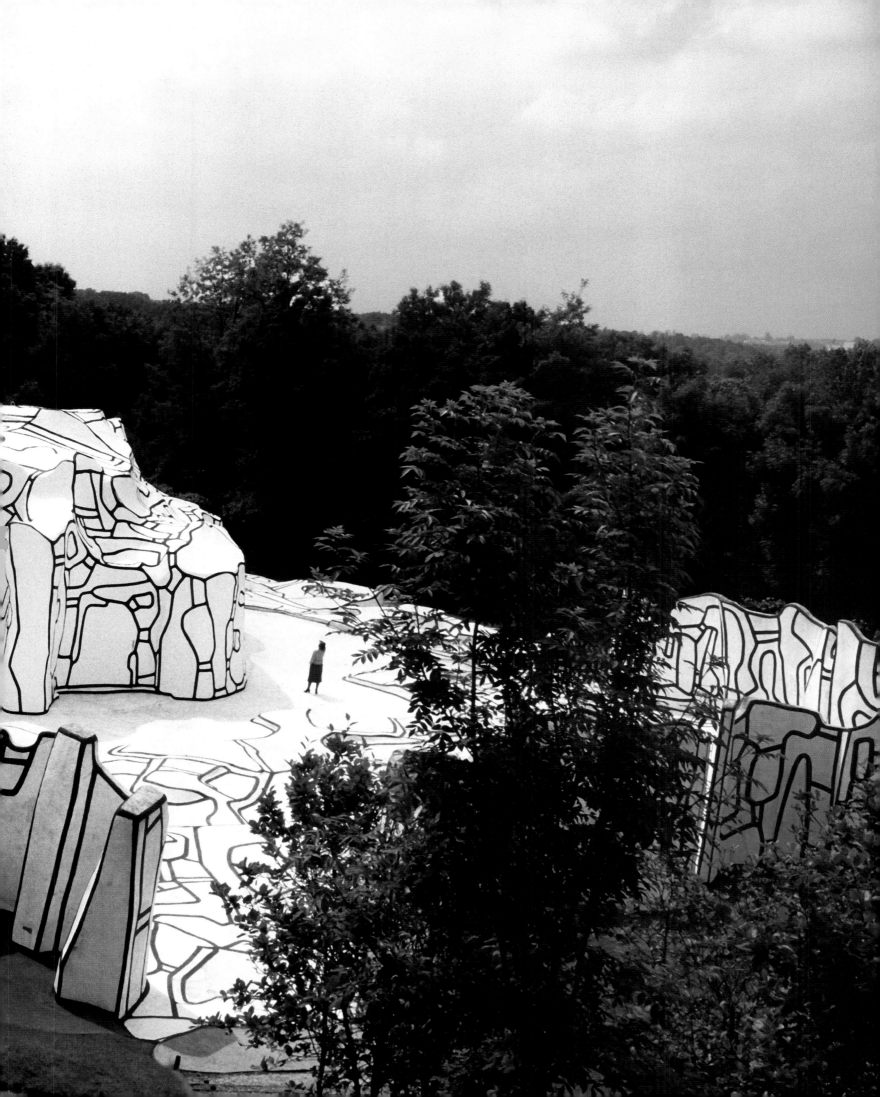

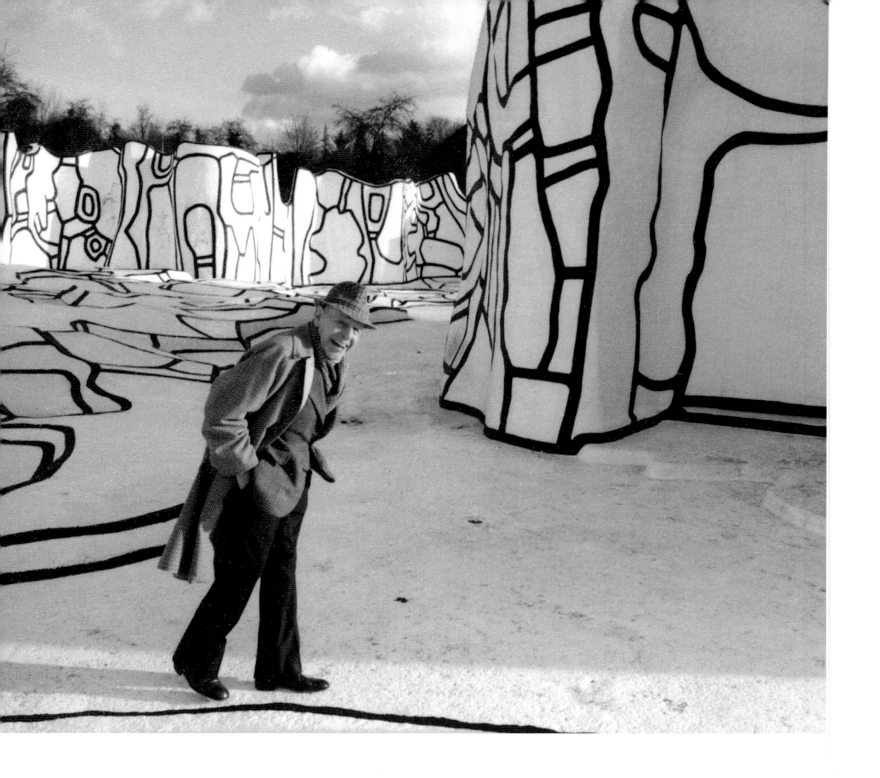

Jean Dubuffet

In front of the Villa Falbala

Following page:

Jardin d'hiver

(Winter garden)

16 August 1968 – August 1970

Epoxy resin, polyurethane paint

500x100x600 cm

MNAM – G. Pompidou Center, Paris

the occasion of the major gift of work in 1967. Finally the Dubuffet Foundation was born in 1974.

The fact remains that the failure of the Renault project, ending in a historic legal verdict, was a cruel disappointment at the end of such a prolific artistic career: "I was not at all happy with enforcing the building of my work where it was so clearly unwelcome, so I decided to give up my right to do so." ("Biography…", *Prospectus IV*, p. 530).

VISIT TO THE CLOSERIE FALBALA

To form a better idea of what Jean Dubuffet was trying to achieve by his architectural endeavors, nothing equals a visit to Périgny-sur-Yerres, near Paris, to see the Dubuffet Foundation. Here, by appointment, it is possible to get in to the museum to see that part of the artist's gift of work, created mainly after 1967, that complements what he donated to the Musée des Arts décoratifs. And it is also possible to get into the incredible "environment" – walk-through sculpture – called the *Closerie Falbala*. This is a sort of promenade half enclosing the villa of the same name, with an antechamber, a cave with wall paintings in the *Hourloupe* style, and its inner sanctum, the strange rectangular room in which is enshrined the *Logological Cabinet*.

Nearby there is also a shed that was the workshop where the *Group of Four Trees* was built, which is now in New York. Here you can also see the costumes of *Coucou Bazar*, amid a profusion of décors, dogs, cows, chunks of countryside, not to mention accessories such as trousers turned into statues, spare heads, gloves, shoes, hats, etc. The *Coucou*

"The title given to the *Logological Cabinet* comes from the idea of a logos in a figurative sense, which, instead of being an index of phenomena and objects, begins to proliferate of its own volition. So it's coasting along, with the clutch let out."

("Note on the title *Logological Cabinet*", March 1970, *The Common Man at Work*, Idées, Gallimard, Poche, p. 54)

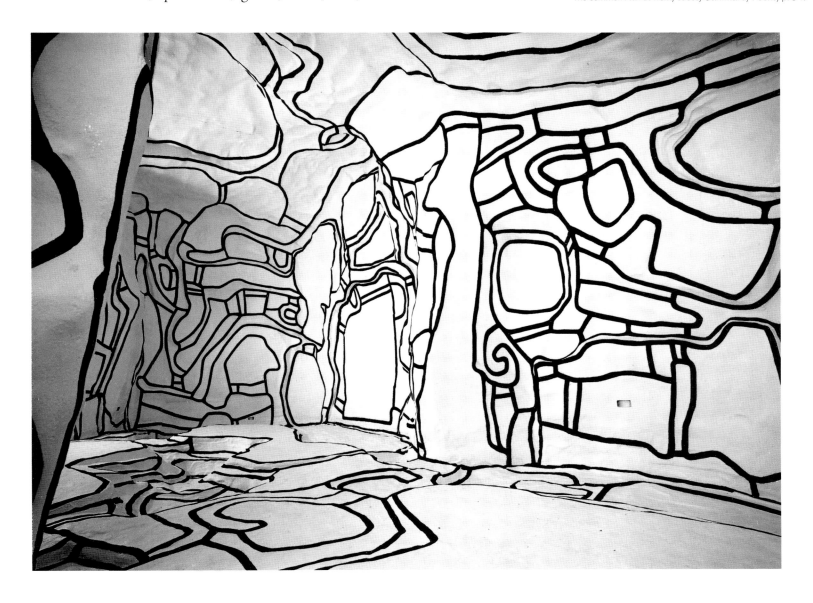

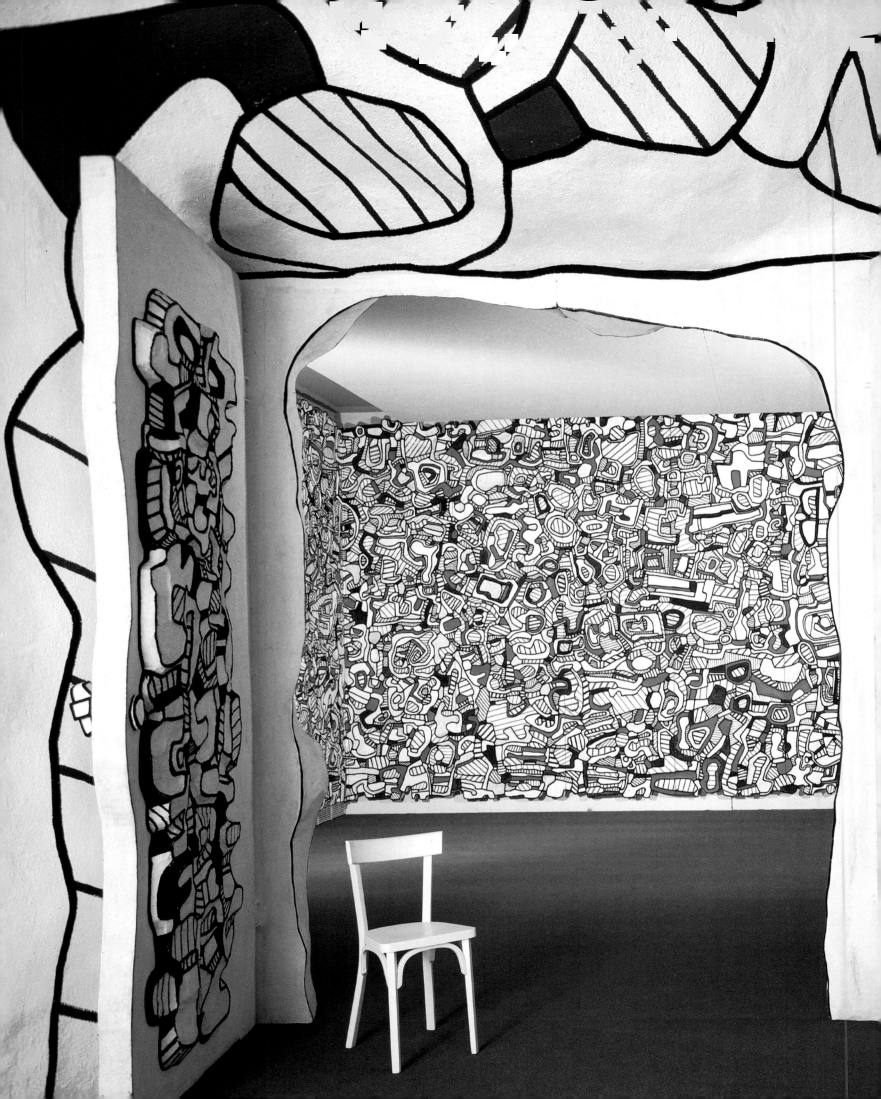

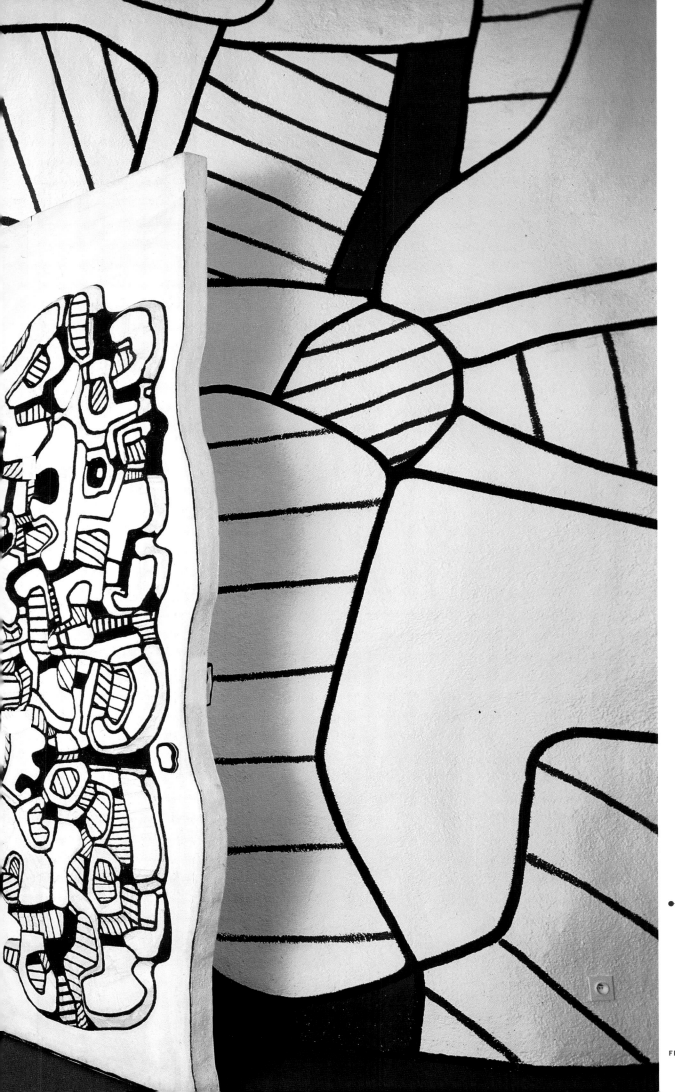

**Antechamber
of the Villa Falbala**
(door opening on to
the *Logological Cabinet*)
1974
Epoxy and polyurethane paint
Fondation Dubuffet, Périgny-sur-Yerres

Bazar characters are some twenty in number, fantastic, clumsy robots, more impressive in their hugeness and stiffness compounded of resin and tarlatan fabric than the armor of a Samurai warrior or protective gear of an American Football player. A room in the museum also exhibits the "practicable" scenery used in the production, more than a hundred large assemblages made out of painted polystyrene panels, mounted on wheels and sometimes remote controlled.

Paris is also the place where you can shut yourself away in the *Winter Garden*, a sort of artificial grotto set up in the middle of Beaubourg, imitating the rocky settings to be found in zoos; it is painted in a dazzling polyurethane white edged with black, creating a plastic effect. An alternative is to go to the Kröller-Müller Museum at Otterlo in the Netherlands to walk in (or on?) the *Enamel Garden*, a subtly undulating artificial landscape like those designed for children, but in this case for adults.

What we have here is a theoretical space existing in the mind, as deliberately artificial as a stage set, where you sit down on a notional chair or bench, in the shade of a virtual tree, and then cross a conceptual floor to enter houses or other spaces as uninhabitable as the fantasy palace built by the Postman Ferdinand Cheval. Clearly the architectural universe of the *Hourloupe* functions as a kind of parallel world, as bewildering and yet as enchanting as a children's game provided one accepts the rules. This is because it is a pure life-size projection of make-believe, like a megalomaniac architect's giant mock-up of a building or the inside of a laboratory prototype. Everything here is sham and imitation, and significantly Dubuffet was to talk more and more of a world of "ghosts". We experience the same sort of pleasure – or disquiet – as we do on leaving the serious environment of the real world and stepping light-heartedly into the labyrinths and other amusing features with which the grounds of stately homes were once

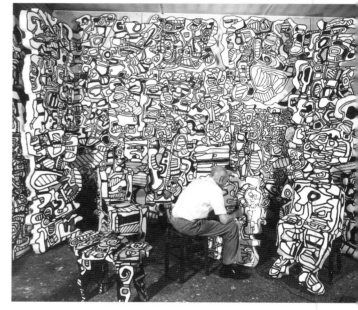

Dubuffet working on the Blue Sections
rue Labrouste workshops
1967

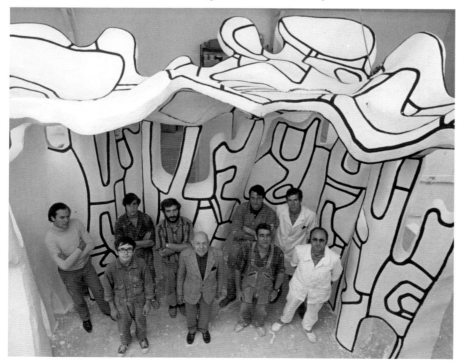

Jean Dubuffet
with his assistants
during the building
of *Le Bocage*
1 October 1970

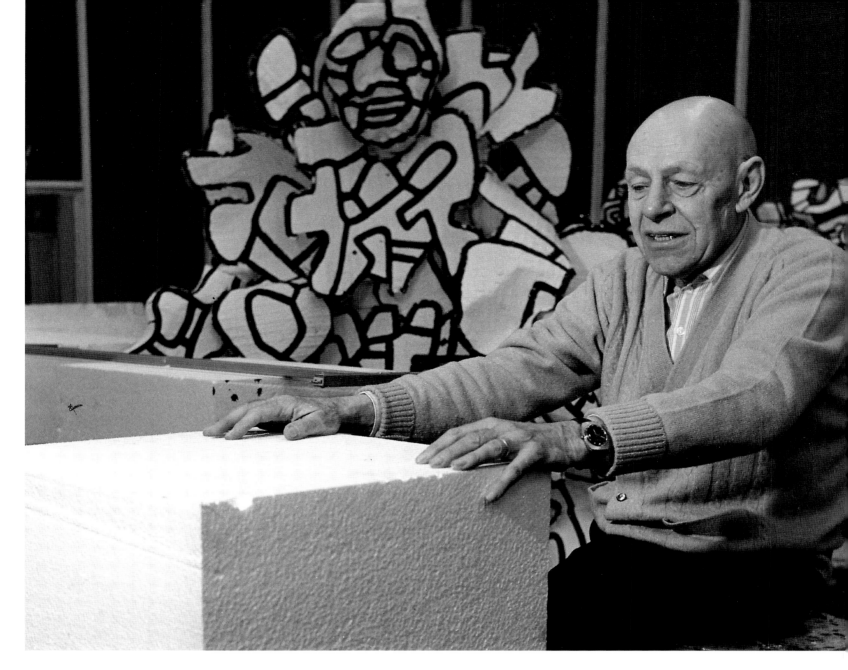

Jean Dubuffet————●
handling a bloc of polystyrene
in his studio
1972

adorned, and of which we now find less exalted versions in modern-day fairgrounds and theme parks.

Yet there is something desolate and desert-like about a visit to Périgny and its *Closerie Falbala*, almost unbearably mute and silent which adds a note of gravity to what might otherwise be just an afternoon's entertainment. In this grave silence we find ourselves irresistibly drawn to speculation of a different order, philosophical or metaphysical perhaps, if not even magic and religious: it is as if we had gone by chance inside an empty temple temporarily abandoned by priests from an obscure origin and penetrated the sanctuary of extra-terrestrials absent for an unknown reason.

The *Closerie Falbala* was originally built for a purely practical reason, to accommodate the twenty-two panels of the *Logological Cabinet*, an unbroken strip more than twenty meters long by three and a half meters high covered with all the motifs of the *Hourloupe* in a swarming, intermingled writing in red, white, blue and black. The *Closerie Falbala*, which became a listed historic monument in November 1988, offers a sort of initiatic journey in three stages. It is surrounded by sections of wall with intervals between

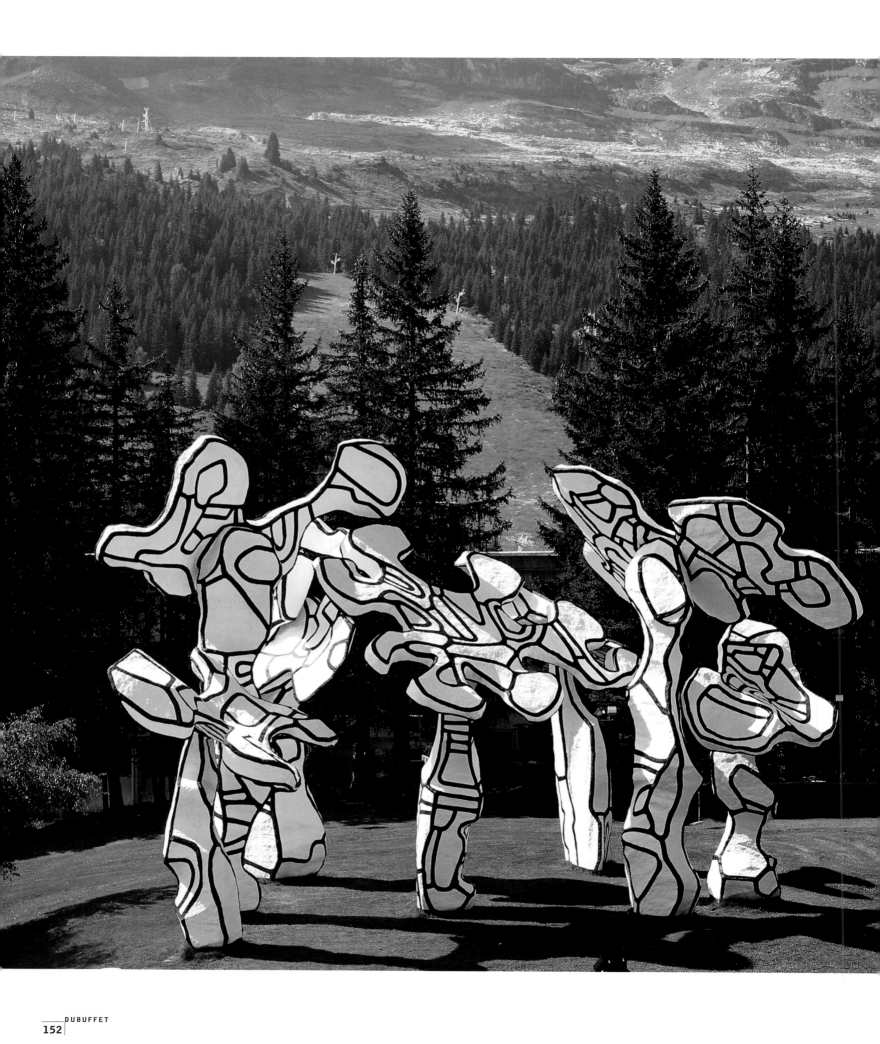

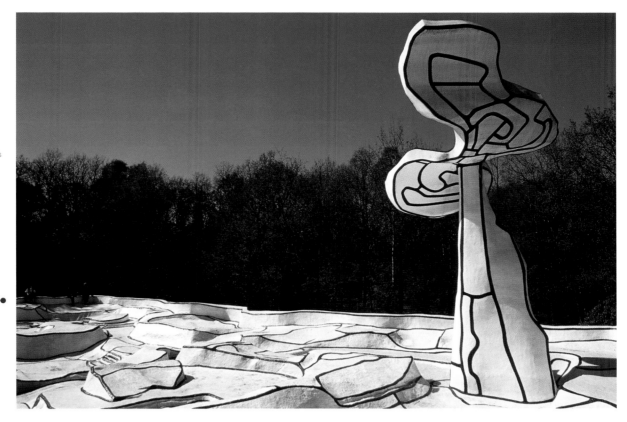

Le Boqueteau
(The Copse)
Flaine (Haute-Savoie)
maquette: 1969
realization: 1988
Height: 9 m
Epoxy and polyurethane paint
Stored MNAM G. Pompidou Center, Paris

Jardin d'émail
(Enamel Garden)
maquette: 1968
realization: 1973-1974
30x20 m
Cement and epoxy,
Polyurethane paint
Kröller-Müller Museum, Otterlo

them, hence its name, esplanade, or rather non-esplanade as it is a sort of haphazard relief structure with no complete flat surface. It is an immense white space of unbearable intensity on days when there is strong sunlight, despite the wide black borders. We feel as Dubuffet must have done deep in the Sahara, or when he was walking in the dry arid region that he loved so much near his house in Vence, and which is so apt for the solitary wanderer. It is difficult to imagine a more bizarre contrast with the banality of the surroundings of the *Closerie*, the prim and proper pseudo-countryside of the outer Paris suburbs.

Next, in the middle, there is the Villa itself, a polyester shell with a vague rock-like appearance, also dazzlingly white but with thin black *Hourloupe* stripes, quite close together. Everything in the *Closerie* is closed, just as firmly as was the scholarly father's retreat back home in Le Havre: you venture into *the Villa Falbala* with the curiosity of the hunter exploring a wild beast's lair or of the archeologist looking for the innermost chamber in the Pharaoh's tomb. Via an entrance to the side, rather like the jagged entrance to a cave, you then get in to the Antechamber. This is a winding corridor with cave-like walls of a whiteness as pure as on the outside. In addition to having black outlines, the corridor is embellished with large blue panels, matched by the immaculate blue of a floor-covering worthy of the interior of a bank. Finally comes the sacred moment, the moment of discovery in a real sense: the opening of the doors of the *Logological Cabinet*, when an unrelieved mass of seething reds, whites and blues hits your eyes and literally takes your breath away.

In this meticulously hermetic chamber, everything is rectangular: floor space, walls, ceiling. All of a sudden, with the exception of the jigsaw-like outline of the entrance, you rediscover unrelentingly geometrical straight

"Everything is to be gained from specifying the sites of thought and making them more numerous."

("Rambling conversations", *Prospectus II*, p. 125)

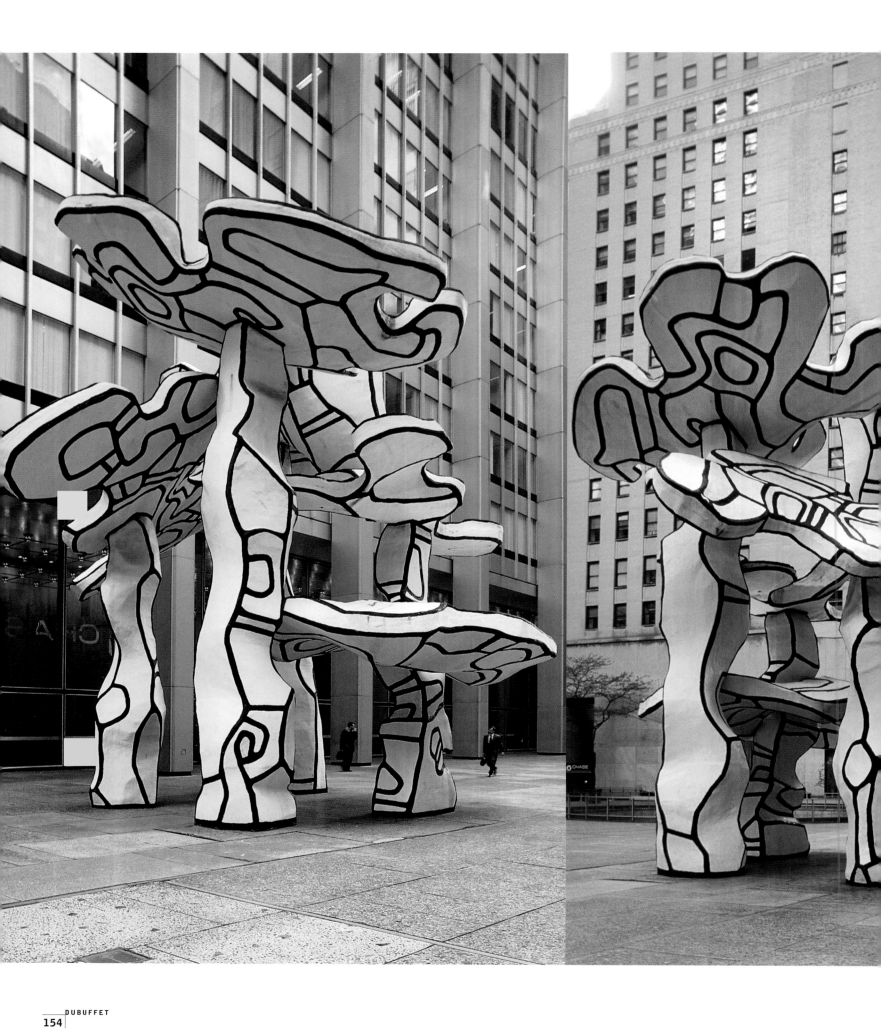

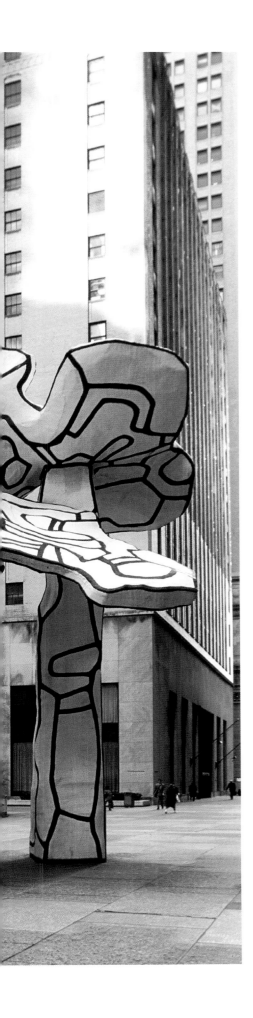

lines. You half expect to hear the sound of a mechanism discreetly closing the doors behind you, so great is your feeling of being enclosed, cloistered without hope of exit. In the middle, as if in preparation for some mysterious board meeting or profoundly esoteric ceremony which will seal the fate of the world, there is just a large table covered with a green cloth. More prosaically perhaps, this simplicity allows the visitor to concentrate on his meditations, confronted with the delirium of line and color that covers the walls, and have the time to try to decipher the continuum of signs embedded one within the other in a jumble without beginning or end. We have before us symbol heaped on symbol, as inextricably enmeshed as rubbish in a public dump. Like the chaotic gibberish of a language whose unstructured phonetic system echoes in the void, eternally incomprehensible, the artificial delirium of the *Logological Cabinet* creates an impression that is fascinating and haunting, but also disturbing – to the extent that you almost feel like running away.

In the first works in the *Hourloupe* mode it was still possible occasionally to distinguish objects that were born at the whim of the artist's improvising brush or marker. Except when Dubuffet opted for the inverse process, starting with figures and then filling in the spaces in the jigsaw puzzle pieces with stripes or painted solids. Hence a spontaneous and random flow of animate or inanimate creatures: bizarre characters, wheelbarrows, boats, beds, as well as a wide range of everyday objects, taps, washbasins, teapots, and typewriters. But now, in the *Closerie*, there is no longer anything recognizable. We are in a permanent elsewhere, having lost all links with the outside world, and that is what makes it such a disorienting place.

The panels of the *Logological Cabinet* were begun in 1967 and conceived as a mathematics-related combinatorial system; they were completed at Le Touquet towards the end of 1968 and reproduced in polyester the year after. Originally they were intended to be hung on the walls of a real lived-in house, every part of which, walls, furniture, decoration included, would get the *Hourloupe* treatment. It was a dream as stifling and unlivable as that of Picassiette, the gardener of the Chartres cemetery and creator of the famous house in which even the bed and the sewing machine were eventually the victims of their owner's obsession with fossilization, covered with mosaics and pottery fragments.

The buildings and monuments of the *Hourloupe*, a massive reaffirmation of freehand drawing as opposed to the plumb-line principle of houses and sky-scrapers, can doubtless be considered at first sight as a defiant challenge to the set-square methods of architects and of town-planners. "I really felt strongly," Dubuffet said, "that laminated plastics were a wonderful

Groupe de quatre arbres

(Group of Four Trees)
April 1971 – July 1972
Epoxy and polyurethane paint
Height: 12 m
Chase Manhattan Plaza, New York

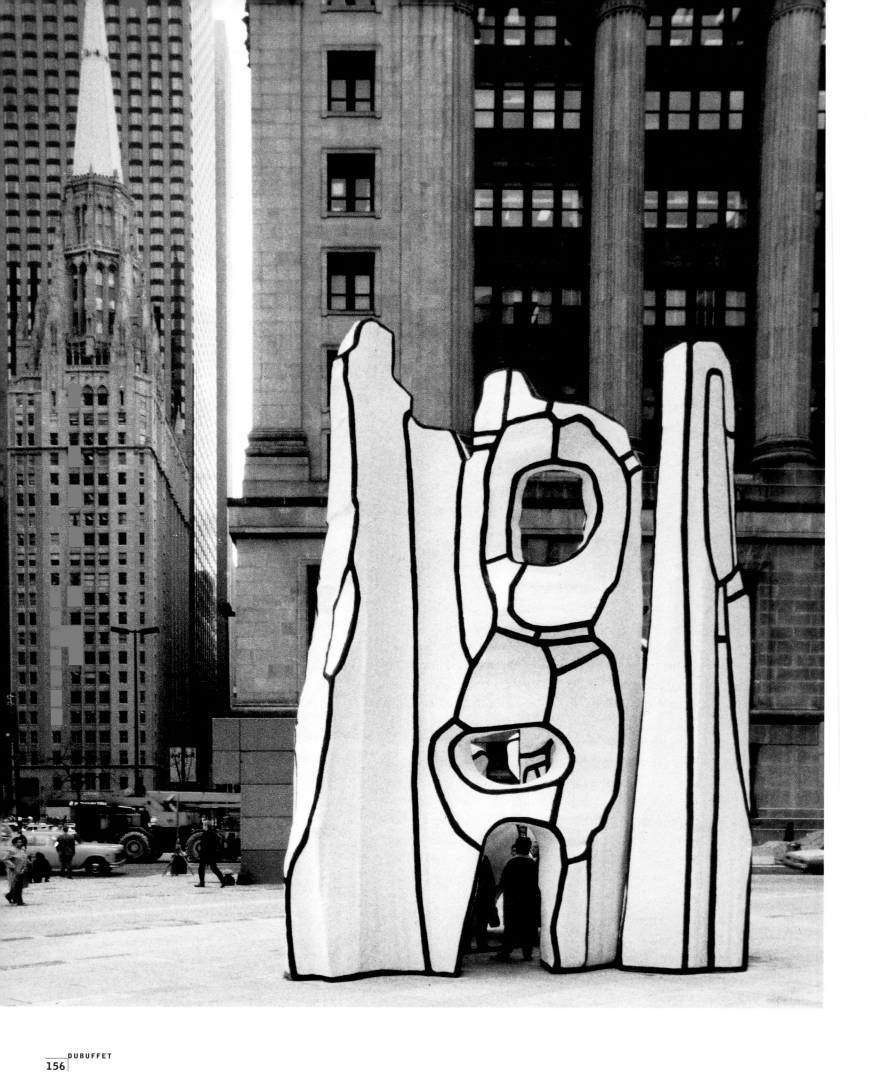

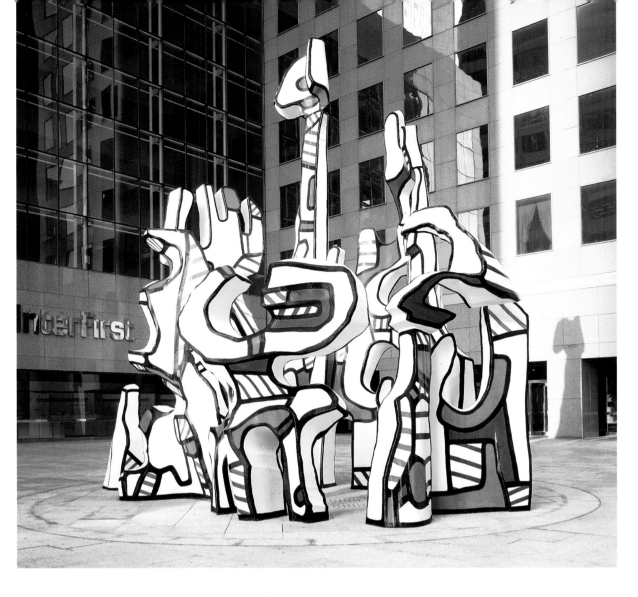

Monument à la bête debout

(Monument with
Standing Beast)
maquette: 1969
realization: 1984
Epoxy painted
with polyurethane
Height: 9 m
Plaza of the State of Illinois Center,
Chicago, Illinois

Monument au fantôme

(Monument with Phantom)
maquette: 1969
realization: 1983
Epoxy painted
with polyurethane
Height: 10 m
Interfast Plaza, Houston, Texas

lease of life for architects, allowing them to move in a new direction by getting away from the basic straight lines and rectangular shapes which traditional materials have always made them respect. Living in the middle of those structures affects our thought, and it struck me that the foundations and mechanisms of our thought would be changed if our habitat had the fantastic shapes that you find in my *Hourloupe* work."("Biography…", *Prospectus IV*, p. 523-524)

Very soon however Dubuffet, as in the rest of his work, preferred to keep the project at a purely theoretical level, and he renounced the temptation of real architecture. He was content to imagine his works on a different scale, a mental exercise which, he said, gave him as much satisfaction as reality. Or else, which comes to the same thing, he had simple photo montages made. This is how the *Logological Cabinet*, a graphic monologue without beginning or end, produced at the start on large freely interlocking polystyrene panels designed to decorate the walls, pillars and furniture of an interior, came to forfeit its architectural destiny. In the end it was just an immense picture liable like any conventional work to be exhibited in different places and on different occasions. And it was because it had to be found a more permanent home that the honor fell to the *Villa Falbala*; it was thus at a late stage that this happened, and it was not the original intention.

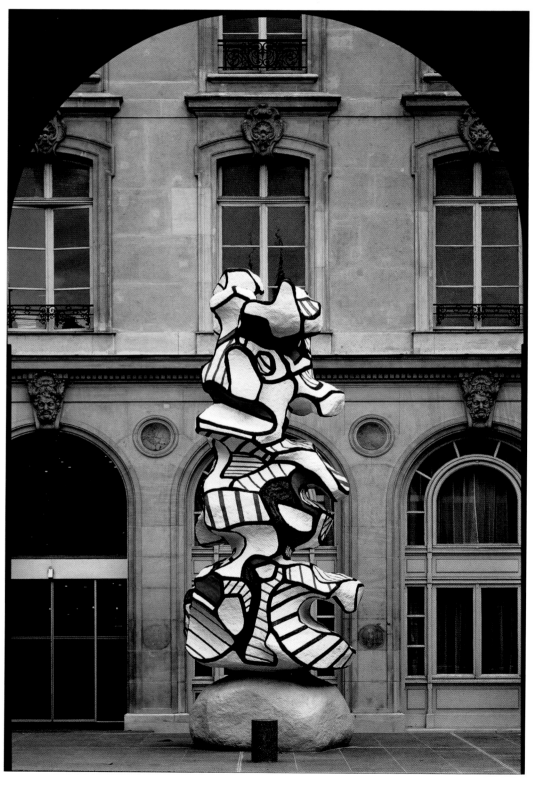

Tour aux figures
(Tower of Figures)
maquette: 1967
realization: 1988
Epoxy and polyurethane paint
Height: 24 m

Île Saint-Germain, Issy-les-Moulineaux

The Reseda
maquette: 1972
realization: 1988
Epoxy and polyurethane paint
Height: 6.62 m

Caisse des Dépôts et Consignations, Paris

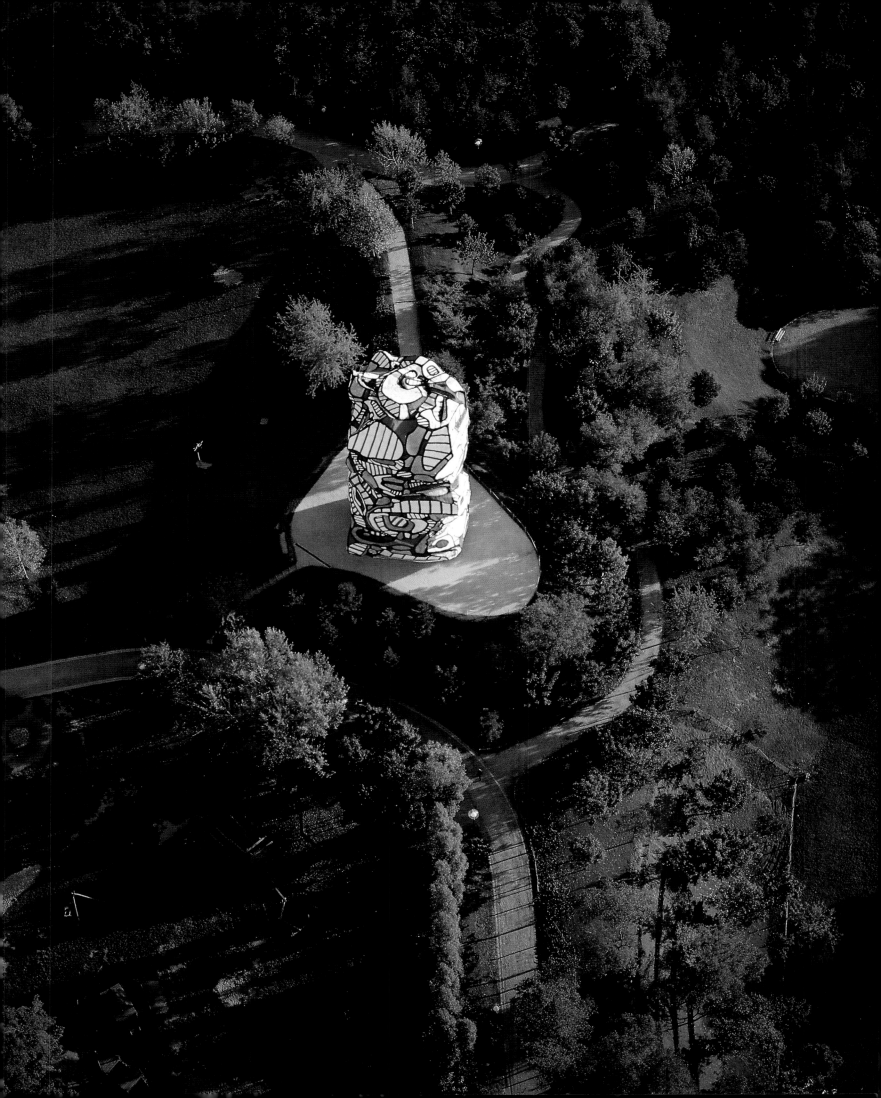

"The gaze that we direct towards everything, the artist explained in *Rambling Conversations* - whether it's things physically in front of us or our moods and judgements – has to pass through a filter, namely the conditioning we have all been subjected to since our early childhood. It is impossible for there to be a gaze without a filter, by which I mean a set of keys and references supplying an interpretation. Every gaze involves interpretation: to look at something is to interpret it. I'm searching for new filters, and I'd like them to be very different." (*Prospectus III*, p.145). The visitor who is confronted with the "logological" incoherence of the *Hourloupe* is inevitably astonished by the gulf between these hyper-intellectual aims and the apparently gratuitous and childish nature of the result. Yet Dubuffet's concerns were to border increasingly on the metaphysical, as became more obvious in the work of his last ten years.

It was as if in the ripeness of his years Dubuffet felt several questions weighing upon him more and more, those concerning the relationship between existence and nothingness, being and non-being, abundance and the void. With those questions came an increasing need to return to the notions of continuum and sameness. From this point of view the unbroken graphic mode of the *Logological Cabinet* is already meant to be acting on the spectator in the manner of a mental exercise designed to put him in a state of mind, a "posture", to use Dubuffet's term, more akin to Buddhism or Islam than to Western philosophies or religions. "The *Logological Cabinet* I think of as a philosophical exercise room designed

Site scripturaire

(Scripturary Site)
Maquette for a garden
on the Plaza de la Défense
11-29 August 1973
Second maquette:
12 January-17 February 1974
polysterene with black
vinyl outlining on hardboard
Height: 200, Length: 620,
Depth: 520 cm
The project was cancelled
at an early stage

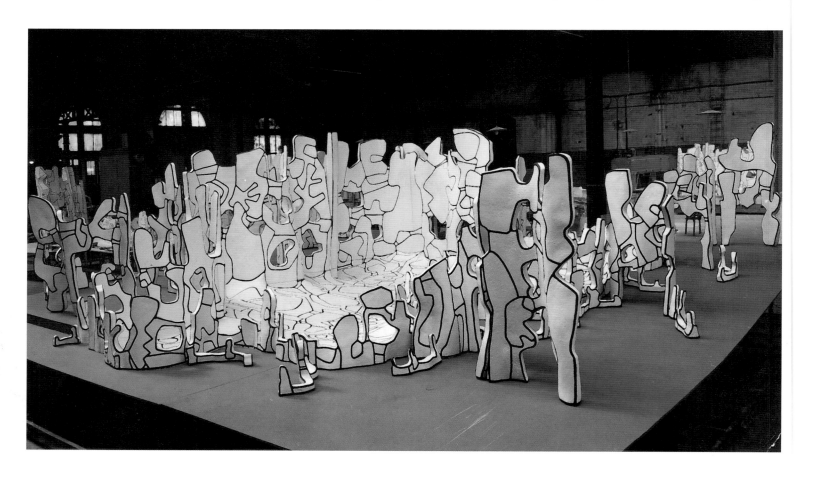

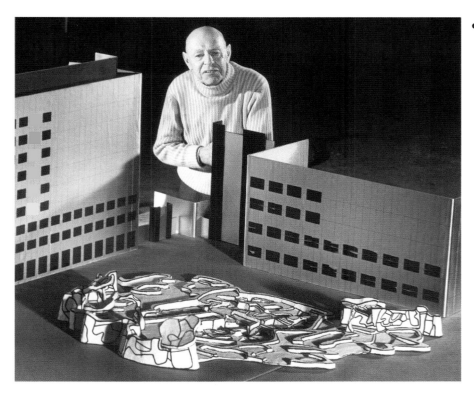

to sensitize people to the illusory character of what is normally considered to be reality, and make them aware of just how many possible realities there are", was Dubuffet's precise explanation in another of his many notes. (*Prospectus III*, p. 357).

The real concern of the author of those lines is no doubt philosophical and not religious, and his metaphysical extravaganza was a game of pure logic operating in a vacuum, like a player of a solitary game inventing a strange and arbitrary rule as he's going along. The fact remains that the *Villa Falbala*, a temple for a solitary worshipper, irresistibly calls forth images more associated with rites of initiation and ceremony or with a new school of meditation, despite the vacuousness of its present artistic role.

A PROBLEMATIC RETURN TO REALITY

"Painting can be a subtle vehicle for philosophy – and indeed for creating it in the first place. Painting is ideal – and quicker than writing – for immediately transcribing the movements of the mind exactly as they happen. It is possible that they may at this early stage be endowed with capabilities that subsequently diminish when they develop further in the realm of consciousness." ("The inititiatory paintings of Alfonso Ossorio", *Prospectus II*, p. 21). For a long time Dubuffet was uncertain about his real vocation: was he a writer, as his family and friends felt, or was he a painter? He made it clear at various times why he was eventually drawn towards painting: his more concrete, sensual, physical character. "Painting carries things in and by their body, and that's better than carrying things by their name. […] Language reduces everything to names, and then puts them all on a one-level keyboard. But painting has several levels, and where one more is needed, it puts it in. Painting operates on several keyboards at the same time." (*Prospectus II*, p. 21).

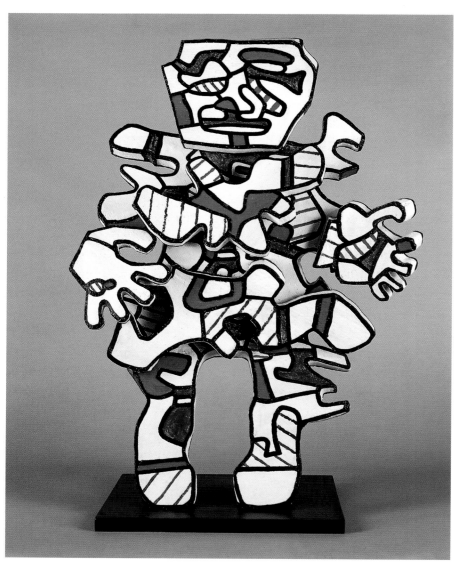

L'Accueillant
(The Host)
maquette: 1973
realization: 1988
Epoxy and
Polyurethane paint
Height: 6 m
Robert-Debré Hospital, Paris

Papa la cravate (maquette)
(Daddy necktie)
12 September-December 1973
Epoxy and
Polyurethane paint
87x60x19 cm
Fondation Dubuffet, Paris

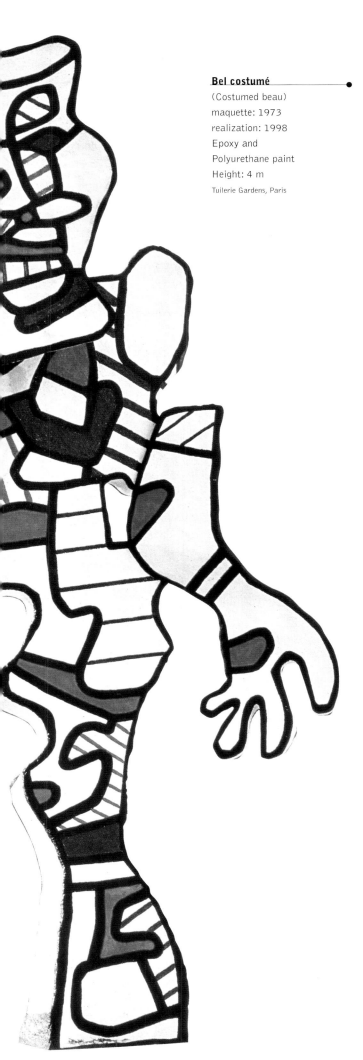

Bel costumé

(Costumed beau)
maquette: 1973
realization: 1998
Epoxy and
Polyurethane paint
Height: 4 m
Tuilerie Gardens, Paris

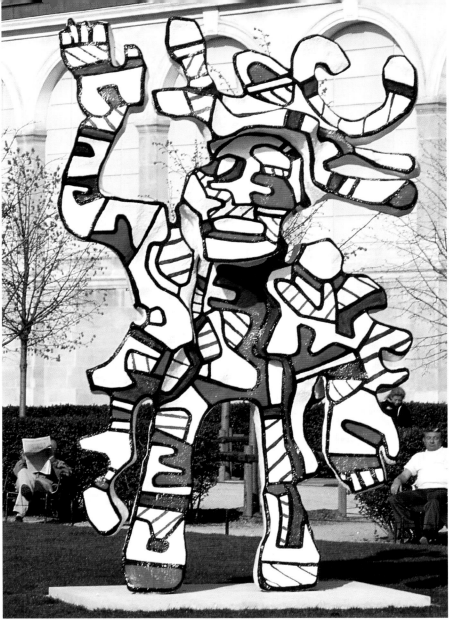

That painting can also lay claim to an intellectual function is a completely legitimate position to defend, and the last phase of Jean Dubuffet's work demonstrated it even more clearly than the two previous ones. This is from the *Doodles* of 1974, a brief return to abstraction, to the *Sights* and *Non-lieux* of 1983-1984, in which once again every figurative technique disappeared and this time for good. Dubuffet's style in the last ten years was more and more abstract, "incorporeal", to use his word, and more elementary, child-like and liberated, as if conforming to a principle of sparseness and simplification taken to the extreme limit. This final work reflects the maturity accrued over a lifetime, and represents the ultimate triumph of mind over matter.

Dubuffet was now showing his age – seventy-three by the end of the *Hourloupe* – and his severe lumbar problems forced him to do most of his work sitting down. As we see in the later photographs, which show him sitting at a table, wearing thick-framed glasses, and with pencil in hand, he resembled a writer more and more. It was as if, *in extremis*, his childhood dream had come true, and painting and writing were at last united in one action. Paper replaced canvas, generally standard offset measuring 67 by 100 centimeters which was then mounted. Felt tips, colored crayons,

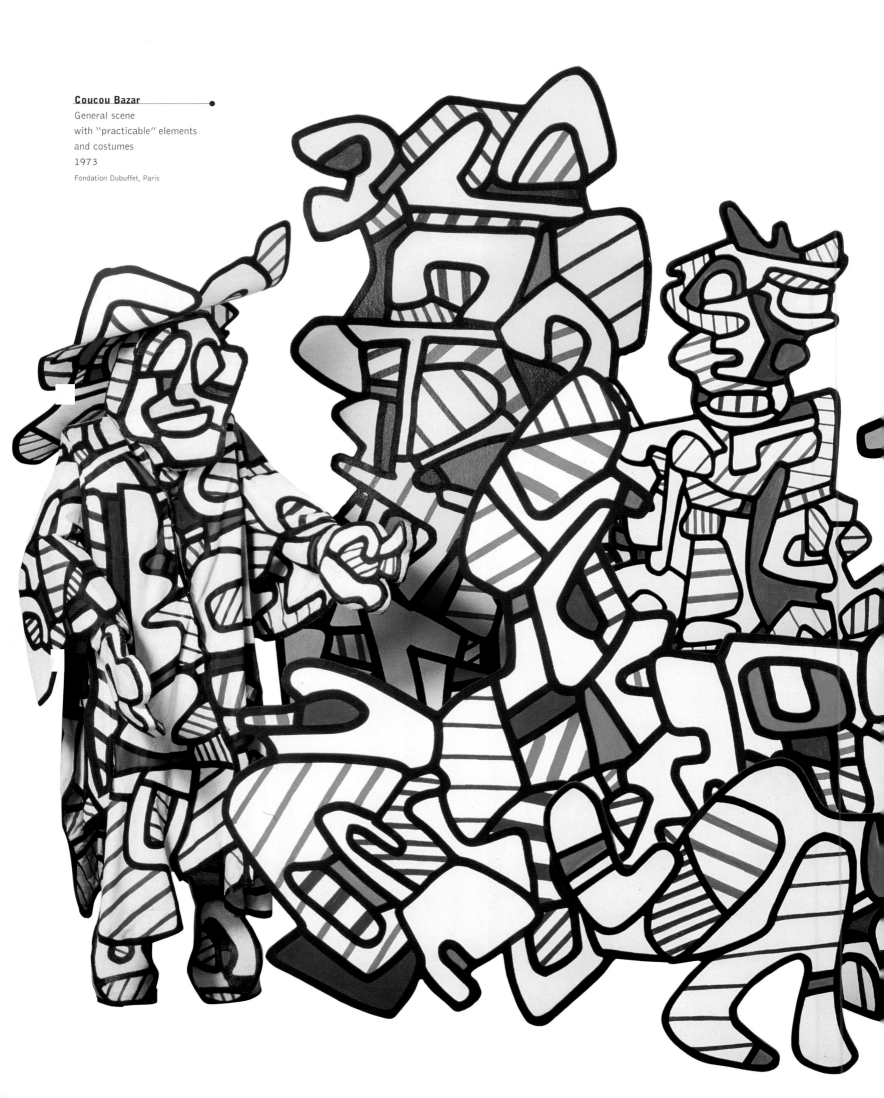

Coucou Bazar

General scene
with "practicable" elements
and costumes
1973

Fondation Dubuffet, Paris

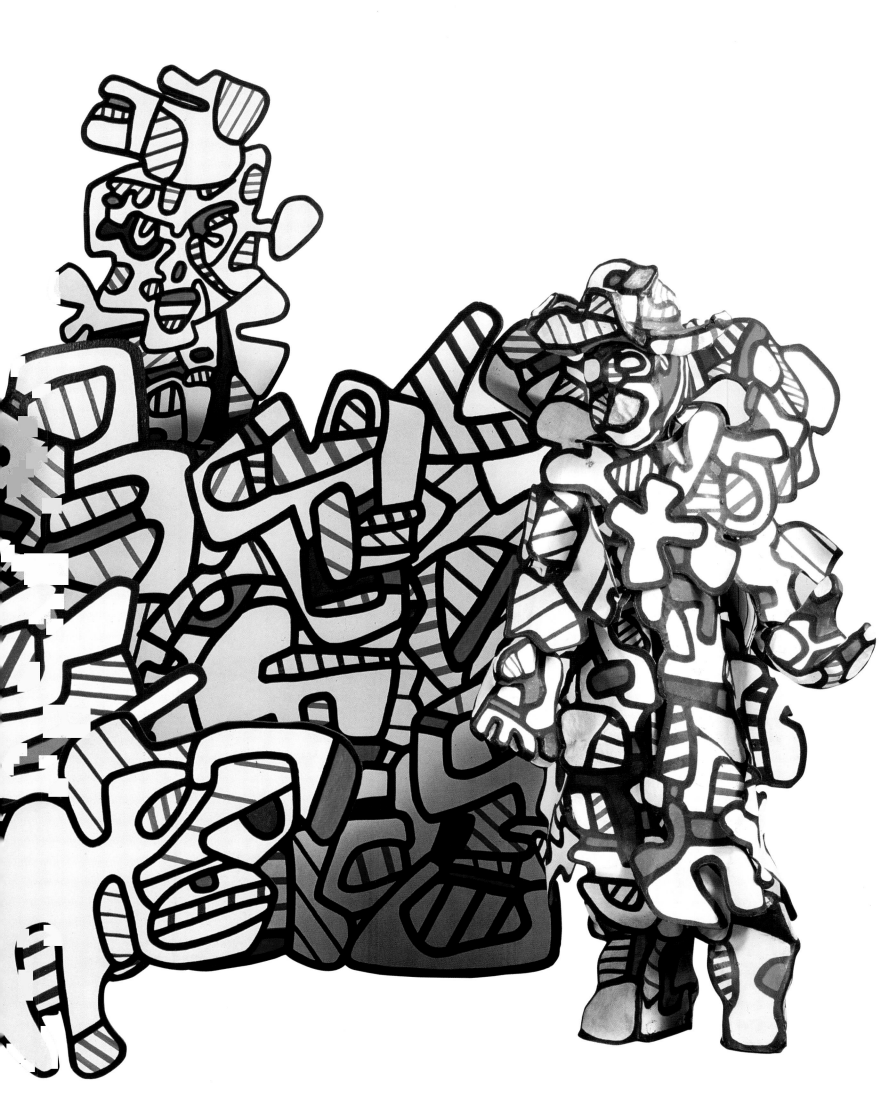

Le Patibulaire (costume)

(Sinister guy)

February 1973

Starched tarlatan fabric

painted cotton, epoxy sheeting

flexible polyurethane, latex

240x130x60 cm

Fondation Dubuffet, Paris

Gendarme (costume)

(Policeman)

September 1973

Starched tarlatan fabric

painted cotton, epoxy sheeting

flexible polyurethane, latex

210x110x50 cm

Fondation Dubuffet, Paris

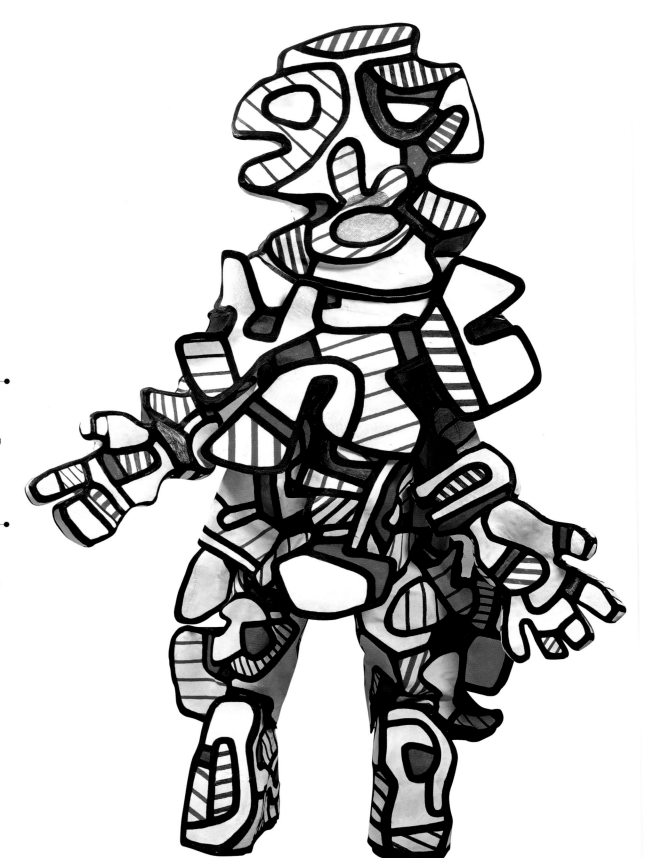

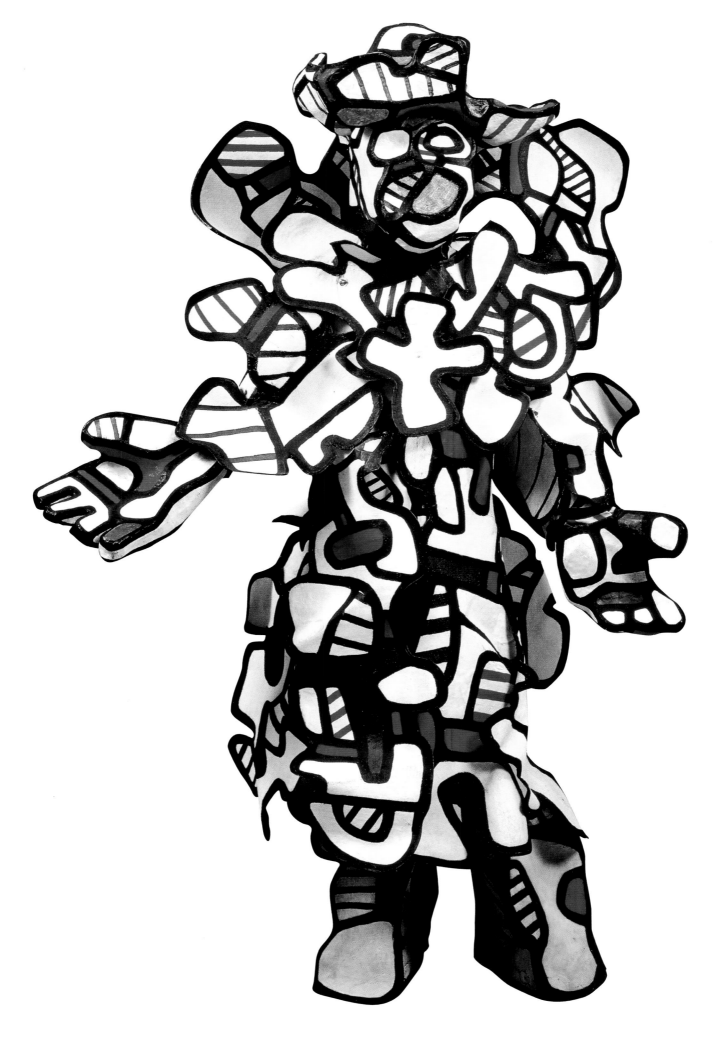

"My own impulses, I believe, have always been those you find in anarchism, with a keen taste for warm fraternization. [...] I always feel very warm towards individuals taken separately. But the greater social unit, whatever shape it takes, I regard as poisonous and loathsome."

(Letter to Henry Poulaille, 1st November 1970,
Prospectus IV, p. 296)

marker pens and quick drying paints – acrylic from 1975 on – took over completely from the heavy, thickly-mixed materials preceding the passionate affair with the *Hourloupe*.

Significantly, drawing, or rather the handling of line, the "graphic" medium, as it is called, tends to take over from painting. Dubuffet's surfaces, patchworks of bright, solid colors like those found in coloring-in books, now become just an indefinite background, a half empty stage set representing an indeterminate place. This is where all of a sudden the funny little characters of *Paris-Circus*, more stylized than ever, make their reappearance in twos and threes. And Dubuffet takes to his scissors again, cutting, pasting and assembling. Just the fixed expression on the faces and the excessively large mouths suggest something vaguely disturbing, like one last grimace that leaves the spectator feeling ill at ease. Dubuffet's titles are more and more abstract and philosophical and point to the arbitrary and hypothetical nature of the reality being depicted; the works are often just numbered and no effort is made to hide the fact that they are being produced in series.

Paradoxically, however, it is just when the painting seems to achieve the most childlike simplicity that Dubuffet's thought in his theoretical writings becomes the most elaborate. He engages in almost metaphysical speculation about being and the void, the continuity of the cosmos, the illusory nature of the world and life, or else the theory of art and perception, and in particular a conception of the gaze, a system of flat-surface reductions of the volume of objects which is in a sense not far from cubism. And the last photos of him in his studio make very clear the growing gulf between the seemingly naïve and lively character in the pictures and the serious, industrious, almost sad (Dubuffet's word was "morose") old gentleman: bald, semi-infirm, busy scribbling away with great intensity like a child.

To catch up on the sequence of events, it was on 18 August 1974, according to Andréas Franzke, that Dubuffet finished the last picture in the *Tricolor Sites*, thus concluding the *Hourloupe* cycle. This had been an adventure for which he would always feel a certain nostalgia and which would stay with him, as some *Hourloupe* "environments" were still being built or would be in the years ahead. "With these paintings, in which you can already detect dissatisfaction with the mode and a desire to return to sanity, the *Hourloupe* aberration finally came to an end, after a run of twelve years. It had been for me a mental stance aloof – perhaps too much so – from how we normally see things in everyday life, from our immediate perceptions and our emotions. All my works that derive from it seem to me because of this to be the ones that most resemble *art brut*, as I define that term. For a long time I had been very happy in that phantom world, but now I was aspiring to set foot on more solid ground." ("Biography", *Prospectus IV*, p. 531).

For some months, as if he was trying to clean out his mind and get back into artistic training, Dubuffet went in for scribbling and sketching, a sort of transitional fitness exercise while waiting for figures or shapes to turn up and point to a possible new way forward. These will be the

Site à l'oiseau

(Site with bird)
September 1974
Vinyl on canvas
195x130 cm
Fondation Dubuffet, Paris

Ontogenèse

(Ontogenesis)
April 1975
Vinyl on laminated panel
245x307 cm
Musée des beaux-arts, Le Havre

Following page:

Portrait d'homme ●

(Portrait of a Man)

21 September 1974

Colored crayons, felt tip pen,
paper pasted on to blue
background

245x307 cm

MNAM – G. Pompidou Center, Paris

● **Parachiffre XVI**

19 December 1974

Vinyl and Indian ink

on paper mounted on canvas

69x95 cm

Fondation Dubuffet, Paris

Doodles, Tales, Figurations and *Conjectures*, doodles with enigmatic titles like *Autumn in Peking*, which of course do not depict anything. He used simple school pencils and then felt tips on small sheets of paper that he then cut and pasted on to colored cardboard backing. Finally he ended this phase of his work by returning to painting in the shape of the *Parachiffres*, indecipherable lines and marks in acrylic transferred to a background as previously. Like a medium staring into the tea leaves, he was still looking for a hint of the future.

Once again it proved impossible to stay with abstraction for any length of time, and the human face began to loom up in the tangle of lines made by the brush or felt pen. These will be the *Meetings* and *Uncertain Effigies* series, squashed faces, heads and people resembling jigsaw puzzle pieces trapped in a mesh of black lines, which present the same ambiguity for interpretation as at the beginning of the *Hourloupe*, where intricately interlocking faces and profiles never got further than the very margins of perceptibility. Next came the *Abbreviated Places*, a rather disparate collection depicting the comings and goings of the characteristic little folk in Indian ink and black vinyl on colored backgrounds.

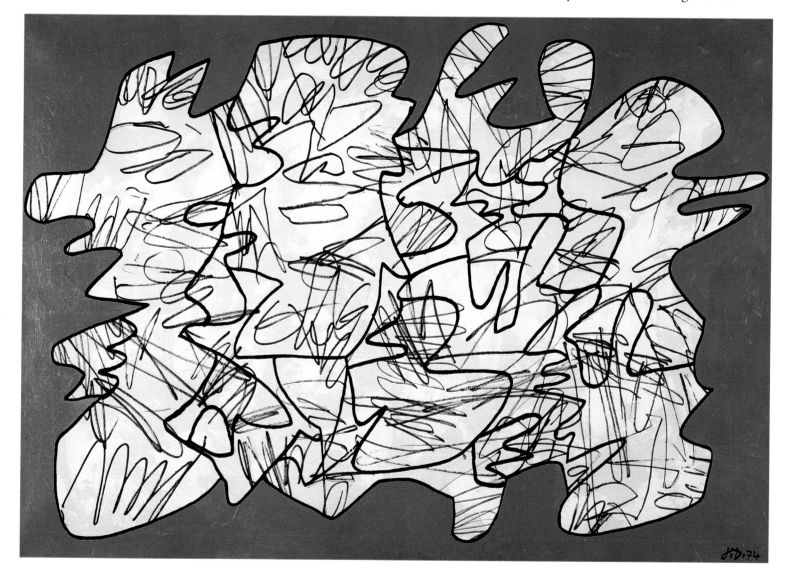

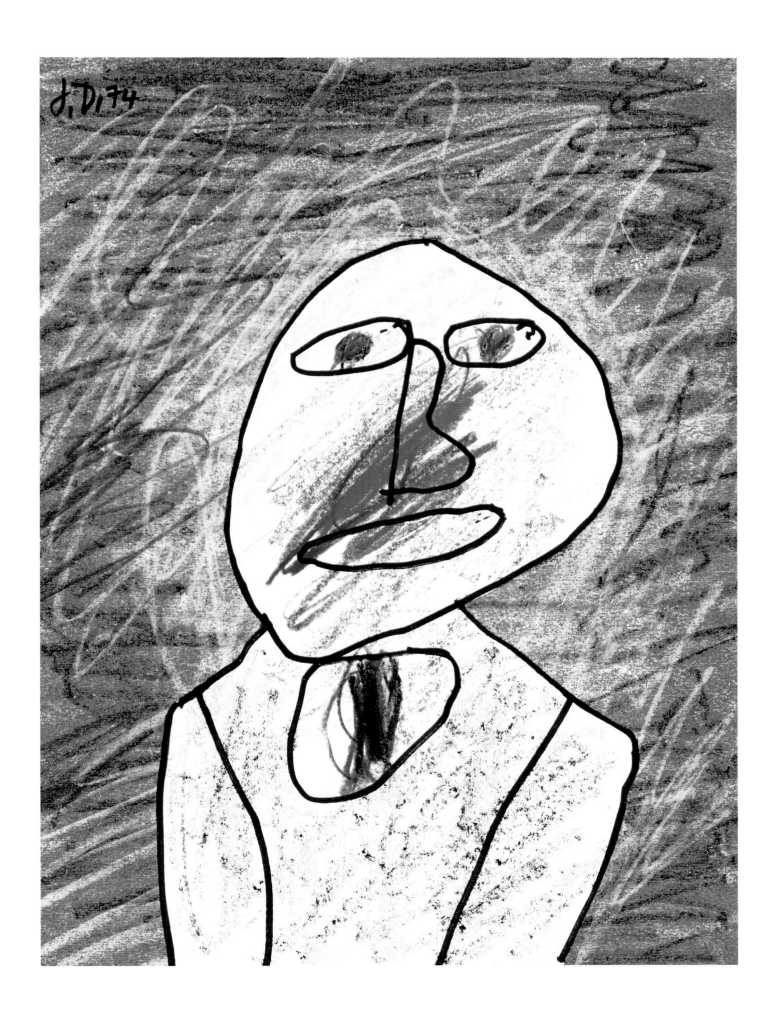

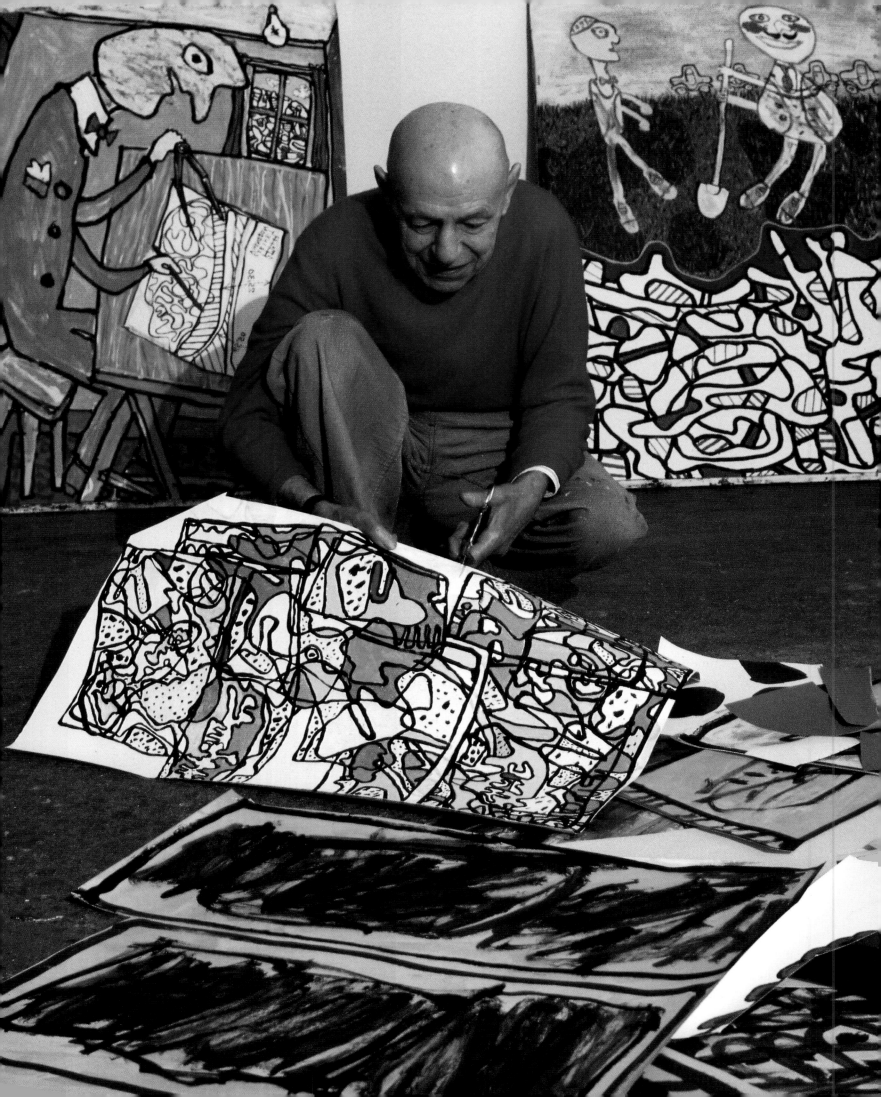

**Site à trois personnages
dont l'un porte un gâteau** •
(Site with Three Characters,
One with a Cake)
22 July 1975
Oil on canvas
92x73 cm
Private collection

• **Jean Dubuffet**
in his studio
1978

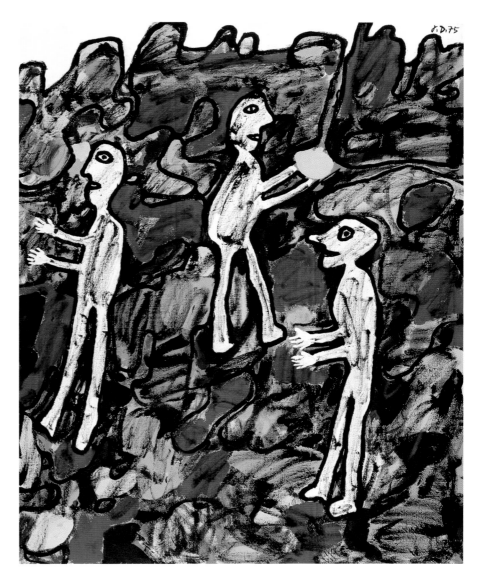

Dubuffet then moved up a gear by yet again turning to assemblage, a key technique every time he wished to create works of greater complexity. These are the famous *Theaters of Memory*, a hundred or so large-scale pictures with a deliberately contrived patchwork effect, juxtaposing heterogeneous motifs. These can be either figurative or abstract – sometimes as many as sixty per picture – and consist of abbreviated and simplified borrowings of images from earlier series. It is as if he had deliberately made the decision to plagiarize himself in a parody or rather final parade of the whole of his career: the result is a self-referential, self-cannibalizing display for the benefit of the initiated.

Nothing more aptly describes what he was trying to do than this extract from *Rambling Conversations*: "I really believe that juxtaposing very dissimilar fragments is conducive to creativity. And not just to creativity; in the realm of thought too. It introduces a note of polyphony into it. What harms thought and prevents it from soaring on the wind is the constant pull of unequivocal meaning. It is crippling. Polyphony sets it free. What thought needs to take to the air is simultaneous plurality of meaning [...] we should perhaps rather talk of cacophony than of polyphony. Thought operates on several rails that overlap and contradict one another, not on a

"The appetite for coherence is the main cause of our exorbitant and unnatural fear of things."

(Letter to Christophe Guilmoto, 7 April 1979,
Prospectus IV, p. 626)

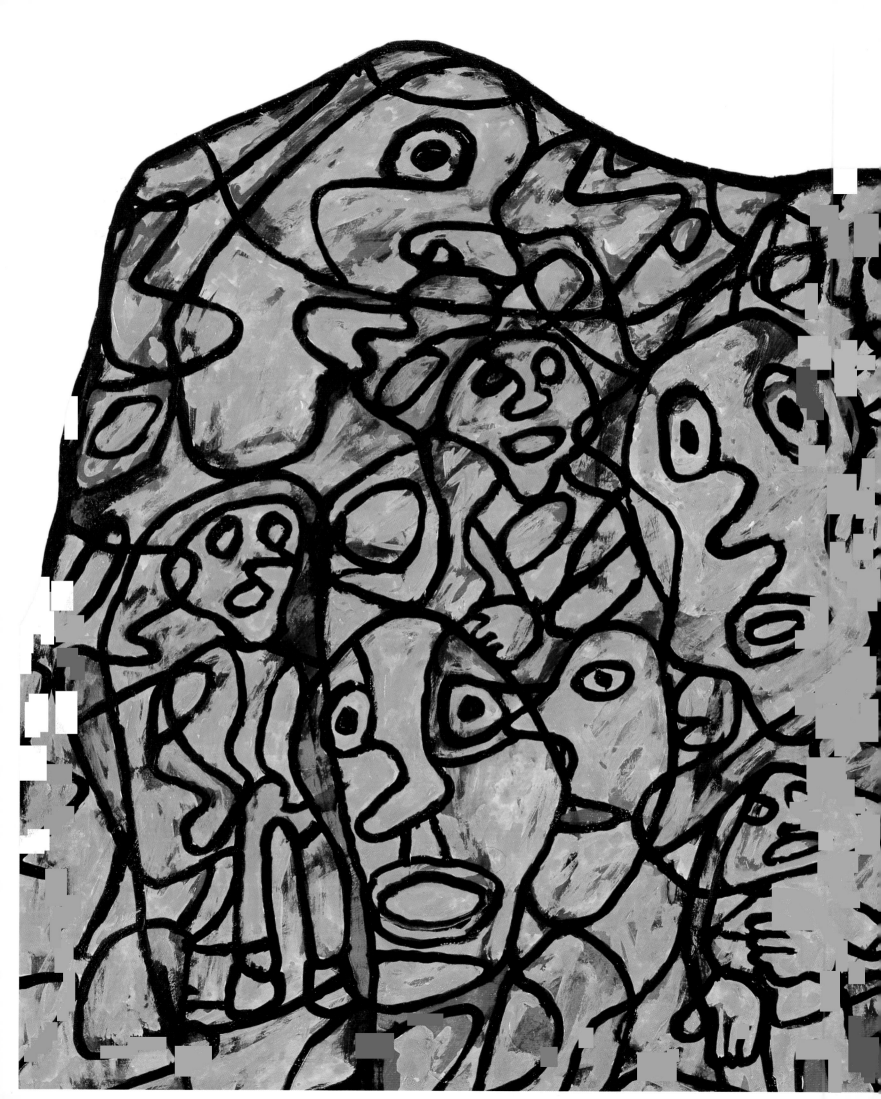

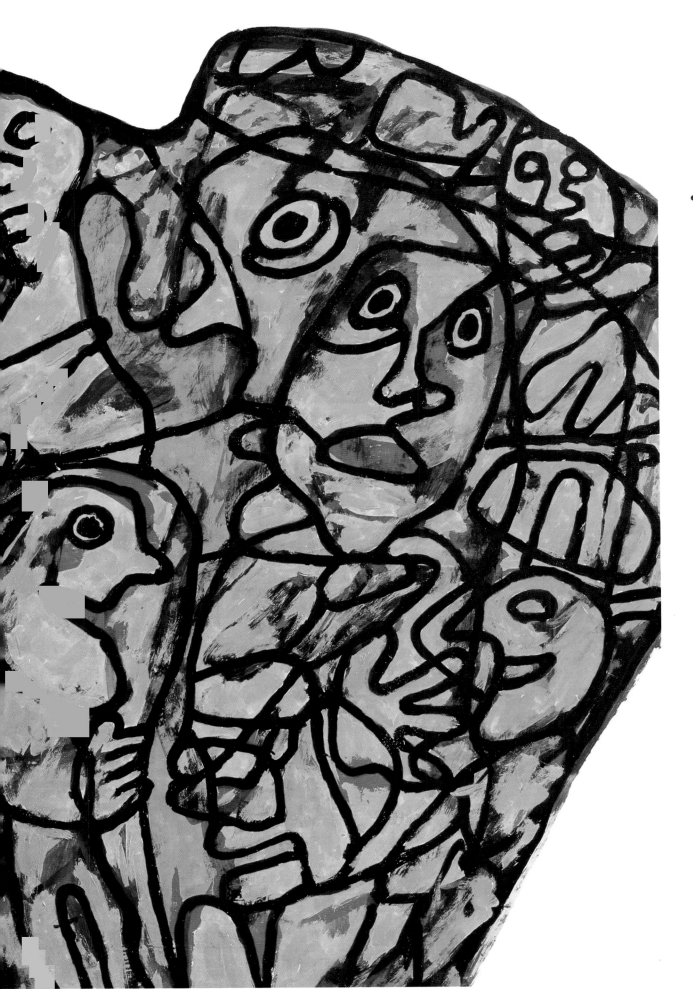

Mondanité XXVIII
(Meetings XXVIII)
28 March 1975
Vinyl on paper mounted
on canvas
67x100 cm
MNAM – G. Pompidou Center, Paris

single rail, which is what traditional culture insists on restricting it to. Thought must be given back its multiplicity." (*Prospectus III*, pp. 104-105).

We move on to 1979 and the *Annals* series, which is a transposition of the spirit of the preceding series to offset paper with black marker pen, resulting in what is doubtless one of the finest series of this period. But Dubuffet is now laid low by illness, and unable to work for several months. When he recovers, his sense of line is no longer as assured as it was, and his forms are more crudely drawn. We are now close to the final vague scribblings, as if the whole of his repertory, having been recapitulated for one last time in the brilliant parade of the *Theaters of Memory,* were beginning to grow fuzzy. It is a sort of defocusing, in which form and line gradually break up and fade away. This is doubtless an involuntary decline but one which Dubuffet, with the exceptional mental agility that was typical of him, took on board and made a central part of his philosophical program.

There then followed the *Sites with Figurines, Partitions,* the *Psycho-sites* and the *Random Sites* of April 1980 to September 1982, a few hundred acrylic or black marker pen works, occasionally with paste-on additions. These

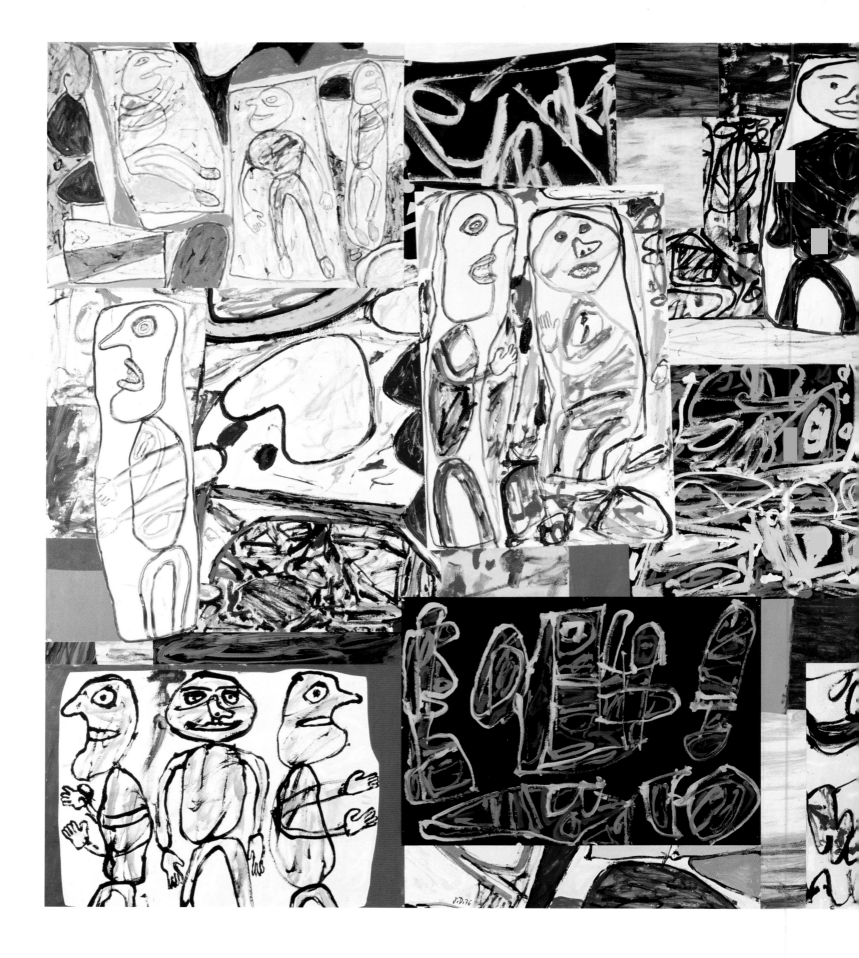

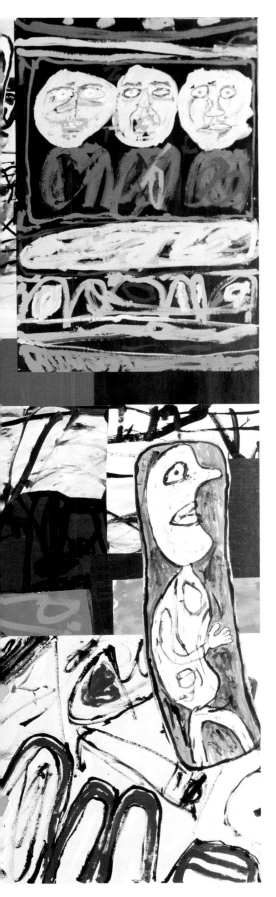

Following double page:
Les Commentaires
(The Comments)
24 May 1978
Acryl on paper
mounted on canvas
(with 30 pasted pieces added)
140x204 cm
Fondation Dubuffet, Paris

depict increasingly elementary figures, sometimes strangely scribbled over and with disturbing expressions on their faces. But now Dubuffet reaches his eighties and runs out of steam a second time. For a few weeks he is racked with pain and unable to draw, so he writes his last text in "jargon", comic phonetic French, a piece with the elegant title *Bonpiet beauneuille* (Bon pied, bon oeil / Fit as a Fiddle). Two series remain, *Mires* (Sights) and *Non-lieux* (Nonsuits or No place), a perfect antithesis in that the first is a new search for figurativeness and the second is totally negative in denying any such possibility. It is as if, after the last illusory imagining of a possible hereafter – it was necessary to accept the certainty of non existence.

THE WISDOM OF NOTHINGNESS?

On several occasions we have noted the analogy between one of the extreme tendencies of Jean Dubuffet's approach and certain oriental philosophies. This is notable at the time of the *Texturologies* in the Lamaist preference for contemplation in the face of the unnamable, indefinite and undifferentiated aspect of reality; or else with reference to the *Logological Cabinet* in the desire to create in the onlooker a "mental posture" equivalent to a real meditation exercise, as well as a general tendency to resort to what one might call the pedagogy of absurdity and delirium that is revealed by the deliberately clownish and derisory style of the subjects depicted.

Although he was incapable of subscribing to the dogma of any established system of philosophy, Dubuffet in 1975 began a very full correspondence with one Charles-André Chenu, a Tchang (Chinese Zen) philosopher, and went on to make a frank recognition of the affinity he felt at the end of his existence: "A periodical put out by the Buddhist community in the Paris region published an article a few years ago suggesting that my paintings had an affinity with Buddhist views. A long correspondence with the author of the article then ensued, and we got to know each other on friendly terms. I am not at all familiar with the dogma of that religion – if it is a religion – but I do not feel ready to join. I believe that the Zen discipline (which my correspondent followed) also lumps together the negative and nihilistic

Tissu d'épisodes
(Fabric of Episodes)
16 April 1976
Acryl on paper mounted on canvas
(with 44 pasted pieces added)
248x319 cm
MNAM – G. Pompidou Center, Paris

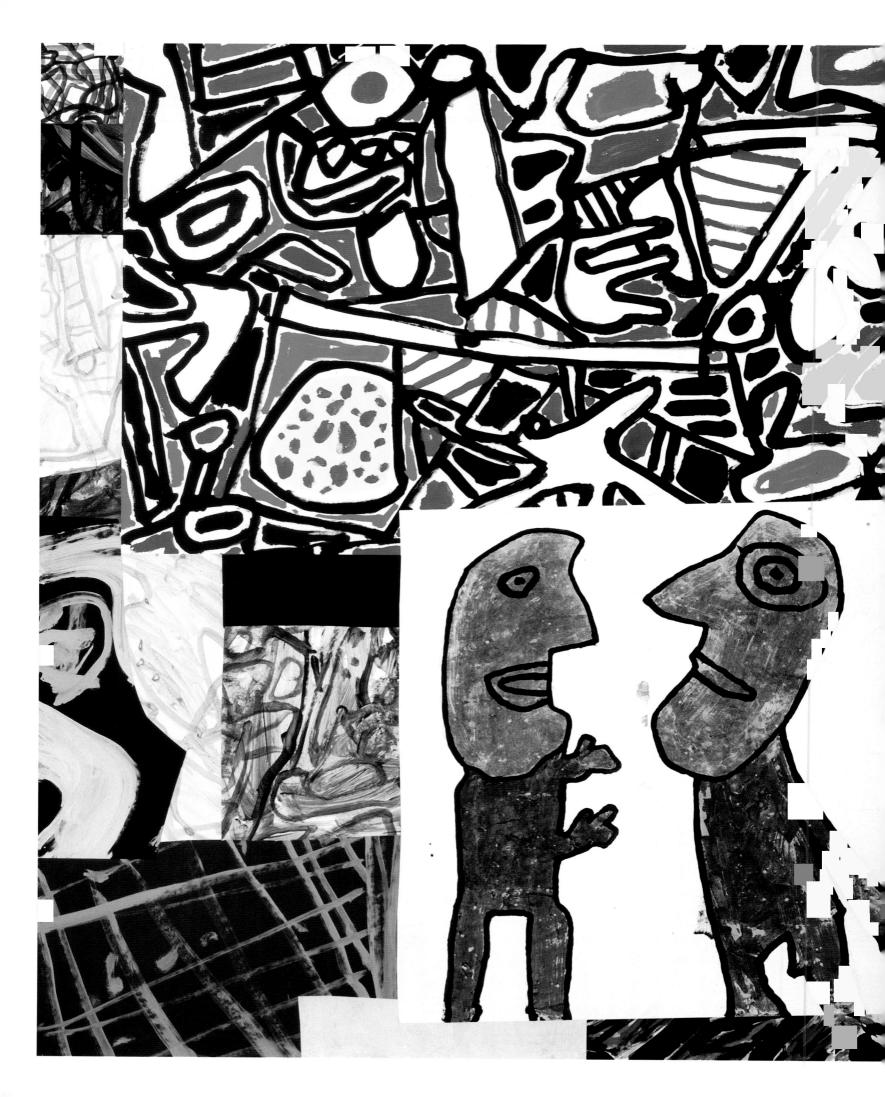

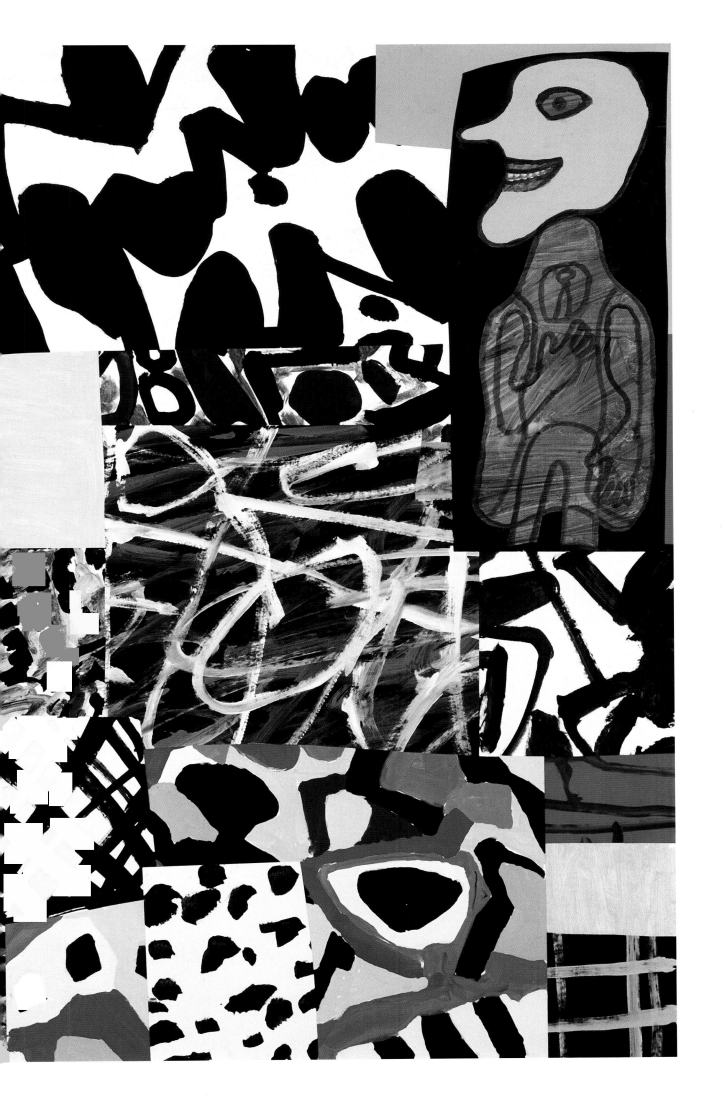

Paysage avec trois personnages

(Landscape with
Three Characters)
15 May 1980
Felt pen on paper
(with 3 pasted pieces added)
35x25.5 cm
Fondation Dubuffet, Paris

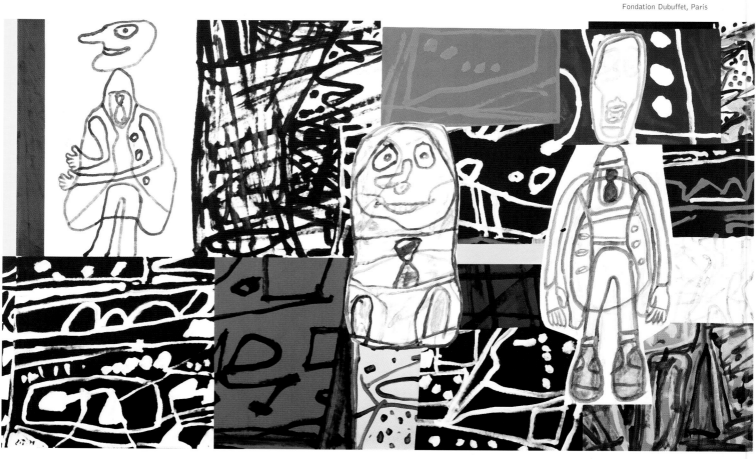

Avantage aux cravates

(Advantage to Neckties)
8 March 1978
Acryl on paper mounted on canvas
(with 24 pasted pieces added)
127x215 cm
Fondation Dubuffet, Paris

views of Buddhism and the meaningful trivia of everyday life, however illogical that may seem, like being hit with a stick or having a stone fall on your foot. I admit I feel close to this territory." ("Rambling Conversations", *Prospectus III*, p. 117).

Jean Dubuffet's last paintings and drawings, especially the most abstract such as *Sights* and *Non-lieux* are conceived as mandalas, iconic aids to meditation. They are the work of a sage despite himself who followed his own way, his own yoga, and through drawing, assemblage and painting spontaneously reached a state of true transcendental meditation. As is clear from his break with the College of Pataphysics, and even earlier when he put distance between himself and the Dada and Surrealist movements, he had long since eliminated all trace of puerility, of anti-conformist practical joking and rebelliousness – paradoxically just at a time when his style was becoming more pared down and childlike than ever.

In the empty dojo of Périgny the visitor was invited to embark on the *Hourloupe* journey with himself as sole guide and master, and discover both the arbitrariness of culture and the limits of thought. A similar mood of demystification and desire to denounce illusion pervade the images of the

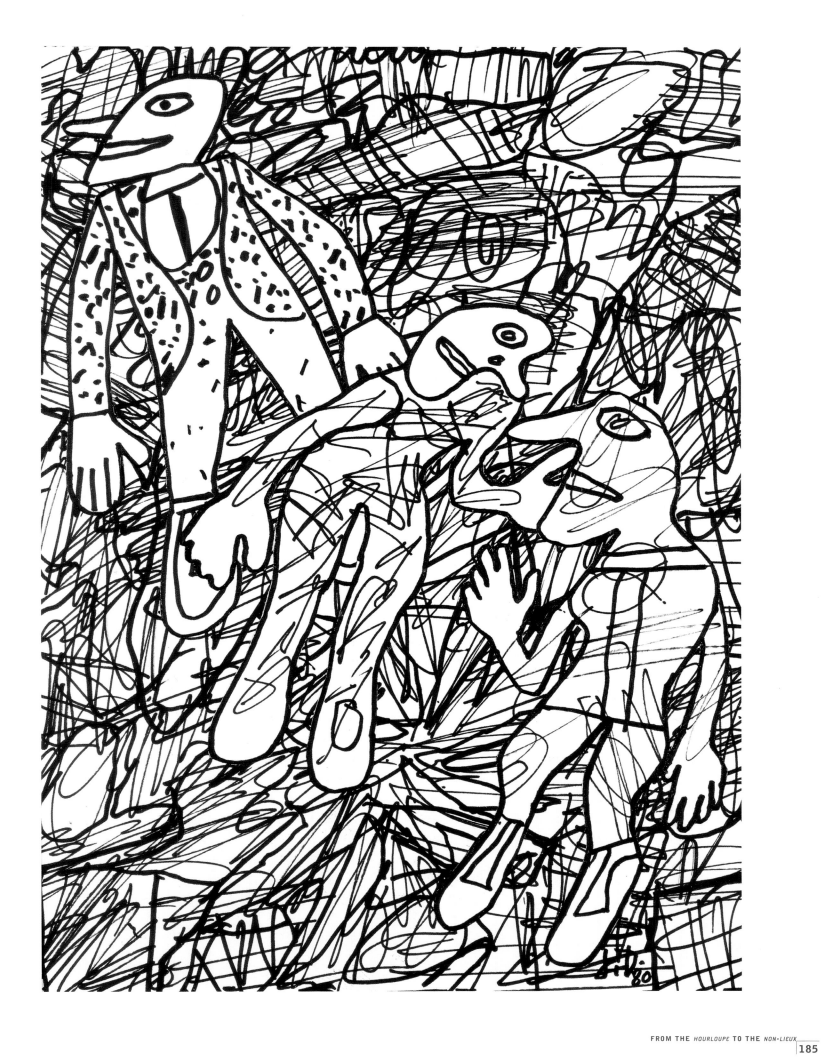

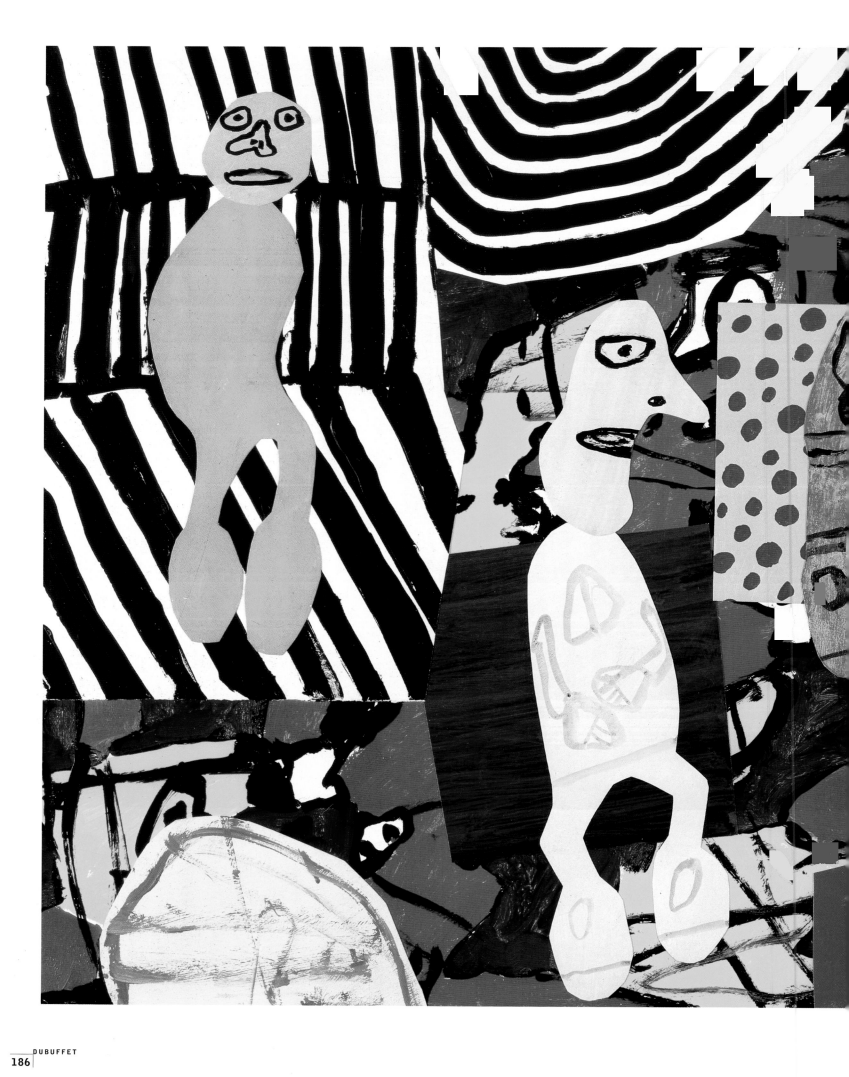

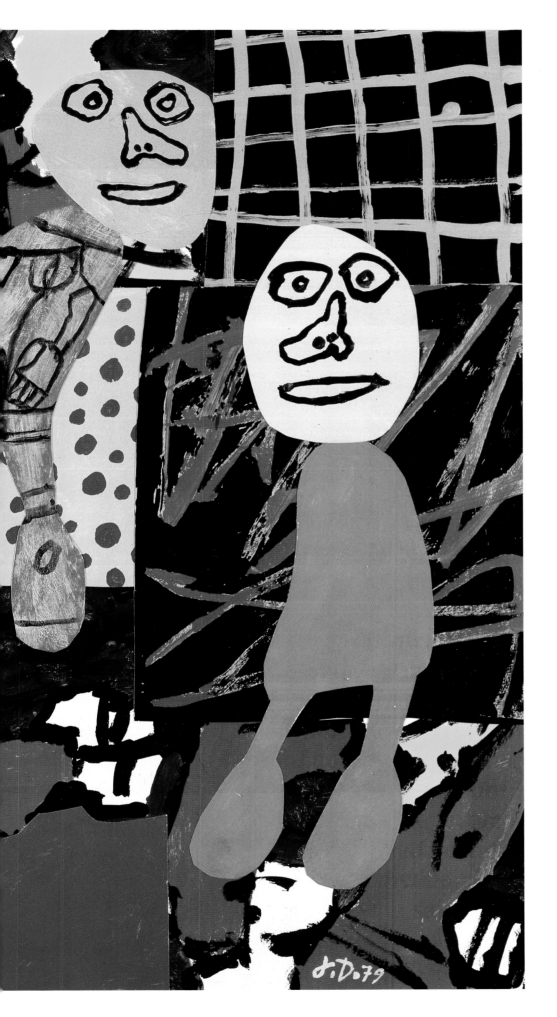

● **Les Pas perdus**
(Killing Time)
24 October 1979
Acryl on paper
(15 pasted pieces added)
51x70 cm
Fondation Dubuffet, Paris

"I feel that the categories established by critics and art historians are always very arbitrary and based on quite vague criteria. At all events they derive from the viewpoint of the person looking and not the person creating. The lettuce cannot itself feel that it must be classified among the salads."

(Letter to M. Mark Minguillon, 8 April 1976, *Prospectus IV*, p. 349)

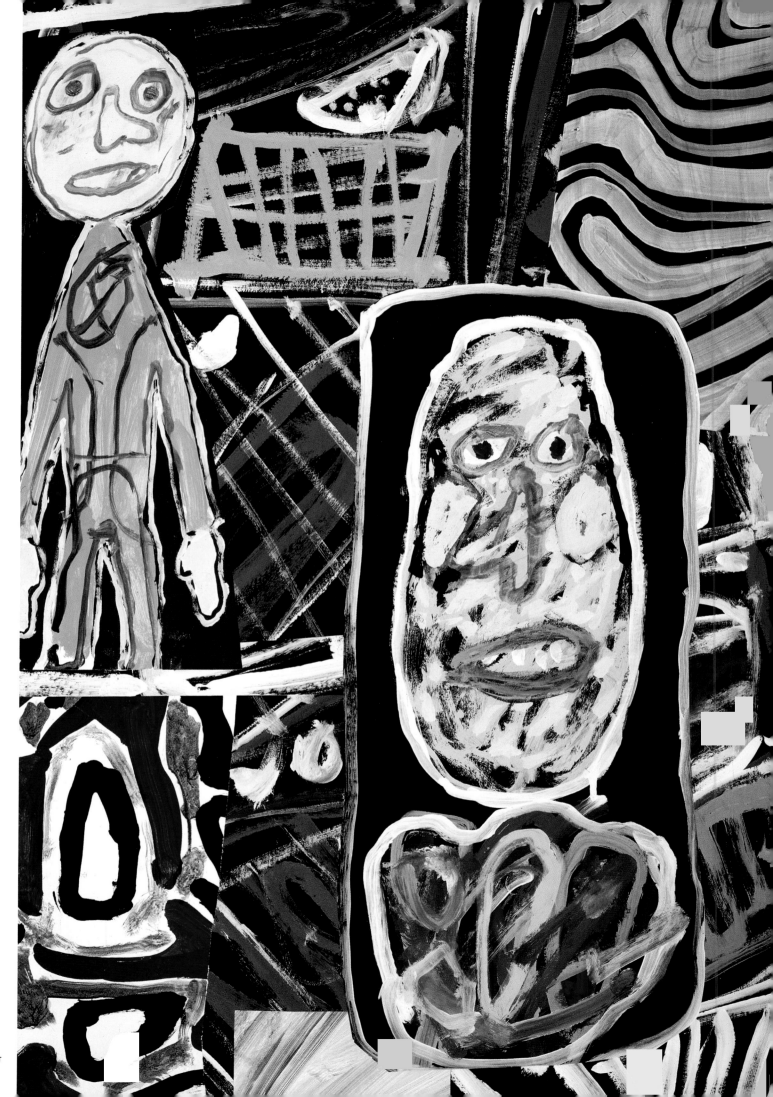

Non-lieux, coming after the meander of *Sights* into territories even more unknown than the new language of logological delirium.

Throughout this study attention has been drawn to the almost scientific type of curiosity possessed by Jean Dubuffet regarding all physical and chemical phenomena having a bearing on painting, namely the methodical manner and objectivity with which he observed the results of his work, recorded its slightest vagaries and embarked on various experiments – his systematic and controlled way of progressing assimilates him more to a scientist than to our familiar image of a painter. Finally there is the periodic quest for total effacement of the self, the obsessive desire for an anonymous return to the cosmic continuum, fed by theories of contemporary physics and to a lesser extent biology.

The truth is that a major intuition pervades the whole of the work, a dialectical vision of the complexity of the cosmos more familiar to scientists than to most artists: what one calls the being is rather "wishing to be", "vague desires to hatch out" ("Initiatic Paintings…", *Prospectus II*, p. 30). There are

all sorts of degrees and levels of reality, and the relative and ephemeral "individuation" of things is nothing but the outcome of an unceasing battle between forces which one might suspect of having a purely mental and psychic origin. With the approach of death perhaps, it is the return to the undifferentiated that fascinates and worries Dubuffet, aware of the unity of the world, a unity beyond ordinary perception: "Representing nothingness, representing at least what has no name, the indeterminate, seems to me the essential task of the painter. That's his activity in its purest form. Depicting an object is a trivial detail for a painter; it tends to distract him from the main business of painting, which is always to conjure up not a particular object but the universe in its entirety as it appears to him." ("Rambling conversations", *Prospectus III*, p. 135).

It is immediately easier retrospectively to see the point of the seamless web of signs making up the *Hourloupe*, and the meaning of those solid or striped surfaces joining up the identifiable shapes, as if any vacuum between objects had to be filled. It was to make a simple graphic analogy, by means of a rough transposition on a macroscopic scale, with the great discovery of modern physics and chemistry, namely that despite the apparent diversity of all bodies, the whole world is reducible to a combination of a much smaller number of elementary bodies. It is rather like a gigantic construction game with infinite possibilities, in which the primary bodies were nothing but concentrated energy.

But Dubuffet was always an extremist and aspired in the last series to go much further, feeling obliged in the end to abandon material things in order to concentrate on the void from which they come. "Representing nothingness" was what he henceforth defined as the purpose of painting – as sterile and impossible an ambition on which to finish as the impasse in

● **Site avec deux personnages**
(Psycho-sites E-313)
(Site with Two Characters)
21 September 1981
Acryl on paper mounted
on canvas
50x67 cm
Private collection

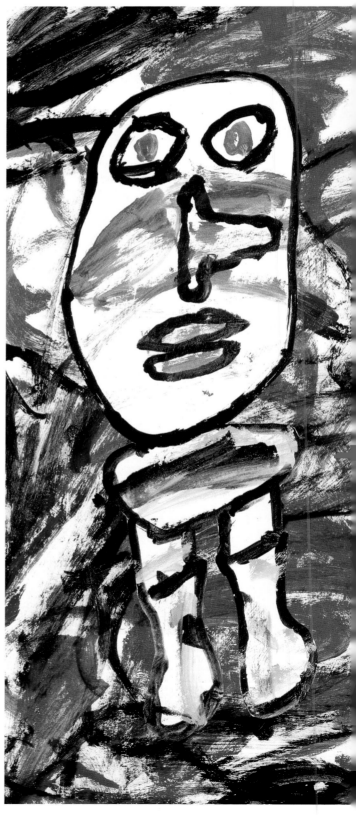

Site avec trois personnages •

(Random Sites – F 105)

(Site with Three Characters)

17 July 1982

Acryl on paper mounted

on canvas

(with 3 pasted pieces added)

67x100 cm

MNAM – G. Pompidou Center, Paris

Deposit at musée de l'Abbaye Sainte-Croix,

Les Sables d'Olonne

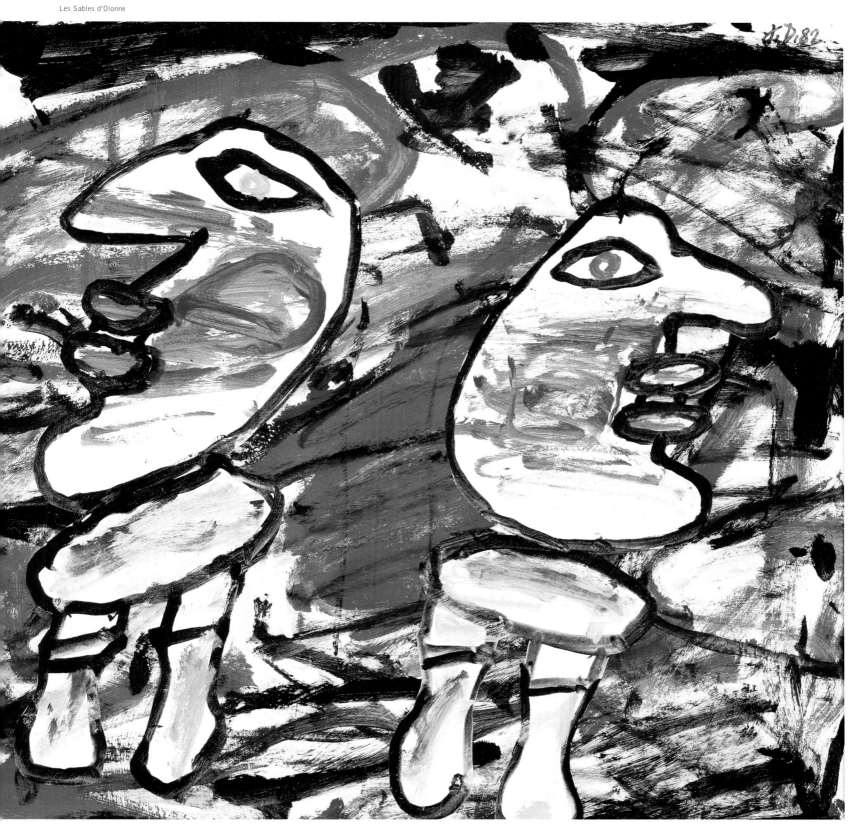

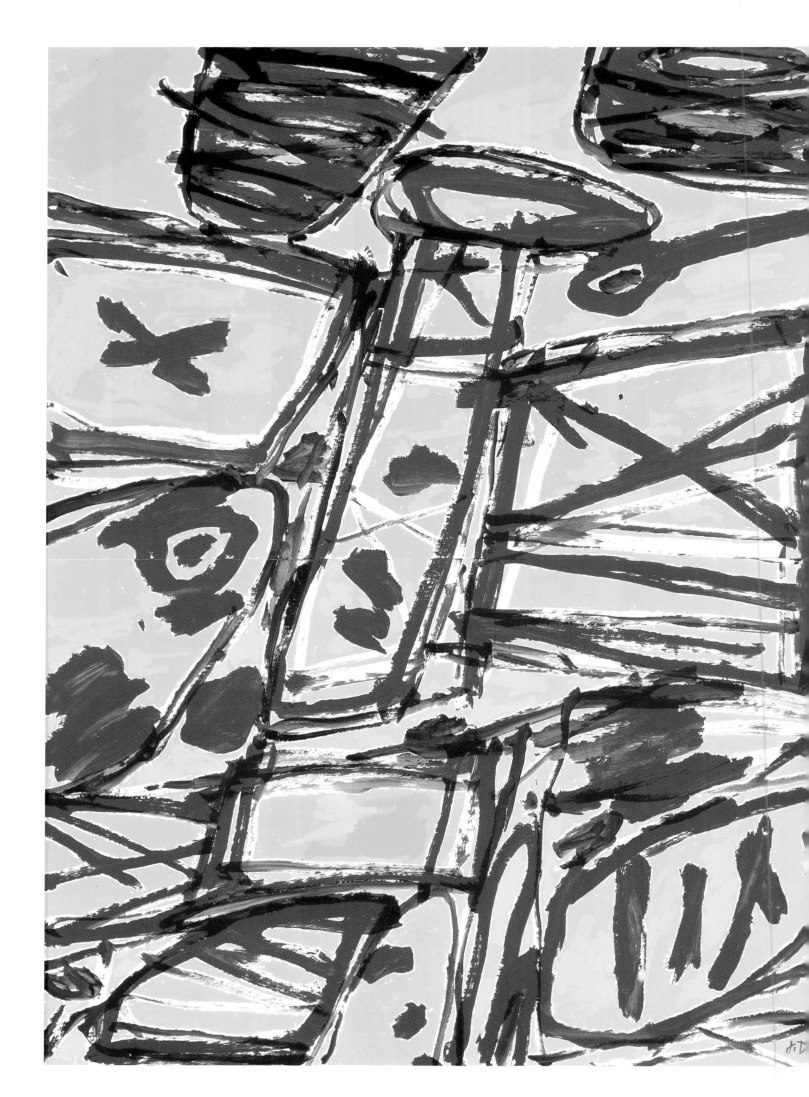

which Malevitch and Mondrian lost themselves in their time, even if it was the logical outcome of an entirely different intellectual process.

In the *Sites* series, scrawled sketches on yellow backgrounds, or *Kowloons*, on white, or *Boleros*, altogether some two hundred large format works created between February 1983 and February 1984, it is a question of simulating another reality again, another reference system and new unknown sites, and the lens of the mental camera is focused on an imaginary depth of vision. The background is suddenly fuzzy, and empty of all recognizable objects. "You can't see anything there you could put a name to", Dubuffet wrote. "The dominant idea is that the interpretation that human beings put on the world and that controls their thought and daily life is entirely wrong, with a new and totally foreign way of looking being substituted for it." ("Biography…", *Prospectus IV*, p. 537).

The biggest work of this period, entitled *Course of Events*, can be seen in the Georges Pompidou Center. It consists of a succession of joined up sections, made up of thirty-two sheets of standard format paper, giving it a length of eight meters by two meters sixty-eight high. It has neither limits nor center, beginning nor end, and being as virtually interminable as time itself or a concert of Indian music, it is the realization of a long-standing aim expressed at the time of *Roads and Roadways* in March 1956: to get away from the very notion of framing. But whereas at that time the taste for the undifferentiated was found in its raw state, in *Course of Events* it exists only in a very refined form, devoid of all sensuality. It is as if the purpose of the *Mires* series were to represent the more

"Representing nothingness, representing at least what has no name, the indeterminate, seems to me the essential task of the painter. That's his activity in its purest form."

("Rambling Conversations", *Prospectus III*, p. 135)

Following double page:
Mire G 180 (Boléro)
(Sight G 180 - Bolero)
4 January 1984
Acryl on paper mounted
on canvas
134x200 cm
MNAM – G. Pompidou Center, Paris

Mire G 131 (Kowloon)
(Sight G 131 - Kowloon)
9 September 1983
Acryl on paper mounted
on canvas
134x100 cm
MNAM – G. Pompidou Center, Paris

Mire G 123 (Boléro)
(Sight G 123 - Bolero)
2 September 1983
Acryl on paper mounted
on canvas
67x100 cm
MNAM – G. Pompidou Center, Paris
Deposit at musée de l'Abbaye
Sainte-Croix, Les Sables d'Olonne

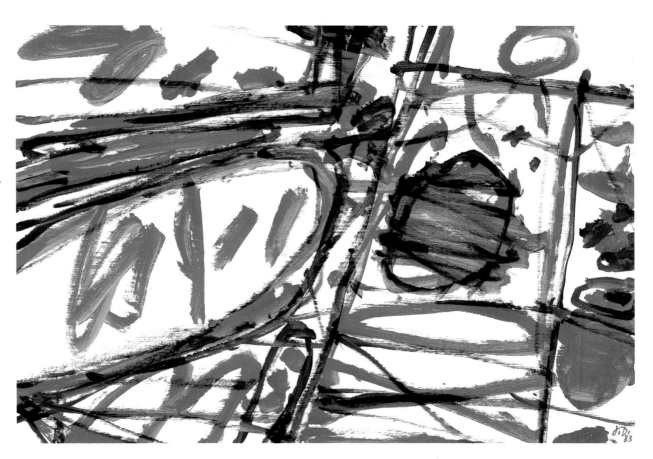

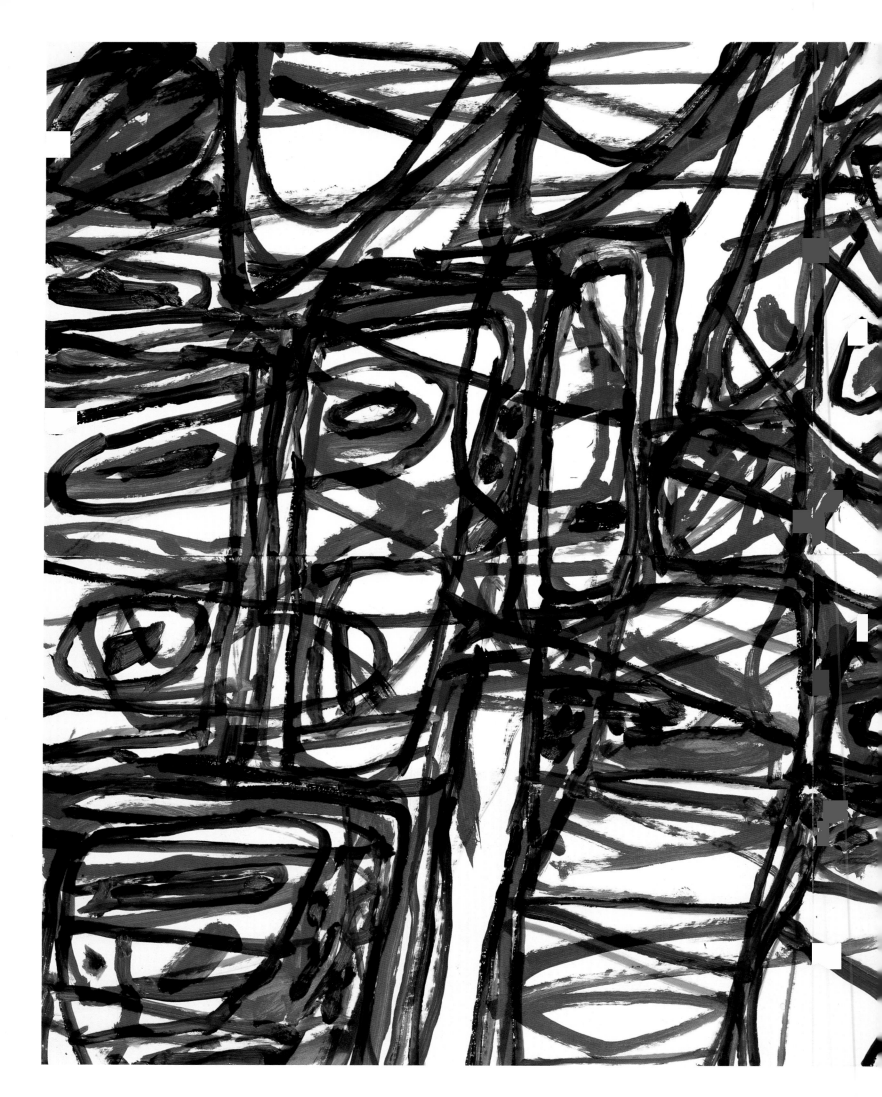

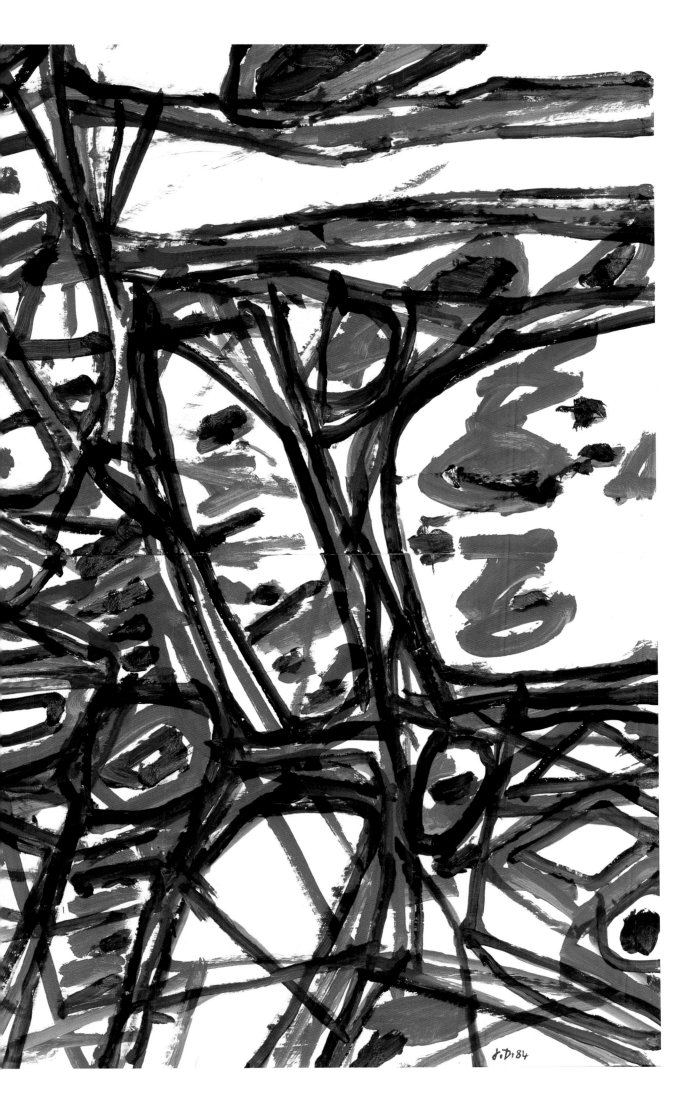

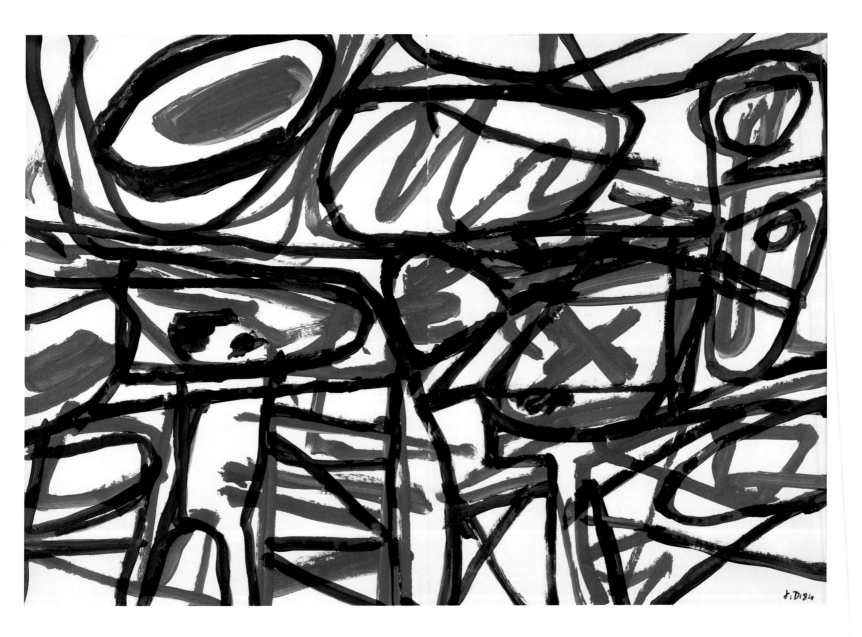

"I've always stubbornly persisted in the idea that values held to be negative can become constructive factors. They have their time to flower just like other values."

(Letter to Gaiano, 15 October 1979, *Prospectus IV*, p. 389)

Mire G 204 (Boléro)
(Sight G 204 - Bolero)
17 February 1984
Acryl on paper mounted
on canvas
100x134 cm
Musée des Beaux-Arts, Nantes

abstract and incorporeal equivalent of those *Texturologies* and *Materiologies* that had also been a terminal point, but in the first period.

Then came the last change of direction. We arrive at the final series, *Non-lieux*, which have black as their ground – the color of the cosmos, of nothingness and the infinite. In these final pictures, in a free-flowing swirl of red, white and sky blue acrylic lines, color, movement and purpose are liberated once and for all. After the ever impossible attempt to represent nothingness, there is now no point in even trying; it is the ultimate void. Dubuffet wanted first of all to settle his account with culture one last time and offer the bare rudiments of a new symbolic system as an alternative language and new program of vision. He is now subverting the very principle of all thought, or at least is claiming to. There were almost as many of these works, which were painted from February to December 1984, as in the preceding series, and this is what Dubuffet had to say about them: "Almost all of them have a black background. They are even more philosophical and even more seriously nihilistic than the *Sights*, because they are no longer just pervaded, as the latter were, by the idea of conjuring up "being" in a very generalized and conceptualized way, but now by the

Donnée (Non-lieux H 15)
(Data - Nonsuits H 15)
28 April 1984
Acryl on paper mounted
on canvas
67x100 cm
MNAM – G. Pompidou Center, Paris

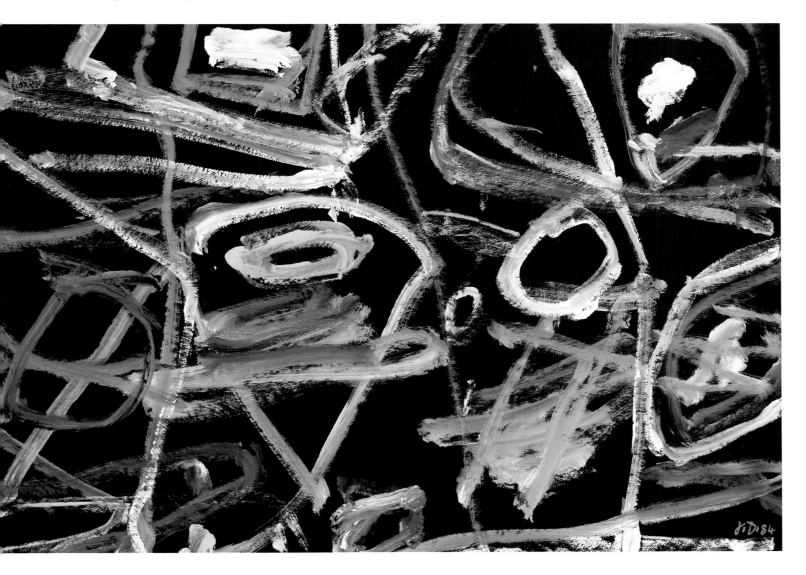

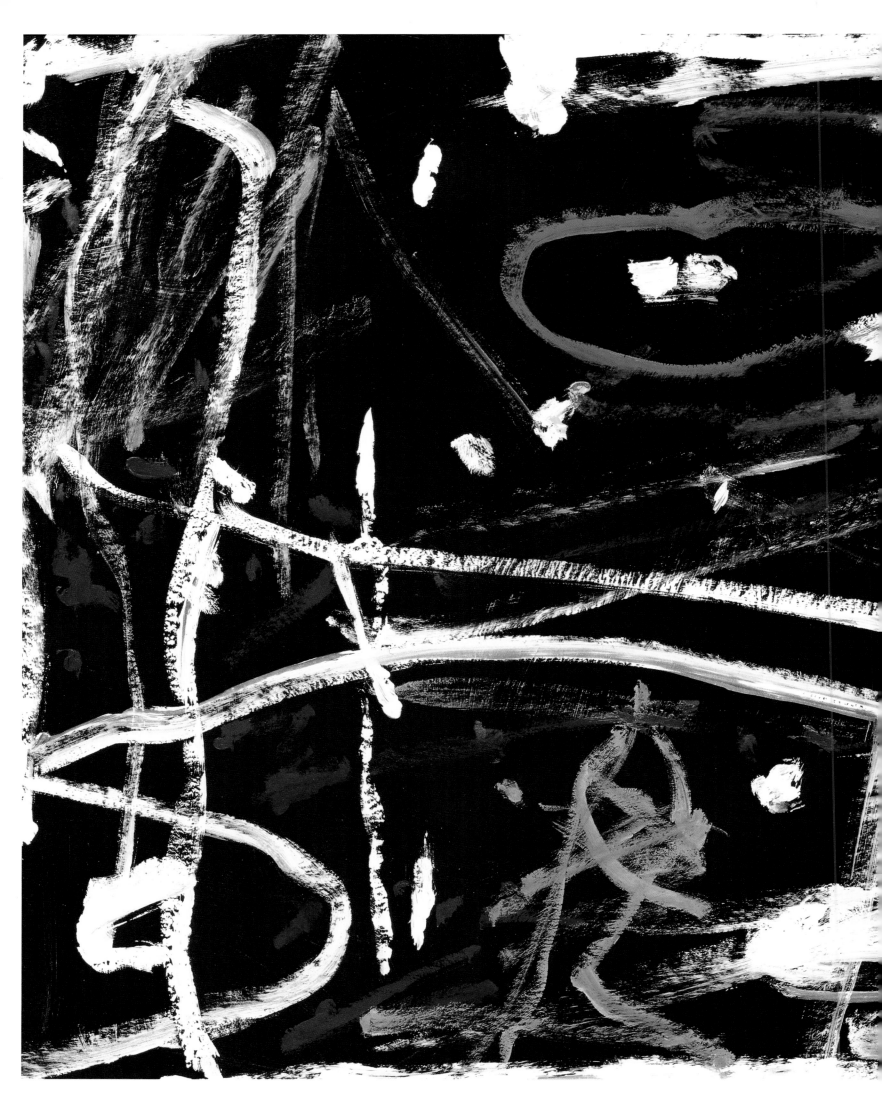

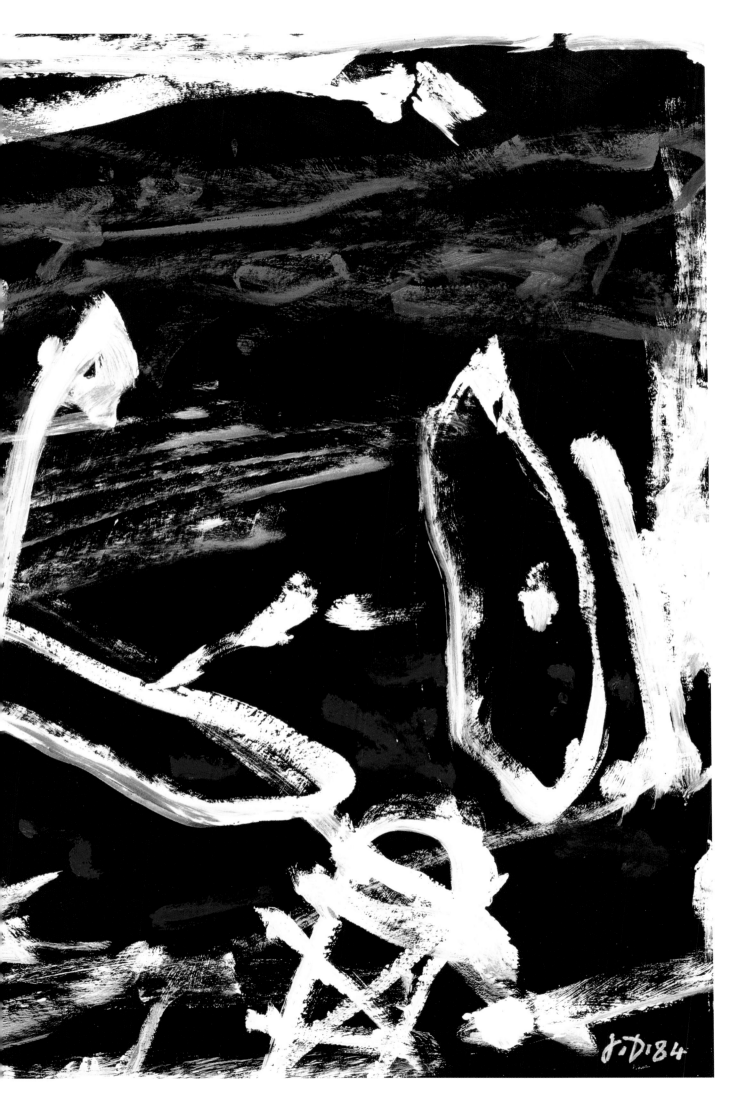

"I no longer believe in the meaning of nothing, I no longer believe even that the notion of meaning has a meaning. What painting can I do at this stage?"

(Letter to Valère Novarina, 30 January 1985,

Prospectus IV, p. 452)

idea that this notion of "being" is in itself without foundation, a futile projection of our imagination. Hence paintings which seek to represent not the world but the incorporeality of the world, or, let us say, nothingness with the ghostly population of fantasies which we project into it" ("Biography…", *Prospectus IV*, p. 537).

Doubting everything, even the notions of more and less, and claiming to have arrived at a "maieutics of what we call nothingness", he went so far as to assert: "What is certain is that our understanding leads to nothing but dead ends and lamentations, so let us stride on beyond it, let us get our lungs used to breathing in the absurd." ("Rambling Conversations", *Prospectus III*, p. 165). Then, in a moment of doubt, he confessed: "It could well be that I've driven the train too far, right off the rails without any hope of going back. To the extent that there it is – with the difference between being and non-being having disappeared – painting perhaps no longer retains anything of what was once its purpose. It has lost its direction. So has thought. It's not just *tabula rasa*, there's no table left at all. The painter might as well just pack up his paints. These are the fears that plague me." ("Rambling Conversations", p. 165).

And the last line of the manuscript of these unfinished *Rambling Conversations*, that Dubuffet was still working on at the time of his death in May 1985, instead of any kind of rational statement is a simple image, "the nuptial flight of the bumblebee". With the detachment of the stoic sage that his friend Georges Limbour had for a long time known him to be, he departed this world with these awesome last words: "I accept responsibility." (*idem, p.165*). Just as *Psycho-sites* could seem in French roughly to be a phonetic metathesis of "psychotic" (psychotique) for the artist who was so familiar with the work of the mentally ill, *Non-lieux* has a distant echo of the hazardous litigation with the Renault automobile company. Nothing is finally proven one way or the other, and Dubuffet's work ends on both a yes and a no. In his trial with reality, the artist, more Taoist than ever, will remain ambiguous to the very end.

Jean Dubuffet's
● **last drawing, untitled**
17 April 1985
Colored crayons
on writing paper
21x13.5 cm
Fondation Dubuffet, Paris

Jean Dubuffet and his wife, Lili
18 August 1983

"They say that wisdom comes with age. It makes me laugh. The notion of wisdom is also false. The best thing is to let yourself be carried along like a cork in the water. The cork is wise."

(Letter to Pierre Carbonel, 27 January 1981, *Prospectus IV*, p. 401)

Appendices

BIBLIOGRAPHY

JEAN DUBUFFET'S
MAIN WRITINGS:

Prospectus et tous écrits suivants, présentés par Hubert Damish, tomes I et II, Éditions Gallimard, Paris, 1967. Tomes III et IV, Éditions Gallimard, 1995.
l'Asphyxiante Culture, Éditions Jean-Jacques Pauvert, Paris, 1968 (rééd. Minuit, 1986).
L'Homme du commun à l'ouvrage, présenté par Jacques Berne, Éditions Gallimard, coll. Idées, Paris, 1973.
*Bâtons Rompus, (*Rambling Conversations , Éditions de Minuit, Paris, 1986.

CORRESPONDENCE:

Poirer le papillon, Letters from Jean Dubuffet to Pierre Bettencourt (1949-1985), Éditions Lettres vives, Paris, 1987.
Lettres à J.B., Letters from Jean Dubuffet to Jacques Berne (1946-1985), Éditions Hermann, 1991.
Lettres à un animateur de combats de densités liquides, Letters from Jean Dubuffet to Pierre Carbonel, Éditions Hesse, 1992.
Jean Dubuffet et Claude Simon, Correspondence 1970-1984, Éditions L'Échoppe, Paris, 1994.
La Ponte de la langouste, Letters from Jean Dubuffet to Alain Pauzié, Éditions Le Castor Astral, Paris, 1995.
Correspondance, Dubuffet (Jean) and Gombrowicz (Witold), Éditions Gallimard, Paris, 1995.
Jean Dubuffet, Ludovic Massé: correspondance croisée, 1940-1981, Éditions Mare Nostrum, Perpignan, 2000.

CATALOG OF JEAN DUBUFFET'S WORKS

Volume I : *Marionnettes de la ville et de la campagne* (1917-1945).
Volume II : *Mirobolus, Macadam & Cie* (1945-1946).
Volume III : *Plus beaux qu'ils croient (Portraits)* (1946-1947).
Volume IV : *Roses d'Allah, clowns du désert* (1947-1949).
Volume V : *Paysages grotesques* (1949-1950).
Volume VI : *Corps de dames* (1950-1951).
Volume VII : *Tables paysagées, paysages du mental, pierres philosophiques* (1950-1952).
Volume VIII : *Lieux momentanés, pâtes battues* (1952-1953).
Volume IX : *Assemblages d'empreintes* (1953-1954).
Volume X : *Vaches, petites statues de la vie précaire* (1954).
Volume XI : *Charrettes, jardins, personnages monolithes* (1955).
Volume XII : *Tableaux d'assemblages* (1955-1957).

Volume XIII : *Célébration du sol I, lieux cursifs, texturologies, topographies* (1957-1958).
Volume XIV : *Célébration du sol II, texturologies, topographies* (1958-1959).
Volume XV : *As-tu cueilli la fleur de barbe ?* (1959).
Volume XVI : *Les Phénomènes* (1958-1963).
Volume XVII : *Matériologies* (1958-1960).
Volume XVIII : *Dessins* (1960-1961).
Volume XIX : *Paris-Circus* (1961-1962).
Volume XX : *L'Hourloupe I* (1962-1964).
Volume XXI : *L'Hourloupe II* (1964-1966).
Volume XXII : *Cartes, ustensiles* (1964-1967).
Volume XXIII : *Sculptures peintes* (1966-1967).
Volume XXIV : *Tour aux figures, amoncellements, Cabinet logologique* (1967-1969).
Volume XXV : *Arbres, murs, architectures* (1969-1972).
Volume XXVI : *Dessins* (1969-1972).
Volume XXVII : *Coucou Bazar* (1971-1973).
Fascicule XXVIII : *Roman burlesque, Sites tricolores* (1972-1974).
Volume XXIX : *Crayonnages, Récits, Conjectures* (1974-1975).
Volume XXX : *Parachiffres, Mondanités, Lieux abrégés* (1974-1976).
Volume XXXI : *Habitats, Closerie Falbala, Salon d'été* (1969-1977).
Volume XXXII : *Théâtres de mémoire* (1975-1979).
Fascicule XXXIII : *Sites aux figurines*, Volume (1980-1981).
Volume XXXIV : *Psycho-sites* (1981-1982).
Volume XXXV : *Sites aléatoires* (1982).
Volume XXXVI : *Mires* (1983-1984).
Volume XXXVII : *Non-lieux* (1984).
Volume XXXVIII : *Derniers dessins* (1983-1985).

Webel (Sophie), *L'Œuvre gravé et les livres illustrés par Jean Dubuffet*, descriptive catalog, 2 vol., Baudoin Lelon éditeur, Paris, 1991.

The catalog of Jean Dubuffets's works can be consulted in the library of the Pompidou Center, Beaubourg, Paris.

MAIN WORKS ON JEAN DUBUFFET:

Quelques Introductions au Cosmorama de J. Dubuffet Satrape, Travaux du Collège de Pataphysique, Charleville, 1960. Texts by Noël Arnaud, Georges Limbour, François Laloux, Henri P. Bouché, Lutembi, Irène Gondoire, Vasco Tartuca and Jean Dubuffet.
Dubuffet: culture et subversion, L'Arc n° 35, Aix-en-Provence, 1968.
Jean Dubuffet, L'Herne n° 22, May 1973.
Barilli (Renato), *Dubuffet materiologo*, Éditions Alfa, Bologne, 1963.
Fitzsimmons (James), *Jean Dubuffet: brève introduction à son œuvre*, Éditions de la Connaissance, Bruxelles, 1958.

Franzke (Andréas), *Dubuffet,*
Éditions Gallimard, Paris, 1975.
Limbour (Georges), *L'Art brut de Jean Dubuffet.*
Tableau bon levain, à vous de cuire la pâte,
New York/Paris, Éditions Pierre Matisse/
René Drouin, 1953.
Loreau (Max), *Dubuffet et le voyage au centre*
de la perception, Éditions La Jeune Parque,
Paris, 1966.
Paquet (Marcel), *Dubuffet,* Nouvelles Éditions
françaises, Paris, 1993.
Picon (Gaëtan), *Le Travail de Jean Dubuffet,*
Éditions Albert Skira, Geneva, 1973.
Ragon (Michel), *Dubuffet,* Éditions Georges
Fall, coll. Le Musée de Poche, Paris, 1958
(enlarged edition, Fall édition, 1995).
Thévoz (Michel), *Dubuffet,*
Éditions Albert Skira, Geneva, 1986.
Trucchi (Lorenza), *Jean Dubuffet,*
Edizione De Luca , Rome, 1965.

RADIO INTERVIEWS, FILMS, TELEVISION PROGRAMS:

AUDIO MATERIAL (RADIO, RECORDS)

"Quelques Propos sur la peinture": conversation
with Georges Limbour and René de Solier
in *Des idées et des hommes*, a program by Jean
Amrouche recorded on 20 March 1954 as part
of the Dubuffet exhibition at the cercle Volney:
25 mins. Unpublished.

"Ce qu'ils en pensent": conversation with
Georges Ribemont-Dessaignes, broadcast
on 13 November 1956: 19 mins.

"Interactualités", interview with Micheline
Sandrel about the Dubuffet retrospective
at the musée des Arts décoratifs, broadcast
on 16 December 1960: 4 mins. Unpublished.

"Culture et Destin": conversation with Georges
Ribemont-Dessaignes, with musical intervals
and followed by the recital of the poem
La Fleur de barbe (Flower Beard) by the author.
Recorded on 20 February 1961, broadcast
on 17 July 1961: 42 mins.

MUSICAL EXPERIMENTS

Six records published by la Galleria del
Cavallino, Venice, 1961 (recorded between
January and April 1961). Reissued as a CD
in 1991 with the title *Expériences musicales*
de Jean Dubuffet ou La Musique chauve, based
on an idea by Jean-Pierre Armengaud, produced
by Circé/Fondation Dubuffet.

AUDIO-VISUAL MATERIAL (CINEMA, TELEVISION)

"Jean Dubuffet", by Michel Chapuis and Jacques
Ruttmann, program *Terre des arts,*
by Max-Pol Fouchet, a French Radio (ORTF)
production, December 1960.
Broadcast in January 1961 on the occasion
of the retrospective at
the musée des Arts décoratifs, Paris.

Dubuffet: autoportrait, (self-portrait), by Gérard
Patris and Lucien Favory in collaboration
with Pierre Schaeffer, produced by Service
de la recherche de l'O.R.T.F. (French Radio
research service) and Braunberger Films, 1962.
"L'Architecture de Jean Dubuffet", by José
Maria Berzosa in the program *Champ visuel,*
produced by ORTF, 1969.

Les Praticables, by J.Scandelari, produced
by L.N.P./Pierre Nahon, 1972 (about *Coucou*
Bazar), 6 mins, 30 seconds.

Coucou Bazar Dubuffet, by Adam Saulnier,
produced by ORTF, 1973.

"Jean Dubuffet Exhibition", by Martin Sarraut
and André Parinaud, in program *Forum des arts,*
produced by ORTF, 1973.

Une visite aux ateliers du peintre Dubuffet,
("visit to the artist's studios")
Fuji Telecasting Company, 1975, 60 mins.

"Jean Dubuffet", by Philippe Collin and
Jean-Daniel Verhaeque in the program
L'Homme en question, produced by F.R.3
and broadcast on 13 November 1977
(about the Renault lawsuit), 65 mins.

Coucou Bazar, produced by Fiat at the time
of the Turin performance, 1978, 60 mins.

Dubuffet à Venise, by Laurent Coignard, script
by Daniel Abadie, 1984.

WHERE TO SEE DUBUFFET'S WORK

DRAWINGS, PAINTINGS, SCULPTURES:

In Paris
Fondation Dubuffet: 137, rue de Sèvres, 75006,
Paris. Tel.: + 33 1 47 34 12 63

Dubuffet Donation, musée des Arts décoratifs:
works from 1942 to 1967 (*Portraits,*
Matériologies, Assemblages, Éléments botaniques,
Petites statues de la vie précaire, paintings
of the *Hourloupe*). Closed to the public at the
present time because of building work. Union
des Arts décoratifs, 107, rue de Rivoli, 75001.
Tel: + 33 1 44 55 57 60.

Georges Pompidou Center: various works,
including the *Course of Events*, the biggest
picture in the *Mires* (*Sights*) series.

Paris region
Fondation Dubuffet: Moving décors and
costumes from *Coucou Bazar*, works from 1964
to 1984. Fondation Dubuffet, Sente des vaux,
Ruelle aux chevaux, 94520 Périgny-sur-Yerres,
by appointment (apply to the Fondation in Paris).

French regions
Various works can be seen in the Museums of
Amiens, Calais, Colmar, Grenoble, Lyon, Les
Sables-d'Olonne, Saint-Étienne, at F.R.A.C.
Rhône-Alpes, Côte d'Azur, etc.

Outside France
Museums in Louisiana and Silkebord (Denmark).
Stedelijk Museum of Amsterdam (Netherlands).
Tate (Modern) Gallery, London, (Great Britain)
Museum of Modern Art, NY (U.S.A.).
Guggenheim Museum, NY (U.S.A.)
Philadelphia Museum (U.S.A.)
Art Institute of Chicago (U.S.A.)

BUILDINGS AND LARGE-SCALE WORKS:

In Paris
Jardin d'hiver (Winter Garden): Musée national
d'Art moderne, Georges Pompidou Center,
19 rue Beaubourg, 75004 Paris.

L'Accueillant: Hôpital Robert-Debré,
48 boulevard Sérurier, 75019 Paris.

Le Réséda: Cour d'honneur de la Caisse
des Dépôts et Consignations,
3 quai Anatole France, 75007 Paris.

Bel Costumé: Domaine national des Tuileries,
place de la Concorde, 75008 Paris.

Paris region
Closerie Falbala:
Fondation Dubuffet, Sente des Vaux, Ruelle aux
chevaux, 94520 Périgny-sur-Yerres.
By appointment (apply to the Fondation in Paris).

Tour aux figures: Parc départemental de l'île
Saint-Germain, 92130 Issy-les-Moulineaux.
Visits: Office du Tourisme - +33 1 40 95 65 43.

Chaufferie avec cheminée: Carrefour
de la Libération, 94400 Vitry-sur-Seine.

French regions
Le Boqueteau: 74000 Flaine.

Outside France
Le Jardin d'émail: Rijkmuseum Kröller-Müller,
Otterlo (Netherlands).

Groupe de quatre arbres (Group of Four Trees):
Chase Manhattan Plaza, New York (U.S.A.).

*Monument à la bête debout (Monument with
Standing Beast):* Plaza of State
of Illinois Center, Chicago (U.S.A.).

*Monument au fantôme (Monument with
Phantom):* Interfirst Plaza, Houston, Texas.

Chambre au lit sous l'arbre: collection Mr. &
Mrs Arnold Glimcher, Long Island (U.S.A.).

RELATING TO OUTSIDER ART AND ART BRUT

BIBLIOGRAPHY:

In addition to the twenty volumes
of the *Publications de l'Art brut*, there are:

Cardinal (Roger), *Outsider Art*,
Studio Vista Editions, London, 1972.
Danchin (Laurent), *Art brut & Cie*,
Éditions La Différence, Paris, 1995.
Delacampagne (Christian), *Outsiders, fous, naïfs
et voyants dans la peinture moderne (1880-1960)*,
Éditions Mengès, Paris, 1989.
Ferrier (Jean-Louis), *Les Primitifs du XX^e siècle
(art brut et art des malades mentaux)*,
Éditions Terrail, Paris, 1997.
MacGregor (John), *The Discovery of the art of the
insane*, Princeton University Press, Princeton, 1989.
Maizels (John), *Raw Creation (Outsider art
and beyond)*, Phaidon Press, London, 1996.
Maizels (John) et von Schaewen (Deidi),
Imaginary worlds/ Mondes imaginaires,
Taschen Editions , London/Berlin/Paris, 1999.
Monnin (Françoise), *L'Art brut*,
Éditions Scala, Paris, 1997.
Peiry (Lucienne), *L'Art brut*,
Éditions Flammarion, Paris, 1997.
Prinzhorn (Hans), *Expressions de la folie*,
Éditions Gallimard, Paris, 1984.
Ragon (Michel), *Du côté de l'art brut*,
Éditions Albin Michel, Paris, 1996.
Rhodes (Colin), *OutsiderArt: spontaneus alternatives*,
Thames & Hudson, London, 2000.
Thévoz (Michel), *L'Art brut*, Éditions Albert Skira,
Geneva, 1975 (reissue, 1995).

MUSEUMS AND PLACES TO VISIT:

Collection de l'art brut,
château de Beaulieu
11 avenue des Bergières, 1004 Lausanne.
Tel.: + 41 21 647 54 35.
Web: www.artbrut.ch.
E-mail: art.brut@lausanne.ch
SWITZERLAND

La Fabuloserie-Alain Bourbonnais
89120 Dicy (close to Joigny).
Tel.: +33 3 86 63 64 21.
FRANCE

L'Aracine, musée d'Art moderne
Lille Métropole - 1, allée du Musée,
59650 Villeneuve d'Ascq
Tel.: +33 3 20 19 68 68
Web: http://www.nordnet.fr/mam
E-mail : mam@nordnet.fr

Museum Charlotte Zander, Schloss
Bönnigheim - Hauptstrassse 15,
74357 Bönnigheim.
Tel.: + 49 71 43 42 25
GERMANY

Photographic Credits

This book is printed by
Grafiche Zanini - Bologna - Italy